ANTHEM

TABLE OF CONTENTS

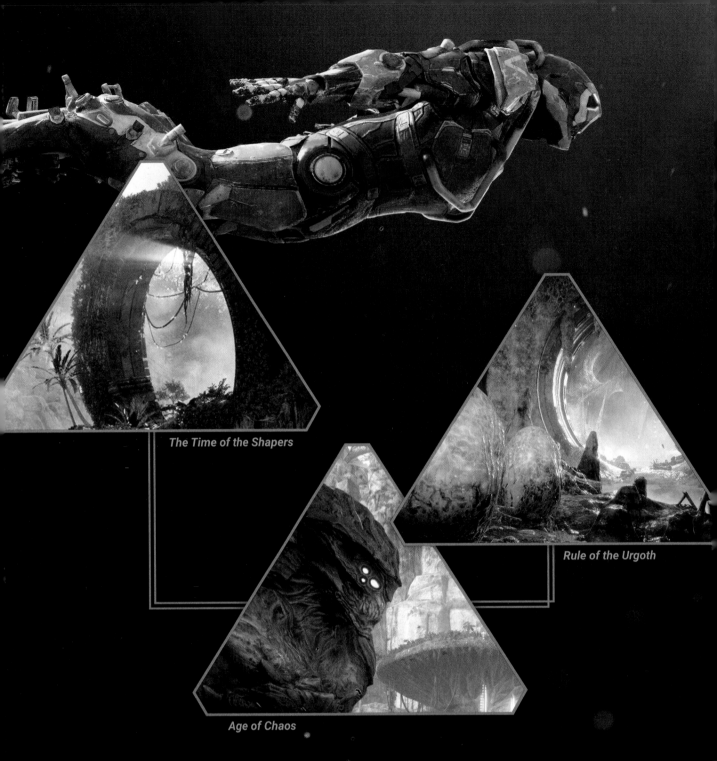

The Time of the Shapers

Rule of the Urgoth

Age of Chaos

THE WORLD OF
ANTHEM™

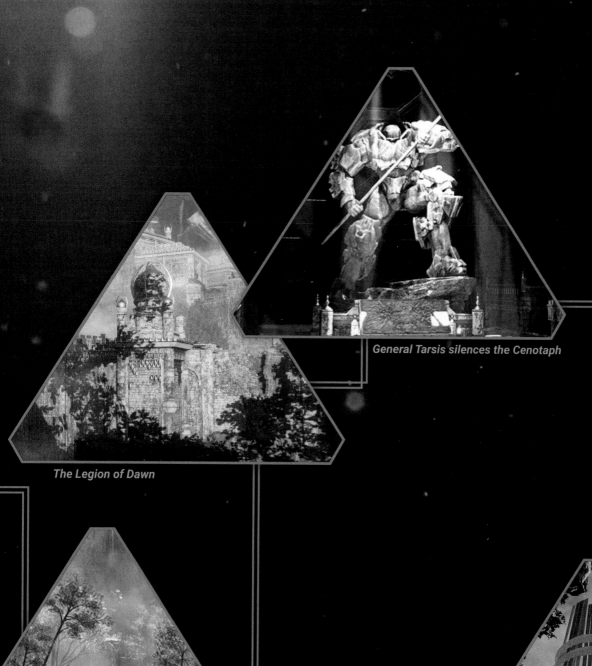

General Tarsis silences the Cenotaph

The Legion of Dawn

The Human Resistance

The Modern Era

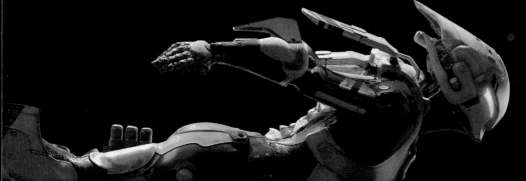

"THAT'S WHEN I HEARD IT. WHISPERING. CALLING TO ME. THE ANTHEM OF CREATION. THE GLORIOUS MUSIC OF THE SHAPERS. THE SONG OF BIRTH. LIFE. DEATH AND BEYOND."

Anthem takes place in a vast, unique world, constantly changing as the Anthem of Creation pulls against the remnants of the Shaper relics meant to harness its power. The flora, fauna, and the environment itself are beautiful and deadly. Most of humanity stays safe behind settlement walls, with only the Lancers to protect them from the dangers of the world.

SHAPERS

The Shapers are humanity's name for the mysterious, godlike beings that created the world, as well as the giant ruins and bizarre relics strewn across it. The Shapers attempted to harness the Anthem of Creation, a source of pure creation that has existed since the beginning of time, for their own purposes. Some Shaper ruins and relics seem to have a clear purpose, while others do stranger things humanity has yet to discover.

The Anthem does not wish to be harnessed or shackled, and the conflict between the Anthem and the ancient Shaper relics that even now try to harness it has resulted in a chaotic, dangerous, ever-changing world.

THE AGE OF CHAOS

The era immediately following the Shapers' departure is known as the Age of Chaos. The tools the Shapers abandoned continued to channel the Anthem of Creation with unpredictable effects as the Anthem struggled to be free of the shackles the Shapers imposed. Monstrous beings, known as Anzu, emerged during this time. Some of them were originally engineered by the Shapers for a specific purpose, while others likely emerged from a Cataclysm. Many think that humanity came through a Cataclysm during this era as well, but no one knows for certain.

The Shapers left behind their assorted servant races to fend for themselves. Some factions, like the Urgoth, survived and flourished; others were either subjugated or wiped out entirely.

RULE OF THE URGOTH

After the Age of Chaos, the Urgoth became the dominant race on the continent of Mirrus. They ruled over humanity, thinking of humans as lesser beings that needed to be controlled. While reliable historical records from this time are virtually non-existent, historians theorize that humanity was held in thrall by the Urgoth for centuries, and there is no evidence of pre-Urgoth human settlements. The Urgoth did not use humans as manual labor. Humans' primary role was in working with the ember-based tech, which would eventually give them the tools they needed to win their freedom.

THE HUMAN RESISTANCE

Although many humans were resigned to their lot under Urgoth rule, others searched for ways to defy them. Due to the Urgoth's inability to manipulate ember-tech, humans forced to work with ember began to secretly experiment with this byproduct of the Anthem. Working slowly and cautiously, they passed knowledge from generation to generation.

Eventually, these inventor-scientists, who later become the Arcanists, learned enough to build the first early, crude versions of javelins. They secretly trained others in using ember and in rudimentary javelin operations and began recruiting others to the resistance. This was the beginning of the Legion of Dawn.

THE LEGION OF DAWN

After years of secrecy, the resistance finally accumulated enough resources to openly rebel. At first, the rebellion utilized guerrilla tactics; its main goal was freeing enough humans to stage a true rebellion. Early on, these raids were very successful; the Urgoth were blindsided by organized human attacks. However, they recovered quickly, and the battles soon increased in scope.

After months, or perhaps years, of battles, General Helena Tarsis led the Freelancers of the Legion of Dawn to a final, decisive victory against the Urgoth, ensuring humanity's freedom.

THE MODERN ERA

Freed from Urgoth rule, humanity began to flourish, founding settlements across Mirrus. For the first time, human technology leapt forward. Advancements such as striders, Seals, and, perhaps most importantly, the Cyphers, were crucial tools in helping humanity explore the world.

From the united Legion of Dawn, humanity fractured into several major factions, including the Sentinels, the Freelancers, and the Dominion.

Founded by Arden Vassa, the architect of the javelins, the Sentinels are part military, part police force, and are charged with protecting the Royal House of Bastion and all of their subjects. Sentinels are present in all major cities and outposts, and their focus is on Antium and the roads that link important settlements and trading partners. Seeing themselves as the true inheritors of the Legion of Dawn, Sentinels adhere strictly to law and tradition. Though they respect trusted Freelancers, the loose independent nature of that other faction can cause tension between the two.

STRONG ALONE. STRONGER TOGETHER.

In contrast to the regimented Sentinels, Freelancers are much more loosely organized. Citing the heroism of General Tarsis herself as the basis of the Freelancer code, the Freelancers serve the people first and foremost. This often means heading out into the wilderness to proactively take on threats before they can endanger anyone.

After their failure to silence the Heart of Rage, the Freelancers of Bastion took a severe hit to both their numbers and reputation. Most of the surviving Freelancers scattered, with those who remain operating out of Fort Tarsis. They continue to help those in need and hope to one day restore the honor of the Freelancers.

The Dominion, founded by respected Lancer Magna Stral, was originally built around the idea of military rule. Stral led like-minded Lancers, then known as Paladins, out of Bastion and into the north. However, she underestimated the harsh conditions and soon lost many followers to exposure, illness, and desertion. The Sistrum, three ancient Anzu sister witches who survived into modern times, offered aid to the Paladins in exchange for a position in their new society. Sundermark was soon founded and quickly became a settlement based on law and strict discipline.

The Paladins flourished, founding new settlements across Stralheim. Eventually, through the witches' influence, the Paladins came to view the inhabitants of Bastion as weak, requiring strong leadership such as the Paladins could bring. With this new expansionist mindset, they renamed themselves the Dominion.

A decade ago, the Dominion attempted to seize control of the Cenotaph in the Bastion city of Freemark. This disastrous attempt caused the Cenotaph to unleash a massive blast of energy, creating the Heart of Rage. Freemark was destroyed, many Lancers were killed, and the attacking Dominion lost 90% of their invasion force.

Eight years later, a Freelancer expedition was launched to try and silence the Heart of Rage. Haluk, Faye, and you played a part in this disastrous expedition that cost many Lancers their lives and left several Cyphers catatonic. The failure devastated Haluk. Faye is haunted by the Anthem of Creation, and you leave to fulfill other contracts without them.

Now led by the Monitor, the Dominion is moving south once again, and you must seek out old friends and new allies if you mean to uphold the Freelancer code.

YOUR JAVELIN

The world of *Anthem* is set on a grand scale, larger than life for humans. In the days of General Tarsis, humans first handcrafted the javelins as a way to survive in the harsh environment, giving themselves an edge against the dangerous wildlife, which was made even more dangerous by the forces of the Anthem.

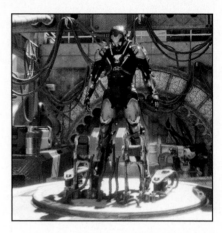

Each javelin has its own look and feel and boasts specific abilities, so playing with each is a unique experience.

At the start of the game, a tutorial mission gets you accustomed to what a javelin can do. Once you complete the mission, you're Level 2 and unlock the Ranger javelin.

At Level 8 you unlock your choice of one of the other three javelins: Storm, Colossus, or Interceptor. Once you reach Level 16, you unlock the third type, and the fourth at Level 26. The order you choose to unlock the different javelins should be based on your preferred playstyle. While each javelin is unique and has its own abilities, all are equally capable of taking on the challenges you encounter in *Anthem*.

Because each javelin is an extension of the Freelancer who pilots it, the javelin works best when crafted specifically to an individual. Upgrade your javelin with equipment to suit your preferences.

THIS WOULD BE HUMANITY'S SALVATION...

THE CREATION OF THE JAVELINS

"Arden Vassa crafted a suit of armor, plated in ember and hope. This would make General Tarsis stronger than the Urgoth, than the Ursix, than the Titan."

—*From The Volume of Tarsis by Garred*

Javelins are airtight, armored exo-suits linked to a pilot's thoughts and impulses. They are humanity's major technological tool for defense and exploration in a world not built for human-scale interaction.

When Cyphers began to appear, Corvus integrated new technology into the javelins, allowing Cyphers to accompany Freelancers on missions, giving information and guidance. While working with a Cypher isn't necessary to piloting a javelin, it's often proven to be a lifesaver.

BASIC ABILITIES

All javelins have a handful of basic abilities in common, although some of these basic abilities are modified based on which javelin you're currently piloting. In addition to these basic abilities, each javelin has its own unique abilities, which we cover later in this chapter.

Sprint: While on the ground, you can activate the sprint ability, firing the jets on the back of your javelin to propel you forward at greatly increased speed. This is best used for closing distances quickly to engage enemies in melee combat or with short-range weaponry, or to reach cover to escape a dangerous situation. Jumping while sprinting grants you increased jumping distance.

Double Jump: Javelins can jump extreme distances, and while your javelin is in the air, you can fire your jets to jump again, gaining even greater height. This is useful for reaching higher ground when your javelin is overheated, when there isn't enough room to fly, or when flying is otherwise prohibited in the area. Double-jumping is quick and precise and, when combined with dashing, can give you a tactical advantage against certain enemies. For example, when facing a shielded enemy, double-jump and dash to quickly get behind them and attack their critical, unshielded areas.

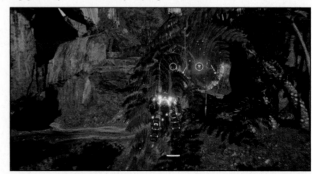

Evade: On the ground, evade is essential for dodging incoming enemy attacks. A quick blast of the javelin's jets propels you in the direction you're moving. This ability has essentially no cooldown, but you cannot fire while evading. Evasion can be used as an alternate means of quickly traversing dangerous ground with little risk. While flying, evading causes you to enter a barrel roll in the direction you're strafing. Use this tactic to avoid incoming attacks or navigate hazards in the world.

Flight: All javelins are capable of limited flight time. Flight is the fastest way to traverse the world and reach your objectives quickly. Most locations cannot be reached unless you use flight. It's a great tool for exploring and is essential for finding hidden areas. However, during flight, your javelin heats up, indicated by a growing bar at the bottom of the center reticle. If this bar begins to turn red, you're about to overheat. Once you're overheated, all flight is disabled, and you plummet from the sky. Flight is then unavailable for a short period while the suit cools down, or you find a means of cooling it down.

During flight, you're always at risk of overheating. There are several methods you can use to cool off your javelin and maintain flight indefinitely. The most common way to prevent overheating is to put your javelin into a deep dive, which gradually lowers the temperature of the suit, allowing you extended flight. The best way to cool off a javelin immediately is to fly through a waterfall or skim across the surface of a body of water. Not only does this instantly cool down your javelin, it provides a short "Cooled" buff where your javelin doesn't suffer the effects of overheating.

Hover: Hover can be engaged anytime you're in the air. This includes flying or jumping. While hovering, you can fire weapons and special abilities as if you were on the ground. This can give you a great tactical advantage, especially against melee or short-range enemies, since you're unreachable. The major drawbacks to hovering are that your movement is limited and you must carefully monitor your Overheat gauge. Overheating while hovering over enemies can put you in an extremely disadvantageous position.

JAVELIN LOADOUTS

In addition to the shared basic abilities, each javelin type has a similar loadout. Within that loadout, abilities and components vary.

Two Javelin-Specific Abilities: These are unique to the javelin type and are explained in detail later in this chapter.

Two Weapons: Each javelin can equip two weapons of any type available to its class. The second weapon slot doesn't unlock until you reach Pilot Level 3.

Six Components: Every javelin has six slots for various components. Equip these to boost your javelin's various attributes, such as health or armor. Your first component slot unlocks at Pilot Level 4. Subsequent slots unlock at Levels 6, 12, 14, 18, and 23.

Support Gear: Javelins each have one available Support Gear slot, unlocked at Pilot Level 5. Each javelin has two unique abilities that can be equipped. The Support Gear abilities can be deployed during expeditions to provide benefits to you and your allies. These abilities have a short duration and cannot be used again until they recharge.

Expedition Consumables: These sigils are short-term boosts crafted at the launch platform and grant bonuses for a single expedition. The effect of these boosts lasts the entire expedition and varies depending on what blueprints you use. Blueprints are unlocked by completing Arcanist Challenges. The first consumable slot unlocks at Pilot Level 10, with subsequent slots opening up at Levels 20 and 30. Crafting expedition consumables is a great way to spend unneeded crafting materials.

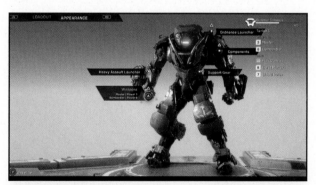

UPGRADING YOUR JAVELIN

As you progress through the game, you gain access to higher-powered weapons and equipment. View a comparison of a potential new piece of equipment versus what you currently have equipped by hovering over the new item.

For more information on individual equipment pieces, please see the **Equipment** Chapter.

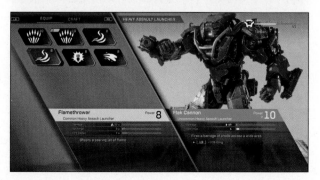

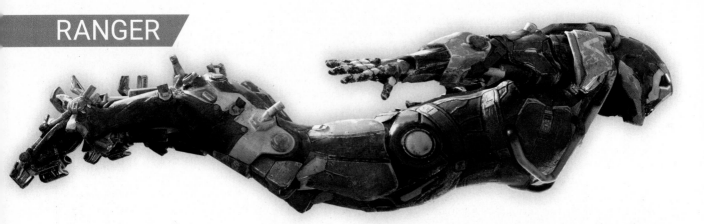

RANGER

The Ranger is your starting javelin and is a jack-of-all-trades choice. Its versatility makes it ideal as a starting javelin while you get used to the world. As the second-most agile javelin, the Ranger can dash and barrel-roll, which helps avoid attacks that lock on. It also has shields to absorb some incoming damage. Once depleted, the shields regenerate if the Ranger avoids taking damage for a short time.

Offensively, the Ranger has access to a variety of weapons, making it an exceptional combatant at both short and long range. Using a mix of special grenades, the Ranger can help control the battlefield when facing large groups of enemies. The Ranger may also contribute to a team's defensive or offensive abilities, depending on which support module they install.

RANGER ABILITIES

ASSAULT LAUNCHERS

A powerful weapon attached to the javelin's arm, the assault launcher comes in a variety of types. All of these types (with the exception of the spark beam) fire once and then go into a cooldown period before they can be fired again. The spark beam can avoid the cooldown period, as long as you pause firing before fully draining its power.

LAUNCHER TYPE	DESCRIPTION
Blast Missile	Explodes on impact with a target.
Pulse Blast	A charged blast that shoots a burst of raw energy at a target.
Seeking Missile	Tracks and pursues a target until it makes contact and detonates.
Spark Beam	Fires a continuous beam of energy, dealing damage to a target as long as the beam is sustained.
Venom Darts	A volley of acid-tipped darts that seeks out a single target, dealing damage and lowering its defense.

GRENADES

The design of the grenade has always been simple but effective: create an explosive device, lob it a group of enemies. The Ranger's grenades are no exception, but offer explosive choices, depending on the situation and your playstyle. Once you toss a grenade, the ability enters a brief cooldown period before you can use it again.

GRENADE TYPE	DESCRIPTION
Frag Grenade	Explodes on impact, hitting enemies in a large area.
Frost Grenade	Explodes on impact, releasing a blast that freezes anything within its radius.
Inferno Grenade	Explodes on impact, igniting anything within its radius and causing damage over time.
Seeker Grenade	Upon impact, the grenade splits into multiple submunitions that seek out nearby targets before detonating.
Sticky Grenade	Attaches to a target, causing fear before detonating after a short delay.

SUPPORT

SUPPORT GEAR	DESCRIPTION
Bulwark Point	A spherical shield that blocks projectiles over a Freelancer's current position.
Muster Point	Deploys a field of energy, increasing the damage inflicted by guns for you and all nearby allies.

ULTIMATE: MICRO-MISSILES

When the Ranger's Ultimate Ability is triggered, you become immune to all damage for a short time. A large targeting reticle appears, with which you paint all targets. Once you tag all threats in range, fire this weapon to release a barrage of missiles at the targets, dealing devastating damage. This ability is excellent for clearing areas when enemy forces threaten to overwhelm you. Additionally, micro-missiles are great for defeating powerful single-target foes, as all missiles converge on them.

COLOSSUS

The Colossus is a heavy tank capable of absorbing a great deal of damage, while protecting its allies. This extreme sturdiness comes at the cost of speed and maneuverability. For example, the Colossus's jump and double jump are more sluggish than other javelins; however, they're controllable.

The longer you hold down the Jump button, the higher you jump. In addition, the Colossus trades the rechargeable energy shield of the other javelin types for a much larger health pool.

As a tanking juggernaut, the Colossus is too heavy to dash. Instead, it activates a shield on its left arm that can absorb an enormous amount of damage in the front 180-degree arc. While this is a great defensive ability, the Colossus cannot use any other weapons while the shield is deployed. However, the shield itself is a powerful melee weapon. Sprinting (or flying) toward a group of enemies with the shield deployed allows the Colossus to get into close-range combat, giving you the opportunity to use a melee attack at the end of the sprint to send weaker enemies flying away, while larger enemies will knock you out of sprint or flight. Its support options are focused around drawing enemy fire and reducing damage taken by allies.

Offensively, the Colossus is no slouch. With a variety of long- and short-range abilities from the ordnance launcher and heavy assault launcher, this javelin excels at eliminating tightly packed enemies. The Colossus has a powerful melee attack as well, smashing the ground and hitting all foes in a nearby area. Dropping from the air to perform this results in a much larger area of effect and does more damage.

COLOSSUS ABILITIES

ORDNANCE LAUNCHERS

Located on the Colossus's back, aimed to fire over the shoulder, the ordnance launcher can fire either mortars or an electric field. Mortars tend to be most useful at medium-to-long range and have decent area of effect. Coils pulse electrical energy out from the javelin and require no targeting, allowing the Colossus to focus on defense and protection.

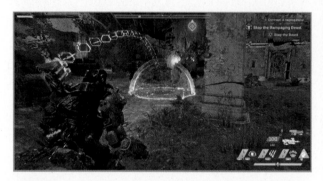

	ORDNANCE TYPE	DESCRIPTION
	Burst Mortar	Fires shells that detonate and shatter over a wide area.
	Firewall Mortar	Generates a wall of flame at a targeted area, causing damage over time.
	High-Explosive Mortar	Launches an explosive shell that detonates with a large area of effect.
	Lightning Coil	Strikes random targets within close proximity for as long as the charge lasts.
	Shock Coil	Sets off blasts, damaging enemies in the area of effect.

HEAVY ASSAULT LAUNCHERS

Strapped to the Colossus's right arm, the heavy assault launcher provides options for a variety of ranges. The flak cannon and flamethrower are great against foes within short range, while the railgun, siege cannon, and venom spitter provide long-range options, with the latter two being highly effective against armored opponents.

	HEAVY ASSAULT TYPE	DESCRIPTION
	Flak Cannon	Fires a barrage of shells in a wide cone.
	Flamethrower	Fires a steady stream of flame in short range, causing damage over time.
	Railgun	Launches armor-piercing projectiles at high velocity.
	Siege Cannon	Fires a high-explosive shell at a target, causing massive damage. Effective against armored opponents.
	Venom Spitter	Launches high-velocity gobs of acid, causing corrosive damage. Effective against armored opponents.

SUPPORT

	SUPPORT GEAR	DESCRIPTION
	Battle Cry	Taunts enemy attackers when they're attacking a vulnerable member of your team.
	Shield Pulse	Produces a shield that reduces incoming damage for you and your allies.

ULTIMATE: SIEGE CANNON

When you trigger the Colossus's Ultimate Ability, you become immune to all damage for a short time. A large, circular targeting reticle appears, complete with a meter measuring how much time you have to fire. While the maximum amount of shots you can fire is three, once the meter depletes, you can no longer fire the siege cannon, so be sure to take your shots quickly. The siege cannon does massive amounts of damage to anything caught within its large blast radius. This ability doesn't lock on to targets and can miss, so aim at groups of enemies for maximum yield.

The Storm utilizes ember-cored Seals to harness the power of the elements. Lightly armored, the Storm relies on its teleportation and vastly superior energy shield to compensate for lack of health. This shield also keeps the Storm from being staggered when hit.

The Storm deals insane levels of damage. Its Seal abilities recharge very quickly and place elemental status effects on targets. This sets up the enemy for combo attacks, which greatly increase the damage the enemy receives. It's imperative to choose Focus and Blast Seal abilities that complement each other in order to set up devastating combo damage for yourself, or to complement your team's particular set of skills.

Unlike the other javelins, when the Storm begins to hover, its Overheat gauge goes up very, very slowly. This means that the Storm can hover for a long time, raining damage from above the fray. Whenever possible, engage the enemy this way, as a hovering Storm is most powerful as the shield absorbs more damage while hovering. Make sure your shield doesn't get too low, as it takes very little damage to defeat you once your shield drops. The Storm also glides when jumping, remaining in the air much longer than the other classes. However, the Storm can't double-jump.

The Storm's support abilities can either fortify an area by putting up wind walls to protect against incoming projectiles, or reduce the recharge time of all Gear abilities for you and your allies.

WE MUST NOT FEAR THIS TECHNOLOGY, BUT INSTEAD EMBRACE IT...

STORM ABILITIES

FOCUS SEAL

Focus Seals provide mostly single-target or small-group damage in fire, ice, or electricity. Choose a Focus Seal that complements you team's abilities, and your preferred Blast Seal.

	FOCUS SEAL TYPE	DESCRIPTION
	Arc Burst	A bolt of electrical energy that hits a target and arcs to other nearby enemies.
	Burning Orb	Can release fire orbs in rapid succession, or charge to release a powerful explosive fireball.
	Frost Shards	Assaults a target with razor-sharp ice shards. Effective against unarmored opponents.
	Glacial Spear	Releases a powerful, concentrated blast of cold energy at a target.
	Shock Burst	Releases orbs of electrical energy that bounce off objects and seek out targets.

BLAST SEAL

Blast Seals have decent areas of effect, with the exception of the living flame. These abilities have multiple charges per cooldown and deal massive damage. Blast Seals are an excellent way to set up large groups of enemies for combo attacks. Even though the Storm does great damage, it's also perfect for crowd control, with Seals like the ice storm. Frozen enemies don't attack you or your allies.

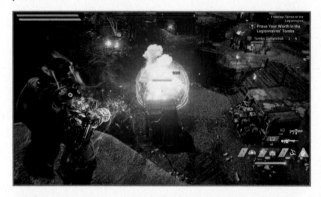

BLAST SEAL TYPE	DESCRIPTION
Flame Burst	Creates explosions in a targeted area, damaging and burning everything in its radius.
Ice Blast	Hurls jagged chunks of ice at a target with massive force.
Ice Storm	Focuses bursts of chilling cold on a target, resulting in a shattering explosion of ice.
Lightning Strike	Calls down lightning on a targeted location, striking all enemies in the area.
Living Flame	Creates a living fire wraith capable of pursuing targets through walls and other objects.

SUPPORT

SUPPORT GEAR	DESCRIPTION
Quickening Field	Greatly increases the recharge rate for you and your allies within the field.
Wind Wall	Fortifies a targeted area to block all incoming projectiles.

ULTIMATE: ELEMENTAL STORM

When you trigger the Storm's Ultimate Ability, you become immune to all damage for a short time. When activated, the elemental storm calls down different elements before dropping a large meteor on the targeted area, dealing massive damage and creating combos. This ability covers a huge area, allowing you to devastate large groups of foes.

INTERCEPTOR

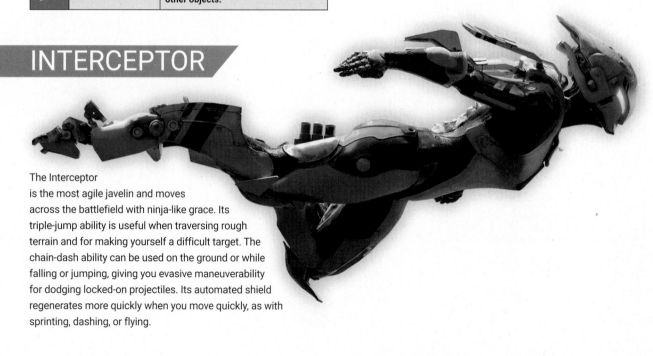

The Interceptor is the most agile javelin and moves across the battlefield with ninja-like grace. Its triple-jump ability is useful when traversing rough terrain and for making yourself a difficult target. The chain-dash ability can be used on the ground or while falling or jumping, giving you evasive maneuverability for dodging locked-on projectiles. Its automated shield regenerates more quickly when you move quickly, as with sprinting, dashing, or flying.

Its attacks are melee-oriented, meant for getting in, hitting hard, and rapidly retreating before taking any retaliatory hits. Utilize quick melee strikes to deal as much damage as you can on unsuspecting targets. The Interceptor's support options are a great boon to your allies—both defensively, to cure your team of status effects, and offensively, helping to take down difficult foes.

STRIKE SYSTEM

The strike system offers a variety of additional melee power, as well as some good short-to-medium-range choices, like the plasma star. Wraith strike is great for adding to the enemy's confusion on the battlefield as well.

INTERCEPTOR ABILITIES

ASSAULT SYSTEM

The assault system abilities give you several options for area denial, or causing extra damage. For example, set cluster mines in an area where you know you can lead the enemy into them— the perfect trap. Other assault system choices serve to make the Interceptor even more dangerous.

	ASSAULT SYSTEM TYPE	DESCRIPTION
	Cluster Mine	Deploys multiple proximity mines that detonate when an enemy approaches them.
	Cryo Glaive	Locks on to a target, freezing it in place when it strikes. Effective against fast-moving targets.
	Searching Glaive	Deploys target-seeking gadget to pursue fleeing targets.
	Spark Dash	Rush your target, dealing damage to anything and everything in your path.
	Venom Bomb	Releases an acidic mist that causes damage to everything in the targeted location over a short period of time.

STRIKE SYSTEM TYPES		DESCRIPTION
	Detonating Strike	Perform a powerful strike against a target that causes it to explode after a few seconds, dealing additional damage to nearby enemies.
	Plasma Star	Fires a burning throwing star that pierces a target's armor.
	Tempest Strike	A quick, powerful strike that electrifies the target.
	Venom Spray	Releases a spray of corrosive acid in a short, wide cone.
	Wraith Strike	Projects a realistic simulacrum of you toward a target, distracting them.

SUPPORT

SUPPORT GEAR		DESCRIPTION
	Rally Cry	Removes all negative effects from you and nearby allies.
	Target Beacon	Marks a target, causing it to take additional damage. If the target perishes while marked, the mark passes to the next-nearest enemy.

ULTIMATE: ASSASSIN'S BLADES

When you trigger your Ultimate, you're invulnerable for a short time. Once you activate Assassin's Blades, striking enemies leaves behind afterimages that continue to do damage even after you move on to your next target. Strike as many targets as you can while the Ultimate is active for maximum damage.

CUSTOMIZING YOUR JAVELIN

Your javelin is an extension of your Freelancer and, as such, should reflect your personal taste. When you're in the Forge, switch to the Appearance tab to view your javelin. From there, select pieces of Gear (helmet, chest, arms, and legs), then vinyls, wear state, animations, and paint to customize your javelin.

You can alter the appearance of individual Gear pieces. Select from the available choices to change the appearance of these pieces.

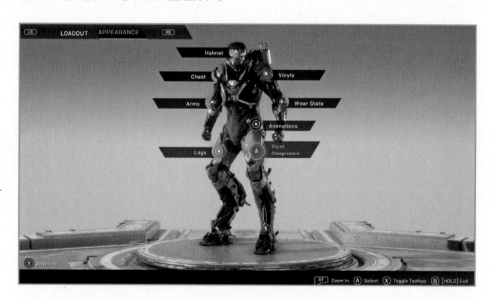

You can also make overall changes to your look by experimenting with vinyls, wear state, and paint. Vinyls allow you to add decals to your existing look. Wear state is the condition of your javelin, ranging from shiny and new to dirty and old. Paint allows you to change the color scheme of your javelin. Use the animations selection to customize common animations, such as arrival, victory, and emotes that include wave, clap, etc.

New appearances and materials are unlocked. Some can be purchased through the Store or the Forge, while others are unlocked by completing Challenges. Unlocked items are displayed in the Appearance section of the Forge. Once you unlock an appearance item, it's available for use by all your pilots.

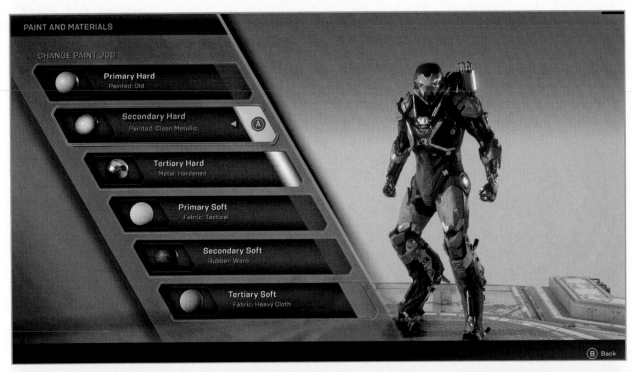

FORT TARSIS

Fort Tarsis is humanity's central hub on Mirrus. Its walls serve to hold back the wild and changing world, giving humanity a much-needed sanctuary. Here, you can interact with other Freelancers, agents, Cyphers, merchants, and other inhabitants of the fort. As you progress through the story, Fort Tarsis changes and grows.

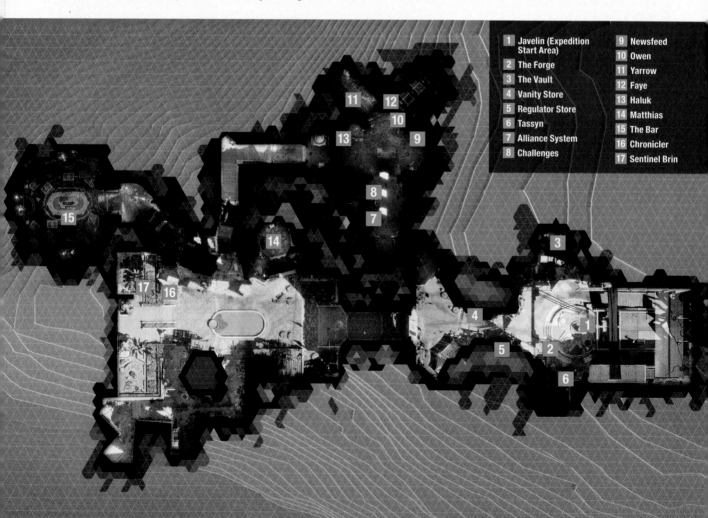

1 Javelin (Expedition Start Area)
2 The Forge
3 The Vault
4 Vanity Store
5 Regulator Store
6 Tassyn
7 Alliance System
8 Challenges
9 Newsfeed
10 Owen
11 Yarrow
12 Faye
13 Haluk
14 Matthias
15 The Bar
16 Chronicler
17 Sentinel Brin

AGENTS

Agents are NPCs who offer you various missions throughout the game. These tasks come in three types:

- **Critical Objectives: These missions send you along the main path of your story.**

- **Agent Quests: Agent Quests are important objectives that help shape your experience in Tarsis as well as with the agent involved. At some points, you must complete some Agent Quests in order to progress along the Critical Objective path.**

- **Agent Contracts: These contracts are optional objectives that grant opportunities to earn reputation, experience, and Gear. As with Agent Quests, you must complete some Agent Contracts in order to progress along the Critical Objective path.**

It's often best to complete missions as they become unlocked so that you progress the main story and the side missions simultaneously. Tackling the Agent Quests and contracts also ensures you have the Gear and experience necessary to take on tougher challenges as you progress in the main story. At any time in the fort, you can view your quests in the Journal.

OTHER FORT ACTIVITIES

In addition to the agents, Fort Tarsis is full of other interesting citizens. Take the time to talk to them, even if they don't offer missions, as they all have something to contribute to your experience in the fort and a lot to say. Talking to the other citizens can also earn you Faction Poiints for the Reputation System.

Visit your Vault to store unused weapons, components, Gear, and crafting materials. However, note that your Vault space is not endless. If you store too much, you'll have to clean some of it out before you can leave the fort. You can also visit two shops that let you purchase vanity items, such as textures and alternate animations with which to customize your javelin. See daily, weekly, and monthly Trials by visiting the Trials desk.

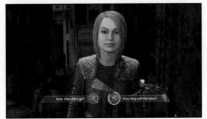

ALLIANCES

Take a look at your Alliance Status. Your Alliance includes other players on your Friends list and anyone you've recently played with. As your Alliance plays during the week, the XP earned by the top five contributors counts toward your Alliance Tier. Friends get bonuses to their contributions, and the bonus is larger if you've played a mission with them. At the end of the week, that tier pays out in Coin, which you can then use to unlock cosmetic options or other special store offers.

PERSONAL TRACK MILESTONE	CUMULATIVE XP REQUIRED
0	—
1	3000
2	4525
3	8075
4	18125
5	36125
6	57100
7	81550
8	110125
9	155700
10	227525

THE FREELANCERS

Freelancers are independent Lancers who chose to follow General Tarsis and the Path of Valor. They silence Cataclysms and provide aid to those in need beyond the walls. Speaking with Freelancer Yarrow and completing any tasks he may have raises your reputation with all Freelancers, unlocking crafting recipes and providing much-needed experience.

THE ARCANISTS

Arcanists are scientists, researchers, and scholars who study the mysteries of the world, from wildlife to Shaper instruments. Some teach, while others spend their lives solving Shaper mysteries in the wilderness. Once you encounter Arcanist Matthias out in the field, he becomes available in Fort Tarsis so you can carry out missions for him, earning Arcanist reputation to unlock crafting recipes.

> Valor to serve the people, regardless of their station.
> Courage to bring silence when the Anthem sings.
> Faith to keep my word and the word of my brethren.
> Trust that the free answer when called.
> Strong Alone, Stronger Together.

THE SENTINELS

Sentinels are authorities that act on behalf of the Emperor. In Fort Tarsis, they function much like a military police force, keeping the peace, as well as protecting Antium's citizens from outside threats. The Sentinels and Freelancers don't always get along, but as you progress through the story, Sentinel Brin reluctantly approaches you and becomes another source of contract work, letting you raise your reputation with the Sentinels.

CYPHERS

"What do we see? Everything..."

Cyphers are humans with a sensitivity to the Anthem of Creation, which makes them capable of telepathic communication and heightened mental calculation. Cyphers undergo ember exposure and dedicated training to enhance their mental skills.

When Cypher abilities first appeared, Corvus sought to use Cyphers for covert purposes, developing amplifier technology and training. Later, the Cypher Revolution brought Cyphers the freedom to choose how their abilities are used. While javelins were invented long before the Cypher phenomenon, adding Cyphers to operations outside Fort Tarsis has greatly improved the safety and effectiveness of the Lancers.

LAUNCH BAY

From Fort Tarsis you can access the Launch Bay. This is a staging area where Freelancers can hang out between missions. In the Launch Bay you can salvage gear, purchase vanity items, show off your javelin customization and interact with other Freelancers as well.

ACCESS

While in Fort Tarsis, you have access not only to the Forge, which allows you to upgrade and customize your javelin (see **The Forge** chapter for more detailed info), but to many other resources:

- **Journal:** Your Journal tracks your quests, both completed and those in progress. Current quests list information on the quest and the rewards. Completed quests give you a summary of not only the quest, but the outcome. This is invaluable for letting you know where you left off if some time passes between your gameplay sessions.

- **Challenges:** The Challenges tab allows you to access Challenges from the various factions and other categories like Missions, Exploration, Gear, Feats, and more. For more detailed information on the Challenges, please see our Challenges chapter.

- **Library:** *Anthem* is a fascinating world rich in lore. The Library compiles information on important current topics, as well as what's known of the world's history, geography, and more. Take a break from running missions and enjoy the information collected here.

- **Armory:** Here you can find information on all the available Gear types for each javelin class, and available crafting recipes.

- **Mailbox:** The Mailbox lets you access any current mail from other inhabitants, as well as see your past correspondence. You can subscribe to various newsletters and news outlets to keep up on current events, and even current fashion.

- **Tutorials:** Here you can access all of the tutorials for important information on each of the javelin classes, how combinations and effects work, how to upgrade your javelin, tackling expeditions, and much more.

THE FORGE

WHICH CAME FIRST...
THE TOOL OR THE FORGE?

Located in Fort Tarsis, the Forge is the centerpiece of a Lancer's life. It's used to craft not only javelins and their parts, but also other machines used by humanity. The Forge requires raw materials found in the world or salvaged from unwanted and outdated Gear into its base matter. It then utilizes these resources to build Gear suitable for use in a javelin. Lancers can set themselves apart by building a javelin to suit their personal styles, altering not only the components, but also the look of their javelins.

Before heading up the stairs to your javelin, you can access the Forge by approaching the small console next to your mechanic. From there you can modify or select your javelin, once you've unlocked more than one.

The Forge has two main tabs in the upper left: Loadout and Appearance. Switch your javelins by pressing the button that appears in the lower left.

LOADOUT

When looking at the loadout screen, you're presented with a view of your javelin where you can see the five different areas in which you can adjust your javelin's current Gear. Three of these five areas are common to all javelins (Weapons, Components, Support), while the other two are specific to the javelin class. For example, the Storm has Focus Seal and Blast Seal, while the Ranger has Assault Launcher and Grenades. Additionally, you can see your current javelin's Javelin Power and name designation in the upper right.

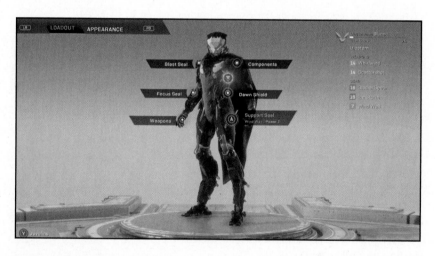

When selecting your loadout, be conscious of the demands of the expedition and how to best fulfill the needs of your current team. Select Gear that helps you excel as part of the team.

WEAPONS

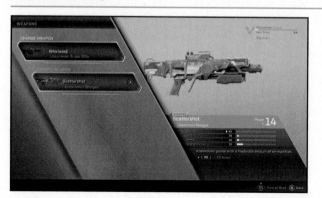

The Lancer can choose which weapon to equip from whatever is available. You see what is in your stash that's available to your chosen javelin class. At the beginning of the game, you only have access to one weapon slot, with the second slot unlocking at Level 3. When viewing potential weapons, you can see a brief comparison of their vital stats by selecting the weapon currently equipped and cycling through the weapons in your stash.

COMPONENTS

This option lets you select various components that boost your javelin's basic stats or other class-specific abilities. Basic, universal components increase health, shield, and armor. Iconic components are class-specific and boost that javelin's favored skill and weapon types. Component slots aren't available at the beginning of the game. The first one unlocks once you reach Level 4, with subsequent slots unlocking at Levels 6, 12, 14, 18, and 23. Equipping components is a primary way to boost your javelin's overall power and survivability. Your power increases exponentially with each new component slot that becomes available.

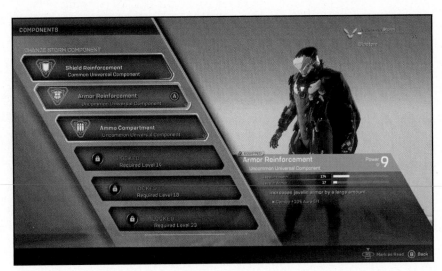

SUPPORT

Support items are class-specific pieces of Gear that usually provide a benefit to you and your allies during expeditions. Ideally, these abilities are chosen based on the needs of the team to help boost survivability during enemy engagements. Only one piece of support Gear can be equipped into a javelin and must be chosen wisely once it's available at Pilot Level 5. Typically, support items adjust the recharge and duration of these specific class abilities.

For more detailed information on class-specific abilities and Gear, see the **Your Javelin** and **Equipment** chapters.

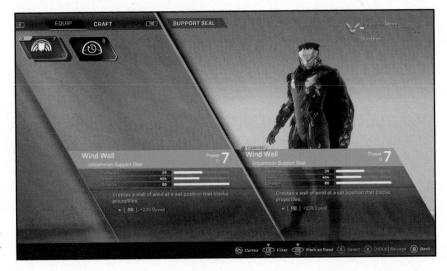

JAVELIN POWER

Your Javelin Power is a direct reflection of your javelin's current power level and the rarity of the equipped Gear. Each piece of Gear has an associated power rating. The cumulative power score of your gear determines your Javelin Power.

Javelins have four rarity levels: Common (white), Uncommon (green), Rare (blue), Epic (purple), and Masterwork/Legendary (orange). A javelin's rarity is determined by its Javelin Power.

The rarity of your javelin determines the chance of earning higher-level Gear. The higher rarity your javelin, the better the Gear you will find. If an item has a higher power level than what you're currently using, it's a good idea to equip it. Your rarity also indicates the level of Challenges you can successfully tackle.

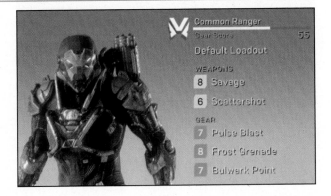

CRAFTING

You can eventually craft each Gear type. However, crafting various items requires completing certain Challenges that unlock the necessary blueprints. Gaining reputation with the various factions, like the Freelancers, Sentinels, and Arcanists, unlocks the blueprints for crafting Gear, such as components and match consumable sigils.

Another way to earn crafting blueprints is to complete missions with various weapons and class-specific Gear you would like to craft. Using these pieces of Gear on missions eventually unlocks the crafting blueprint for the next rarity tier of that item. This is a great way to improve your loadout.

APPEARANCE

The Appearance tab allows you to customize the look of your javelins. All of the options here are completely cosmetic and don't affect your gameplay. However, there are a ton of options available to really make your javelin unique.

For each of the main javelin pieces (helmet, chest, arms, and legs), you can select from the various alternate pieces you've unlocked. The Equip tab lets you select from items you already own, while the Unlock tab lets you access new choices. New appearances can be purchased with Coin or Shards.

The Paint option allows you to select overall color and texture schemes for the various six layers of your javelin. There are an enormous number of combinations, ensuring that your color scheme can be as unique as you want it. For each layer, you select the type of material (for example, heavy cloth, leather, or nylon). You can then also select the color of that layer from a wide palette of preset or custom colors.

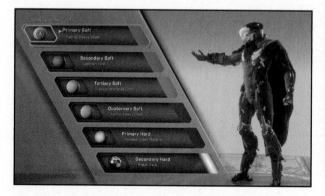

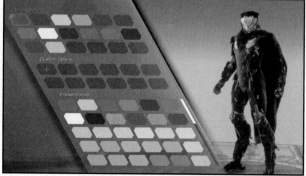

By using the Wear State menu, you can select how worn your javelin appears. You can look like you just stepped out of the Forge, survived a hundred battles, or anything in between.

The Vinyls choice lets you select and place decals onto your javelin. While they work on all javelins, they appear in different positions depending on what javelin you're applying them to. You can unlock many vinyls by paying with Coin or Shards.

Once you have your look down, the next step is to customize your animations. You can select from a range for your victory pose and arrival animation. Additionally, you can customize your emotes. As with javelin pieces and vinyls, you can unlock additional choices by purchasing them with Coin or Shards.

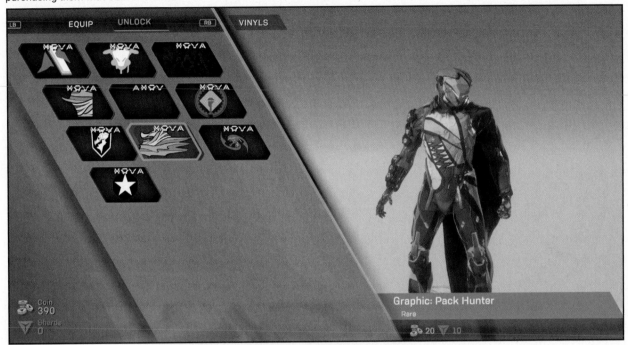

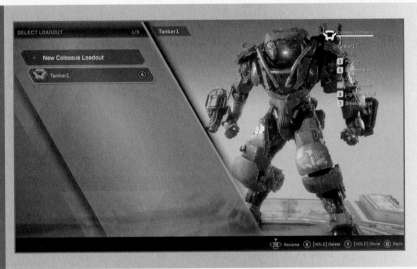

MULTIPLE JAVELINS

In addition to wielding the different javelin types once you unlock them, you can have up to five different javelin loadouts of each class, all with distinct Gear, abilities, and appearances. This way, you're ready for anything!

> The Engineer worked long into the night, switching between the concentration needed for blueprinting and the rigorous physical labor required for the actual forging. When she grew tired, she remembered the lessons passed on by her father. Though he had long passed, his words, his voice, and his laugh still resonated in the Forge. It was when she was deep in the work that she knew he was still with her.
>
> —A Strider in the Everweald

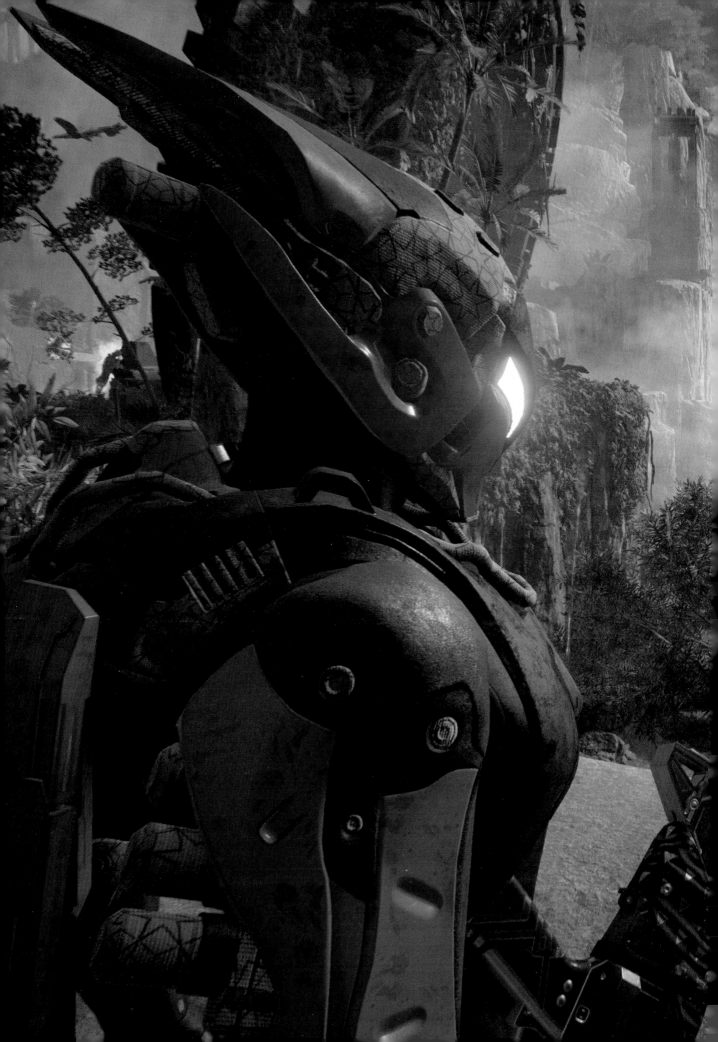

EXPEDITIONS

Whenever you leave Fort Tarsis to complete an objective, you launch an expedition. This is done at the Forge via the launch platform, accessed by interacting with your javelin. Here you can select an expedition, choose a difficulty, modify your squad, and select consumables.

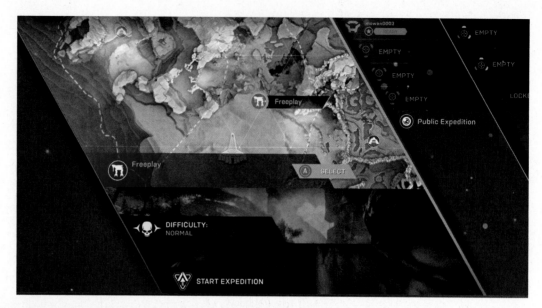

PRIVACY SETTINGS

Press the Privacy Settings button anytime at the Expedition screen to switch between Private and Public. Public allows other players to join your game. Select Private when you wish not to be disturbed during a mission. Some modes are unavailable with the Private setting.

SUMMARY

The Summary tab allows you to change the expedition, modify the difficulty, and begin the expedition. A portion of the Bastion map is shown on the top, with the currently selected expedition highlighted. Select the map for a full view of the world map. Here you can select from any available expedition, including one of the freeplay start locations. Press the Quickplay button to reinforce an existing squad and earn extra rewards.

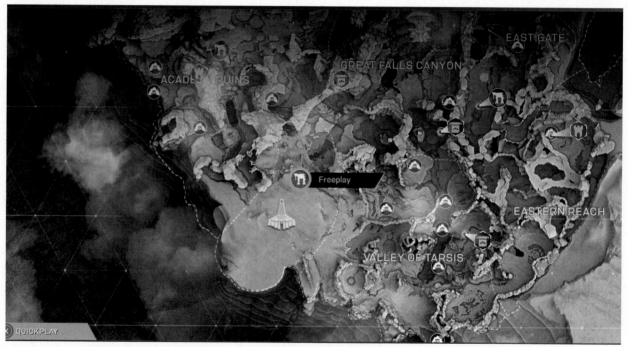

There are five types of expedition, all of which are covered in full in this chapter.

▼	**Critical Objective**	Complete critical objectives to progress the main story, from the tutorial to your return trip to the Heart of Rage.
👤	**Agent Quest**	Assist Sentinels, Arcanists, and Freelancers by completing side quests for Tassyn's agents—Brin, Matthias, and Yarrow.
⬡	**Agent Contract**	Brin, Matthias, and Yarrow also offer contracts. Assist the three factions by completing a random set of three objectives. The final two contracts for each faction become repeatable.
🏰	**Stonghold**	Strongholds are the toughest challenges in Bastion and are unlocked as you progress through the story. They can be repeated. Join a group, especially if playing on Normal difficulty or higher.
🏛	**Freeplay**	Join other javelins anywhere in Bastion and tackle World Events, gather resources, and discover collectibles. Freeplay can only be played on the Public Privacy Setting. Select End Expedition at the Map screen to end a freeplay session.

Enemy damage, enemy health, and the drop chance of maximum rarity change based on the difficulty selected. Easy difficulty provides a casual experience for those who wish to focus on the story. Normal is the default difficulty with the most balanced experience, though it isn't without challenge. Hard difficulty is the greatest challenge before reaching Pilot Level 30, but the drop chance of maximum rarity makes it worthwhile. Join a squad to tackle this difficulty.

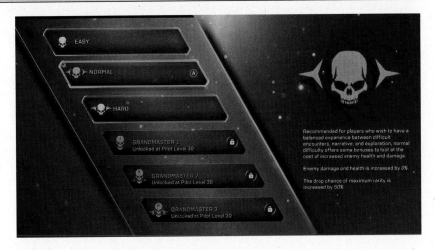

Grandmaster difficulties unlock at Pilot Level 30. Enemy stats are greatly increased, which is why the game suggests a high javelin rarity level. For the Grandmaster levels, the Drop Chance Increase is for Masterwork rarity.

DIFFICULTY	WHEN UNLOCKED	RECOMMENDED MMINIMUM JAVELIN RARITY	ENEMY DAMAGE AND HEALTH INCREASE	DROP CHANCE INCREASE
Easy	From start	—	Decrease	0%
Normal	From start	—	0%	50%
Hard	From start	—	52%	100%
Grandmaster 1	Pilot Level 30	Epic	165%	150%
Grandmaster 2	Pilot Level 30	Masterwork	430%	200%
Grandmaster 3	Pilot Level 30	Legendary	950%	250%

Note that you can launch at any time and visit the Forge with the buttons listed along the bottom of the screen.

SQUAD

The Squad tab allows you to organize your group. Existing members of your four-man squad are listed under your own banner. From this screen you can modify your banner, changing the background to an unlocked graphic.

Players can be invited by clicking on an empty slot. Find players within your Friends list, those you have marked as favorites, and players recommended by the game.

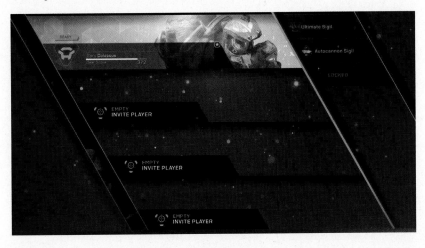

CONSUMABLES

Once you reach Level 10, you can equip a consumable to boost an aspect of your gameplay. For an entire single expedition, the boost is added to a type of weapon or a javelin stat, lasting until you exit the expedition or complete the mission. This provides a great use for extra embers. Second and third slots are unlocked at Levels 20 and 30, allowing you to equip up to three consumables at once.

Consumables can be crafted as long as you've unlocked the corresponding blueprint. Complete Challenges to unlock blueprints. Each consumable costs one ember equal to the rarity of the consumable you're creating. For example, crafting an Epic consumable requires one Epic ember. Here's a full list of the consumables that can be crafted, once you've unlocked the blueprint.

CONSUMABLE	DESCRIPTION	UNCOMMON	RARE	EPIC
Armor Sigil	Improves javelin armor by X% of base armor strength and physical resistance by Y%.	10, 3	20, 6	30, 10
Combo Sigil	Increases the damage of combo reactions by X% of base damage.	10	20	30
Heat Sigil	Increases heat capacity by X% of base capacity.	10	20	30
Gear Sigil	Increases the recharge speed of equipped Gear by X% of base speed.	10	20	30
Melee Sigil	Increases the damage of melee abilities by X% of base damage.	10	20	30
Shield Sigil	Increases maximum shield strength by X% of base strength and shield regeneration by X% of base regeneration.	10	20	30
Ultimate Sigil	Increases the damage of Ultimate Abilities by X% of base damage.	10	20	30
Assault Rifle Sigil	Increases assault rifle damage by X% of base damage and assault rifle reserve ammo by X% of base capacity.	10	20	30
Autocannon Sigil	Increases autocannon damage by X% of base damage and autocannon reserve ammo by X% of base capacity.	10	20	30
Grenade Launcher Sigil	Increases grenade launcher damage by X% of base damage and grenade launcher reserve ammo by X% of base capacity.	10	20	30
Heavy Pistol Sigil	Increases heavy pistol damage by X% of base damage and heavy pistol reserve ammo by X% of base capacity.	10	20	30
Light Machine Gun Sigil	Increases light machine gun damage by X% of base damage and light machine gun reserve ammo by X% of base capacity.	10	20	30
Machine Pistol Sigil	Increases machine pistol damage by X% of base damage and machine pistol reserve ammo by X% of base capacity.	10	20	30
Marksman Rifle Sigil	Increases marksman rifle damage by X% of base damage and marksman rifle reserve ammo by X% of base capacity.	10	20	30
Shotgun Sigil	Increases shotgun damage by X% of base damage and shotgun reserve ammo by X% of base capacity.	10	20	30
Sniper Rifle Sigil	Increases sniper rifle damage by X% of base damage and sniper rifle reserve ammo by X% of base capacity.	10	20	30

REWARDS

After completing a mission, or ending the expedition, you and your squad are presented with everything earned during the expedition. XP from completed expedition feats is accrued and added to Alliance bonus. If you gain a level, you're informed at this time, along with any bonuses unlocked with that accomplishment. All of the loot gathered is then revealed on a special Loot screen. Here you can preview everything you found, and salvage anything you don't want to keep. After you're presented with rewards, you're given the choice to return to the Launch Bay, Forge, or Fort Tarsis.

Completing objectives typically rewards you with weapons, Gear, and components. These items are revealed at the Loot screen as mentioned previously. Chests earned from completing World Events may also provide ember. As your pilot level increases, the chance of acquiring higher rarity items increases.

ALLIANCE SYSTEM

XP earned by players on your Friends list, and anybody you've played with recently, translates into coin for you. Only the top five contributors count toward this reward. As the amount of XP earned by these players increases, your Alliance Tier increases. This translates into bigger rewards.

END MISSION

At the Map screen, you can end an expedition at any time by holding the End Expedition button. This sends you directly to the Reward screen, but note that mission progress is reset.

FACTION REPUTATION

Earn reputation toward the three factions—Sentinels, Arcanists, and Freelancers—by completing Challenges. As you reach certain levels of reputation for each faction, sets of component blueprints are unlocked, as well as a new title.

Faction: Sentinel
Agent: Brin

TITLE	SENTINEL REPUTATION	BLUEPRINTS UNLOCKED
Sentinel Loyalty 1	500	Uncommon Javelin-Specific Components
Sentinel Loyalty 2	1500	Rare Javelin-Specific Components
Sentinel Loyalty 3	3000	Epic Javelin-Specific Components

Faction: Arcanist
Agent: Matthias

TITLE	ARCANIST REPUTATION	BLUEPRINTS UNLOCKED
Arcanist Loyalty 1	500	Uncommon Sigil Consumables
Arcanist Loyalty 2	1500	Rare Sigil Consumables
Arcanist Loyalty 3	3000	Epic Sigil Consumables

Faction: Freelancer
Agent: Yarrow

TITLE	FREELANCER REPUTATION	BLUEPRINTS UNLOCKED
Freelancer Loyalty 1	500	Uncommon Basic Components
Freelancer Loyalty 2	1500	Rare Basic Components
Freelancer Loyalty 3	3000	Epic Basic Components

Unlock the Challenges for Freelancer Veteran, Arcanist Executor, and Sentinel Ally to unlock "The Champion of Tarsis" Challenge (50,000 reputation per faction). This allows you to earn more reputation with all three factions, ultimately unlocking the Masterwork blueprints.

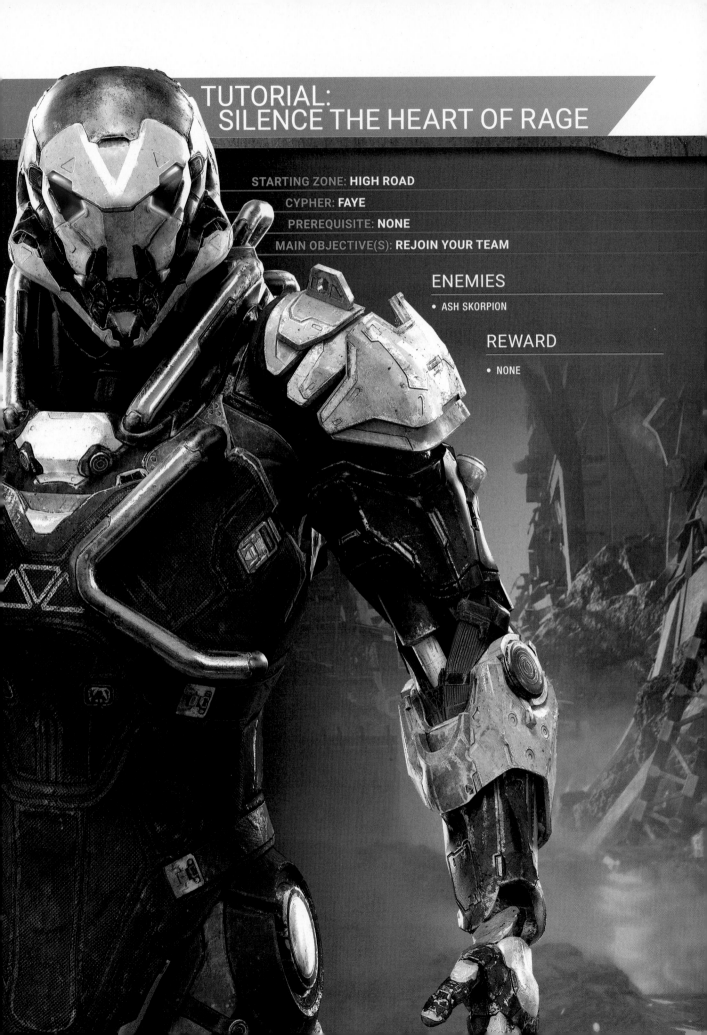

TUTORIAL: SILENCE THE HEART OF RAGE

STARTING ZONE: **HIGH ROAD**

CYPHER: **FAYE**

PREREQUISITE: **NONE**

MAIN OBJECTIVE(S): **REJOIN YOUR TEAM**

ENEMIES

- ASH SKORPION

REWARD

- NONE

PICK UP THE REPAIR PACK

Your pilot begins with the Ranger exosuit, which is immediately brought down by a Wyvern. Choose your pilot's gender to get back on your feet. Look southeast to find an objective marker and follow it. The flight system is down, so you start out on foot. After collecting a Repair Pack, perform a double jump to reach the ledge above. With the Ranger, hold the jump button longer on the first jump and tap again for greater height.

FREELANCERS

Independent lancers who chose to follow General Tarsis and the Path of Valor. They silence cataclysms and aid those in need beyond the safety of the walls. Freelancers act without direct orders from any central organization.

FOLLOW THE OBJECTIVE MARKERS

As long as you are tracking a quest, a hexagonal objective marker appears on your HUD. Move toward the marker to progress in the quest and display the next point. If the marker has a triangle arrow attached, you must turn toward that direction. The objective icon also appears on the compass in case you are having trouble spotting the marker.

Stay on the path until you reach an obstruction. From a safe distance, shoot one of the explosive barrels to clear it out. Ash Skorpions are scattered throughout the rest of this objective, but they go down fairly easy with the Ranger's powerful weapons. Clear the foes out as you descend to the right and climb out the other side. A quick grenade near the explosive barrel can obliterate the first group with one shot.

31

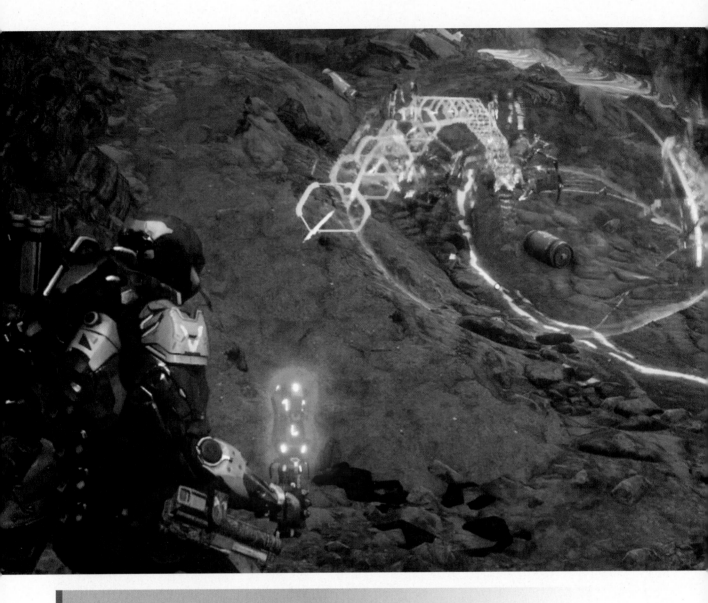

ENEMY STRATEGIES

We mention the types of enemies faced as you progress through the Campaign, and may include a tip or two for the specific situation. For more in-depth strategies, refer to the Enemies chapter.

FULL ARRAY OF WEAPONRY

Your Ranger is equipped with an assault rifle, Frag Grenade, Seeking Missile, and a melee attack. Your Ultimate ability is also available right away, allowing you to clear out a large group of Skorpions with one shot. It is best to save this ability for bigger groups of enemies or tougher foes. For full details on weapons, components, Gear, and ultimate abilities turn to the Equipment chapter.

LOOT

Enemies may drop health pickups (red pyramid shape), ammo pickups (green pyramid), or a tech (white octahedron). The health pickup restores armor. The ammo pickup provides ammunition for your weapons. The tech unlocks a random weapon or Gear at the rewards screen once the mission is complete.

SAVE THE DOWNED FREELANCERS

Continue east up the ledges until you spot a Titan ahead. Don't worry; the big guy clears out before your arrival, but he does leave three fellow Freelancers in a downed state. Fight through more Ash Skorpions and repair the three javelins. The Ash Skorpions will interrupt the repair process, so it is often best to clear the immediate area first. Freelancer Pavic is found at the entry point, while Freelancers Bencana and Rizzo are on the right; look for the plus icons that signify downed players.

GET BACK IN THERE

When a Freelancer's shield and health are fully depleted, the player enters a downed state. At that point, the player can be repaired by a teammate, while a respawn timer counts down to zero. At that point, the player can immediately respawn at the previous checkpoint or continue to wait for a repair. If you spot a downed player (look for the plus icon), stand next to the javelin and hold the indicated button to get the Freelancer back into the fight.

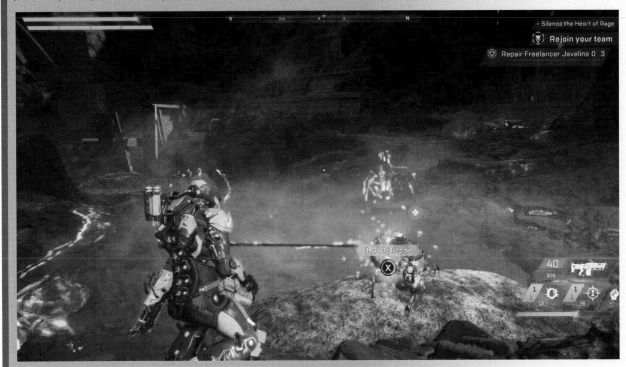

REJOIN YOUR TEAM

With the others back on their feet, run north through a hole in the wall created by another Titan. Perform double jumps to clear the cavern and then fight through more Skorpions as you continue toward your objectve. Don't advance too quickly and become overwhelmed. As you approach an opening on the right, you rejoin the team. A cinematic leads directly into the next quest, "Early Warnings."

STARTING ZONE: —

CYPHER: OWEN

PREREQUISITE: COMPLETE "SILENCE THE HEART OF RAGE"

MAIN OBJECTIVE(S):

• **COLLECT SENSOR READINGS FROM EARLY WARNING NETWORK.**

• **PREVENT A CATACLYSM EVENT.**

ENEMIES

• DIGESTER

• WYVERN

• WOLVEN

• FROST ELEMENTAL

ACTIVATE RELAY

Two years later, you are paired up with a new Cypher. The mission requires that you collect sensor readings, but first you must activate the relay. Take flight into the clearing and land near the relay to the left. Reset the device and then dive into the ravine to the north. Follow the markers left into a cave to find the first sensor.

CYPHERS

Individuals with a sensitivity to the Anthem of Creation who undergo ember exposure and dedicated training to enhance their mental skills. They are capable of telepathic communication and heightened mental calculation.

COOL OFF

Note the tip at the start of this mission that teaches you to "Dive steeply to cool off..." If you dive straight down while in flight, the temperature will slowly lower, allowing you to extend flight time. You can also fly low over bodies of water to enable the Cooled effect, or straight through waterfalls to completely cool the suit off. Refer to the Your Javelin chapter for more information about the ins and outs of your exosuits.

ACCESS THE THREE SENSORS

Interact with the sensor to display a circular, green outline on the environment and a scanning bar in the upper-right corner of your HUD. As long as you stay within the circle, the meter fills—indicating Owen's progress with the scan. Digesters continuously attack during this time, so fight them off until the bar fills completely.

RESOURCES AND TECH

Keep an eye out for valuables throughout Bastion, easily recognized from a short distance by a white glow that rises from the item. Harvesting resources, such as organics and minerals, provides the materials necessary to craft new equipment, while supply caches hold valuable weapons, Gear, and weapon parts (used to forge new equipment). Note that resources can be attacked in order to release the material; make sure to collect the item before leaving the area.

At this point, your Cypher directs you west and north to a second sensor. Noone bothers you there, so simply wait for the scan to complete. Next, fly northwest through a few arches and land near the third and final sensor. Immediately access the sensor before dealing with the Wyverns that fly overhead. It is not necessary to defeat them all, although their presence does slow down the process. Be sure to avoid their fire attacks until the scan is finished.

UNLOCK THE SHAPER RUIN DOOR

With the scans complete, take flight and dive into the water ahead. The next room holds a relic along with echoes, or floating lights, scattered around the interior. You must collect and deliver five of these lights to the relic in order to open the nearby gate. Flying through one of these lights causes it to latch on, allowing you to drop it off at the lock. You can only hold three of these echoes at a time, so make two trips around the room. Once five have been delivered, the gate opens.

ECHOES

Pieces of the Anthem of Creation that often exist as semi-animate globes of energy. Echoes tend to hover around the Shaper relics they escaped from and can be used to silence cataclysms, although how and why this is possible is purely theoretical.

RETURN SIX ECHOES TO ARTIFACT

Fly through the long corridor, grab the Weapon Parts from the javelin on the floor, and exit through another gate that opens as you approach. Inside the next area, vertical energy streams continually move toward your position. These cause damage when contact is made, so strafe or use barrel rolls to evade them. If you

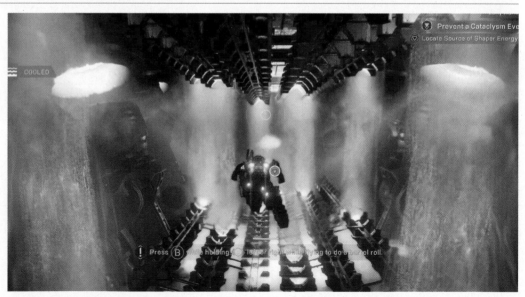

overheat before the end, you restart back at the previous platform. At the far end of the cavern, drop into the hole.

This leads to the relic that needs to be silenced. First you must collect six echoes and deliver them to the relic that sits near the middle of the circular platform. There are plenty of echoes scattered around the cavern, including two underwater. Make a couple of flights around the room and deliver the echoes.

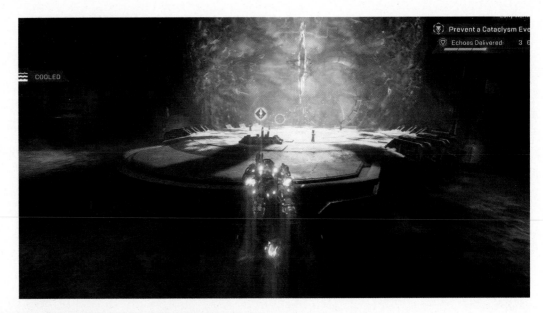

USE HOVER TO LOOK AROUND

If you choose to fly through each echo to pick them up, tap the Hover button to stop in place — allowing you to look around for the next echo. This keeps you from slamming into a wall or obstacle.

COLLECT FRAGMENTS AND RETURN THEM TO THE PEDESTAL

Frost Elementals and Wolven continually spawn from the energy; stay on the move and fend them off until three fragments appear. These are indicated by objective markers along with a pedestal that holds the fragments. Collect each fragment, one at a time, and insert them into the pedestal. Wolven and Elementals continue to spawn throughout this step, so stay alert. Once the third fragment has been inserted, a cinematic wraps up the quest. This completes the prologue and sends you to Fort Tarsis.

FROZEN STATUS EFFECT

Certain enemies inflict status effects on the player, which can have either a negative or positve effect on the javelin. Frost Elementals hit with the Frozen effect, which slows the player down—eventually bringing the javelin to a complete stop. At this point you are vulnerable to enemy attack. Rapidly tap the indicated button to free yourself.

WEIGHTED DOWN

Note that you are unable to fly when carrying an object, such as the fragments collected during this objective. You can still jump, sprint, and evade though—allowing you to avoid taking damage while fighting the enemies.

EARLY WARNINGS
By completing the tutorial you earn the Early Warnings Achievement/Trophy.

1	Owen
2	Forge
3	Javelin

STARTING ZONE: **FORT TARSIS**

CYPHER: —

PREREQUISITE: **ARRIVE AT FORT TARSIS BY COMPLETING "EARLY WARNINGS"**

MAIN OBJECTIVE(S): **INVESTIGATE THE FORGE**

ENEMIES

- NONE

REWARD

- NONE

1 MEET OWEN

Before this objective begins, choose a look for your pilot. "Welcome to Fort Tarsis" introduces the player to the fort. Start out by talking to Owen in the Freelancer Enclave on the north side of the fort. Return to your javelin, where Tassyn asks you to find a missing Arcanist, Matthias Sumner.

2 **3** INVESTIGATE THE FORGE AND UNLOCK YOUR FIRST JAVELIN

Activate the Forge to learn how to equip your javelin. Unlock Exit the Forge to begin the next quest, "Lost Arcanist."

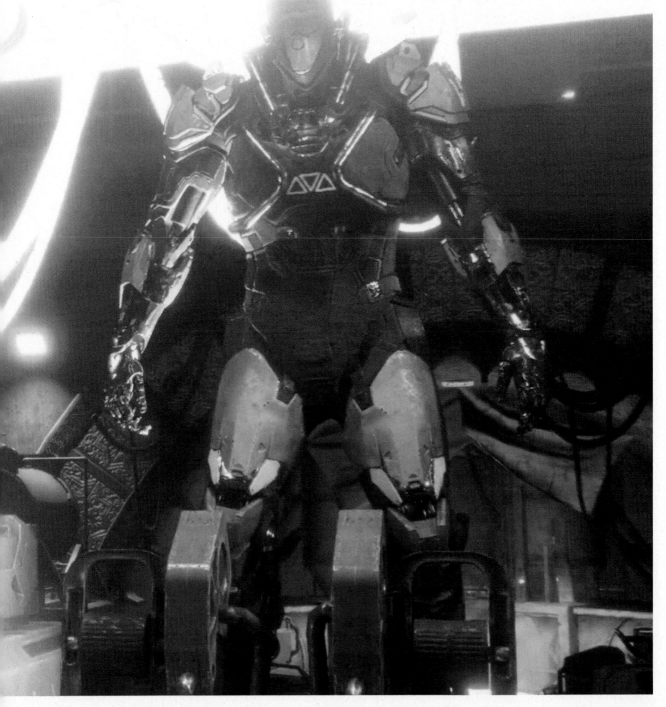

LOST ARCANIST

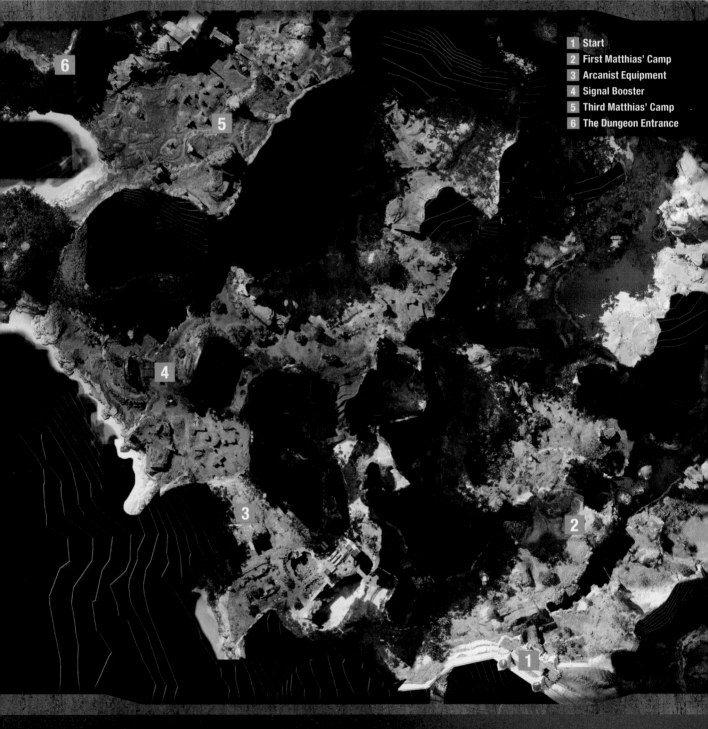

1 Start
2 First Matthias' Camp
3 Arcanist Equipment
4 Signal Booster
5 Third Matthias' Camp
6 The Dungeon Entrance

STARTING ZONE: HIGH ROAD

CYPHER: OWEN

PREREQUISITE: UNLOCKED DURING "WELCOME TO FORT TARSIS"

MAIN OBJECTIVE(S): LOCATE MATTHIAS SUMNER

ENEMIES

- WYVERN
- SCARS: SCRAPPER, DESTROYER, ENFORCER, RUST REAVER

REWARD

- RIFLE
- SHOTGUN
- PISTOL
- PISTOL

1 2 INVESTIGATE FIRST CAMPSITE AND FOLLOW THE RADIO SIGNAL

Start by investigating the last known location of Matthias. Fly northeast to find his camp on a small plateau and interact with the radio. This brings up markers to the southwest, indicating a signal from a second radio. Fly through the rings as they lead through Tarsis Forest and to another clearing at First Refuge.

ARCANISTS

Arcanists are scientists, researchers, and scholars who study the mysteries of the world, from wildlife to Shaper instruments. While some are found teaching in classrooms, others spend their lives solving Shaper mysteries in the wilderness.

3 FIND ARCANIST EQUIPMENT AND USE IT TO PINPOINT MATTHIAS' LOCATION

Explore the burning structures, and Owen suggests looking for any equipment that can be used to track Matthias. A radar appears at the top of the screen, which leads you to the Arcanist equipment. Fly a short way north to find it surrounded by more burning rubble. Activate the equipment to begin a scan for another radio.

OBJECTIVE RADAR

Many objectives in the game require you to find items in a set area. Then you must collect, interact with, protect, or destroy them. To help you find the objectives, a small circular radar appears under the compass on your HUD. It's split into four parts, and one of these sections will blink on and off. This means the nearest objective is in that direction, where up means straight ahead and down means behind you. One line lit up means the objective is a distance away, while all three lines means you are getting close. There isalso an arrow in the middle of the radar which indicates the height.While using the radar to find objectives isn't necessary, many items can be tough to spot from a distance.

This attracts a Scar Hive to the northeast. Quickly destroy it along with the Scar Scrappers that spawn from it. Remember to use your Gear when available, and use the structures as cover to avoid being overwhelmed. A second hive appears on the hill to the south, then a third to the west. Quickly destroy the hives as they appear, then clear out the remaining Scars.

SCARS

This swarm of insects mimics the dominant life form in an area. Scars first appeared from a cataclysm in 413 LV. At the time, Freelancers defeated a large, vicious creature none of them recognized. Later, unknown to Freelancers, the Scars regrouped and changed their mimicry to appear human.

4 FOLLOW THE RADIO SIGNAL

Another radio signal leads you north into Velathra, where you find a signal booster. Clear out more Scar Scrappers around the small body of water. A few Wyverns also show up, so deal with them. Once the area is clear, activate the booster.

5 INVESTIGATE MATTHIAS' CAMPSITE AND FIX THE RADIO

This extends the signal to the northeast. Follow it to find another campsite just inside Fortress of Dawn, in the Darkwood Barrens district. Defeat the Scar Scrappers, then interact with the radio next to the campsite. More Scar Scrappers and a Scar Enforcer show up. Whittle down the big guy's health or, if available, use your Ultimate Ability on it. Repair the radio again to get in contact with Matthias, who's holed up in a nearby cave. Fly west to find the entrance to the Dungeon on the backside of the ruins. Wyverns fly nearby the entrance, but they can be ignored.

6 FOLLOW MATTHIAS' TRAIL AND DEFEAT THE SCARS

Navigate through the corridors of the Dungeon until you reach a big room, where a swarm of Scar Scrappers and Destroyers must be stopped before you can progress toward Matthias. Destroy their hives, then clear out the remaining Scars. Fly south and descend the staircase into a tunnel. The Dungeon is littered with resources and supply caches, so be on the lookout for loot.

At the end of the tunnel is a large arena where gates spawn numerous Scar Scrappers and Destroyers. Stay on the move as you destroy foes. Use pillars and walls as protection, and flee the swarm if health gets low. Eventually, a Scar Enforcer shows up. Try to save your Ultimate and take it down with your Gear, because a tougher foe—a Rust Reaver—joins the fight. Unleash your Ultimate Ability on the boss and finish off the Scars.

EXIT INTERIOR

Deep inside interior locations, you'll find a switch that has the same icon used to mark Hidden Places on the world map. Use this device to return to the entrance. There's no shortcut to the device, so you must navigate all the way back if the mission has not been completed.

GATES

A small, Shaper-related disruption in reality, a gate can be momentarily ripped open to allow living things to "skip through" and emerge elsewhere. This method of travel is dangerous and wildly unpredictable. Those who risk the gates could be flung to unknown locations or never emerge at all, and repeated use of gates has been known to cause madness in humans.

When you arrive back at the fort, talk to Yarrow, Matthias, and Tassyn. This leads right into the next quest, "Lighting a Fire."

LIGHTING A FIRE

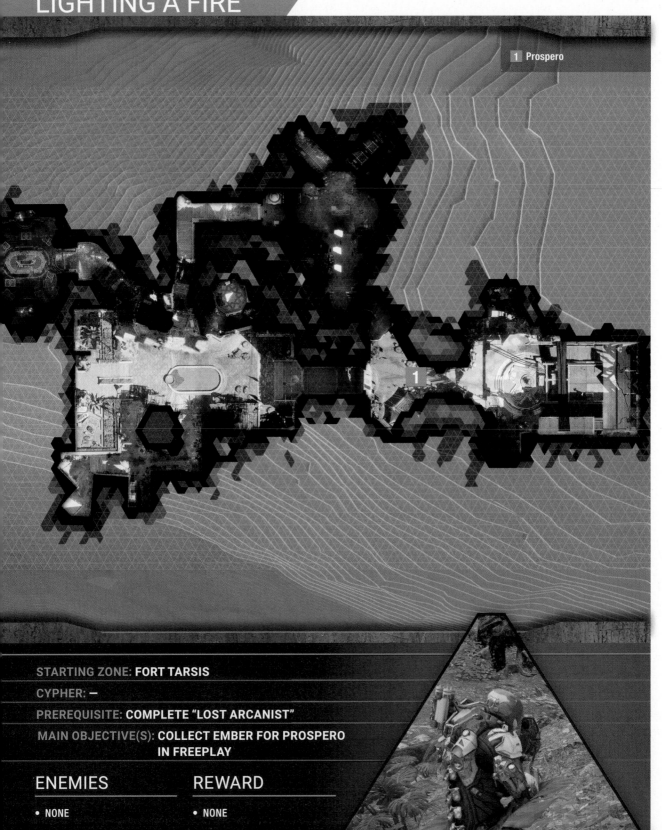

1 Prospero

1

STARTING ZONE: **FORT TARSIS**

CYPHER: —

PREREQUISITE: **COMPLETE "LOST ARCANIST"**

MAIN OBJECTIVE(S): **COLLECT EMBER FOR PROSPERO IN FREEPLAY**

ENEMIES

- NONE

REWARD

- NONE

1 COLLECT THREE EMBER PIECES

Speak to Prospero at Fort Tarsis' bazaar. He asks you to bring him ember, which is randomly dropped from organic and mineral resource nodes. It's possible to already have the three ember in your inventory; if not, leave the fort and harvest resources until the ember is collected. Freeplay is now available at the Start Expedition screen.

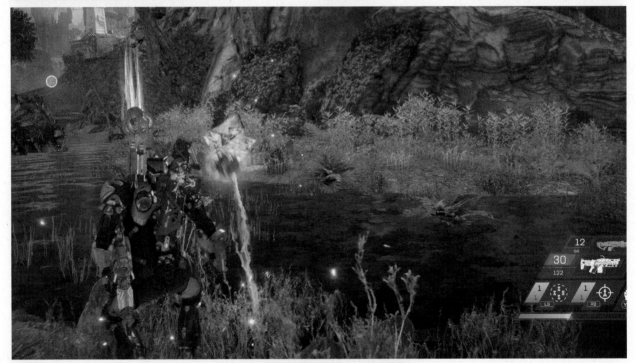

EMBER

A naturally occurring, dangerous by-product of the Anthem, ember is used as a foundation for human technology. While active ember can be found throughout Bastion, it's most bountiful around the engineering city of Heliost.

Visit Prospero with the ember to unlock the ability to change your javelin's appearance at the Forge. The next critical objective, "Incursion," begins right away.

INCURSION

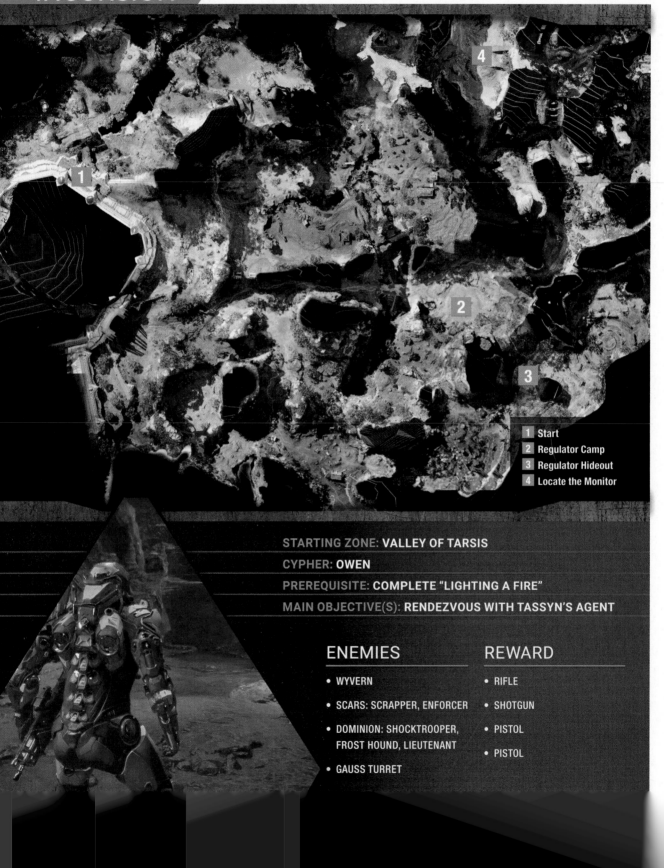

1 Start
2 Regulator Camp
3 Regulator Hideout
4 Locate the Monitor

STARTING ZONE: VALLEY OF TARSIS

CYPHER: OWEN

PREREQUISITE: COMPLETE "LIGHTING A FIRE"

MAIN OBJECTIVE(S): RENDEZVOUS WITH TASSYN'S AGENT

ENEMIES

- WYVERN

- SCARS: SCRAPPER, ENFORCER

- DOMINION: SHOCKTROOPER, FROST HOUND, LIEUTENANT

- GAUSS TURRET

REWARD

- RIFLE

- SHOTGUN

- PISTOL

- PISTOL

2 RENDEZVOUS WITH TASSYN'S AGENT AT REGULATOR CAMP

First, speak to Tassyn, south of the Forge, to get your next objective: meet her agent at a Regulator camp. The camp is on the far side of Valley of Tarsis. A flight of Wyverns hover just

ahead of the camp. Deal with them before interacting with the container on the northeast side of the camp.

REGULATORS

This organized criminal group deals in smuggling, gambling, theft, extortion, and other illegal activity. While not as ruthless as Outlaws, the Regulators are dangerous and operate outside civil society while manipulating others for profit. The recent closings of strider locks and a downturn in the safety of roads have limited legal trade and made the Regulators rich.

Soon a Scar Hive appears on the west side of the camp. Quickly deal with it before cleaning up the Scar Scrappers that spawn. A second hive phases in on the south side, which also spews out a pack of Scrappers. Soon after, a third hive joins the fight on the east side. This one adds a Scar Enforcer along with another group of Scrappers. Focus big attacks against the Enforcer and flee into the nearby water if health gets low. You must defeat the ambush before getting your next objective.

3 TRAVEL TO AND EXPLORE REGULATOR HIDEOUT

Your next destination, a Regulator hideout, is southeast near the southern tip of Eastern Reach in Junkhead Basin. Enter the Shrine and navigate through the cave until you reach a door. Your flight system is disrupted by a Dominion shield generator in the next room, so you're limited to sprinting and jumping to the next objective marker.

Be careful, though, as Regulators have planted mines throughout the cavern. Look for the red glow as you get close to one of the explosives; the mine rises out of the ground and detonates after a short timer. Quickly evade backward so the mine safely drops back into its socket. Either shoot mines from a safe distance or rapidly evade past them to avoid taking damage.

Once you exit through the southern door, your flight control returns. You can fly through the cavern to the next objective marker, but there are several mineral nodes along the way, as well as a possible supply cache. Open the next door to meet the Monitor, a powerful Dominion operative.

THE DOMINION

The Dominion, the expansionist military regime from Stralheim, destroyed the city of Freemark when they attempted to control the Cenotaph. While their technological advances are noteworthy, their methods show little regard for life or individuality.

3 DEFEAT DOMINION TROOPS

A gate spawns a group of Dominion Shocktroopers you must defeat before moving on. These guys go down fairly easily. Avoid taking on too many at once, as they have the ability to overwhelm.

With the foes out of the way, investigate Tassyn's agent, who lies in the middle of the cavern.

4 LEAVE THE HIDEOUT AND FOLLOW THE MONITOR

Exit through the eastern door and leave the hideout the way you came in. When you reach the room with the Dominion shield generator, more Dominion Shocktroopers spawn. Fight your way to the generator and protect it while Owen works on deactivating it (a meter fills up in the upper-right corner as long as you remain close). With your flight controls returned, defeat the remaining foes.

DISABLED MINES

On your return to the generator room, the mines are disabled so they don't detonate near the Shocktroopers. Therefore, you don't need to worry about accidentally setting them off. You can still detonate the devices by shooting them. Use this tactic to your advantage against Dominion forces.

Later, a Dominion Lieutenant spawns into the cavern. Concentrate Gear attacks and your Ultimate (if available) against the boss. After defeating all of the troops, leave the hideout.

Follow the Monitor's signal to the north, just inside the East Gate at Lover's Falls. At the end of the short tunnel, you're ambushed by Dominion Shocktroopers and Frost Hounds.

Before you leave the tunnel, locate the two Gauss Turrets. These powerful weapons fire energy bursts once they obtain a lock on you. Keep obstacles between them and you whenever you're not firing at them. A solid beam from the turret signifies that it's targeting you. Use this time to attack the gun, then step behind cover as it fires its burst. It's possible to eliminate the turrets from the tunnel by ducking back into the enclosure whenever they take a shot. Don't lose track of the troops and hounds while focused on the big guns.

Eventually, a Dominion Lieutenant enters the area. Use Gear abilities and your Ultimate on the boss to whittle down his health. Once the area is clear of Dominion foes, the mission is complete and you return to the fort.

When you arrive at Fort Tarsis, report back to Tassyn, who's accompanied by Owen and Brin at the Freelancer Enclave. This begins the next quest, "Lending a Hand."

INCURSION

By completing this mission, you earn the Incursion Achievement/Trophy.

LENDING A HAND

1 Brin
2 Matthias
3 Yarrow

STARTING ZONE: **FORT TARSIS**

CYPHER: —

PREREQUISITE: **COMPLETE "INCURSION"**

MAIN OBJECTIVE(S): **SUPPORT TASSYN'S AGENTS**

ENEMIES

- NONE AT FORT

REWARD

- NONE
 (REWARDS FOR EACH QUEST)

1 ASSIST BRIN

This quest requires completing three Agent Quests, which can be done in any order. Tassyn asks that you assist three of her agents, all located at Fort Tarsis. Find Brin at the top of the staircase at the far west side of the fort. Speak with her to begin an Agent Quest called "Preventative Precautions." Refer to our Agent Quests section for more details.

2 ASSIST MATTHIAS

Since rescuing him in "Lost Arcanist," Matthias hangs out on the west side of the fort. After passing through the two sets of double doors, enter the first opening on the right and proceed into the small octagonal room. Matthias provides an Agent Quest titled "See in the Dark." Find this quest in the Agent Quests portion of this chapter.

3 ASSIST YARROW

Yarrow is located in the Freelancer Enclave. Speak with him to begin the third Agent Quest, "What Freelancers Do." For complete information on this quest, refer to Agent Quests.

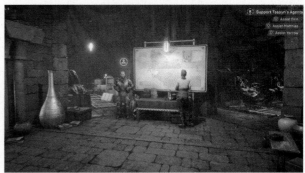

With all three Agent Quests complete, a new mission called "Finding Old Friends" begins.

FINDING OLD FRIENDS

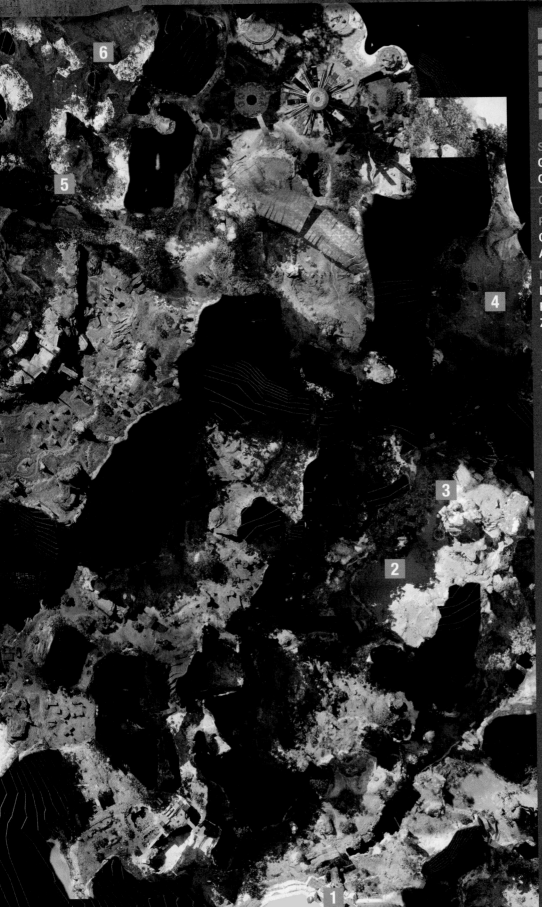

1 Start
2 Weapon Cache
3 Relics
4 Ursix
5 Hideout
6 Strider

STARTING ZONE:
GREAT FALLS CANYON

CYPHER: **OWEN**

PREREQUISITE:
COMPLETE "LENDING A HAND"

MAIN OBJECTIVE(S):
LOCATE HALUK AND FAYE AT "PRINCESS" ZHIM'S HIDEOUT

ENEMIES

- SCARS:
 DESTROYER, SCRAPPER, SCOUT, ENFORCER

- MACHINE GUN TURRET

- URSIX

- DOMINION:
 SHOCKTROOPER, FROST HOUND, BRUTE, VALKYRIE

REWARD

- PISTOL

- SHOTGUN

- RIFLE

- RIFLE

1 2 COLLECT WEAPONS CACHE AS TRIBUTE

Visit the bar in the northwest corner of Fort Tarsis and speak to Owen, who waits on the right side of the room. Tassyn wants you to find your old friends, Faye and Haluk, at "Princess" Zhim's hideout. To get in, you must collect tribute. Your first stop is a Scar camp in Blackshore on the northwest side of Great Falls Canyon.

Clear out the Scar Scrappers, Destroyers, Scout, and a pair of Enforcers. If possible, eliminate the pesky Scout and destructive Enforcers first. Once the Scars are defeated, collect tribute from the weapons cache.

3 COLLECT RELICS AS TRIBUTE

Head a short distance northeast to find another group of Scars. Take them down, but don't get too close to the walkway; two Machine Gun Turrets guard the camp from lower platforms. After killing off the Scars, focus your attention on the turrets. It's possible to target the left gun without attracting fire from the right. Find the second tribute on another platform near the right turret's location.

4 DEFEAT URSIX AND COLLECT FINAL TRIBUTE

One last tribute must be collected before you travel to the hideout. Fly north down through the Scar camp and spot an Ursix battling a group of Scars on a small island. An Ursix isn't particularly fast, but it possesses a large amount of health. Be prepared for a lengthy battle.

URSIX

Now here's a glorious predator! Humongous and highly aggressive, the Ursix will stop at nothing to put you on the menu. One hit from its massive arms can turn your javelin into scrap metal, and one bite from its enormous jaws will pop you out of your armor like a nut from a shell. Watch the Ursix from a safe height, and if you're really lucky, the Ursix might hurl boulders at you. What a sight to behold!

—From Bastion's Amazing Animals! By Venwick Crok

It's best to fight this enemy from distance. It hurls rocks at its target, which can be evaded with a sidestep. If you choose to fight up close, remain alert; its attacks are tougher to dodge at close range and one hit can wipe out a large chunk of your health. Escape into the water to heal if your armor gets low. Continue to whittle down its health until it finally falls. Collect the tribute before leaving the area.

5 ENTER "PRINCESS" ZHIM'S HIDEOUT

Fly west through the Shaper tunnel and continue to the hideout. Speak to Zhim's bodyguard to enter.

5 DEFEAT THE DOMINION FORCES OUTSIDE HIDEOUT

After the reunion, a group of Dominions attacks outside the hideout. A pack of Shocktroopers and Frost Hounds is joined by hard-hitting Dominion Frost Brutes and a Frost Valkyrie. Isolate the bigger foes and quickly take them down with Gear attacks. Continue to assist Zhim's bodyguards in the fight until you hear that the enemy is going after the strider.

6 DEFEND THE STRIDER FROM DOMINION ATTACK

Fly north into Helena's Walk to find the strider. Then spot Owen, who's been downed at the nearby ruins. You must defend him from more Dominions before getting him up. More Shocktroopers attack his position, along with a Dominion Storm Brute and Ash Valkyrie. Defeat the Dominion threat, then repair Owen's javelin to complete the mission.

FINDING OLD FRIENDS
By completing this mission, the Finding Old Friends Achievement/Trophy is earned.

MEETING WITH CORVUS

1 Tassyn

1

STARTING ZONE: FORT TARSIS

CYPHER: —

PREREQUISITE: COMPLETE "FINDING OLD FRIENDS"

MAIN OBJECTIVE(S): SPEAK WITH TASSYN

ENEMIES

- NONE

REWARD

- NONE

1 SPEAK WITH TASSYN

Speak with Tassyn just south of the Forge to unlock the first Stronghold, Tyrant Mine. Refer to the Strongholds section of this Expeditions chapter for more information.

1 Tomb of Yvenia
2 Tomb of Artinia
3 Tomb of Gawnes
4 Tomb of Cariff

STARTING ZONE: VARIOUS

CYPHER: FAYE

PREREQUISITE: COMPLETE "MEETING WITH CORVUS"

MAIN OBJECTIVE(S): COMPLETE THE LEGIONNAIRES CHALLENGES

REWARD

- RIFLE
- RIFLE

LOCATE AND EXPLORE THE FOUR LEGIONNAIRES' TOMBS

Find Faye in the Freelancers Enclave to learn about the locations provided by Zhim. You must visit the four Legionnaires' Tombs in order to find the Javelin of Dawn. These tombs are located all around Bastion and are marked on the in-game map, as well as our map here.

In order to get inside each tomb, you must complete a trial for each of the Legionnaires. Select Challenges from your Cortex and look under Expedition Challenges > Freeplay to see the current Trials.

Refer to our Challenges section for a full list of Challenges.

ZHIM'S LEGIONNAIRE ARCHIVE

This appears to be the fragment of an archive written by the Legionnaire Liatrelle the Unbroken shortly after the death of General Tarsis. It has been heavily annotated by Regulator treasure-hunters as they searched for the tombs.

The Legion of Dawn counted many different members among their ranks—Arcanists, Engineers, healers, cooks, and, most importantly, the Lancers known as Legionnaires. *The Volume of Tarsis* celebrates famous Legionnaires such as Magna Stral, Liatrelle, Sanadeen, and Midderon, but hundreds of other warriors fill their own pages. Mentions are given to Lancers Artinia, Cariff, Gawnes, Alnwik Marigold, Verithan, Yvenia, and the twins Durnwin and Felux, though they're mentioned mostly in passing without great detail.

COMPLETING THE TRIALS

There is one Challenge per tomb. Each necessitates significant freeplay in order to complete their requirements.

Once you complete the requirements for a tomb, interact with its entrance and examine the sarcophagus inside. After you complete this mission by investigating all four sarcophagi, you'll have completed the "Grave Historian" challenge.

1 ENTER TOMB OF YVENIA

LOCATION:

TARSIS BYPASS, HIGH ROAD

REQUIREMENTS:

COMPLETE THE TRIAL OF
YVENIA CHALLENGE

TRIALS:

◆ HARVEST 25
 CRAFTING MATERIALS.

◆ REPAIR THREE DOWNED
 ALLY JAVELINS.

◆ FIND 10 COLLECTIBLE OBJECTS
 IN THE WORLD.

◆ DISCOVER 15 TREASURE CHESTS

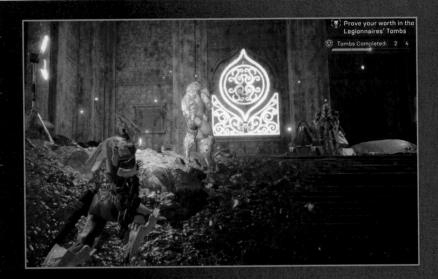

2 ENTER TOMB OF ARTINIA

LOCATION:

BULLET MIRES,
ACADEMY RUINS

REQUIREMENTS:

COMPLETE THE TRIAL OF
ARTINIA CHALLENGE

TRIAL OF ARTINIA:

◆ DEFEAT NINE ELITE ENEMIES.

◆ DEFEAT 15 ENEMIES BY
 HITTING THEIR WEAK POINTS.

◆ DEFEAT 30 ENEMIES
 WITH WEAPONS.

◆ COMPLETE FIVE WORLD EVENTS

3 ENTER TOMB OF GAWNES

LOCATION:

FORTRESS OF DAWN, FORTRESS OF DAWN

REQUIREMENTS:

COMPLETE THE TRIAL OF GAWNES CHALLENGE

TRIALS:

◆ DEFEAT 50 ENEMIES WITH MELEE ATTACKS.

◆ DEFEAT THREE LEGENDARY ENEMIES.

◆ DEFEAT 50 ENEMIES WITH AN ULTIMATE ABILITY.

4 ENTER TOMB OF CARIFF

LOCATION:

THE SANCTUARY OF DUNAR, EMERALD ABYSS (LOWER LEVEL OF RUINS)

REQUIREMENTS:

COMPLETE THE TRIAL OF CARIFF CHALLENGE

TRIALS:

◆ TRIGGER 15 COMBOS ON ENEMIES THAT HAVE EFFECTS ON THEM.

◆ DEFEAT 30 ENEMIES WITH GEAR.

◆ EARN THREE MULTI-KILLS BY DEFEATING NUMEROUS ENEMIES SIMULTANEOUSLY. DEFEATING LARGER GROUPS PROVIDES FASTER PROGRESS.

◆ COMPLETE THREE REINFORCEMENT MISSIONS

THE TOMB OF GENERAL TARSIS

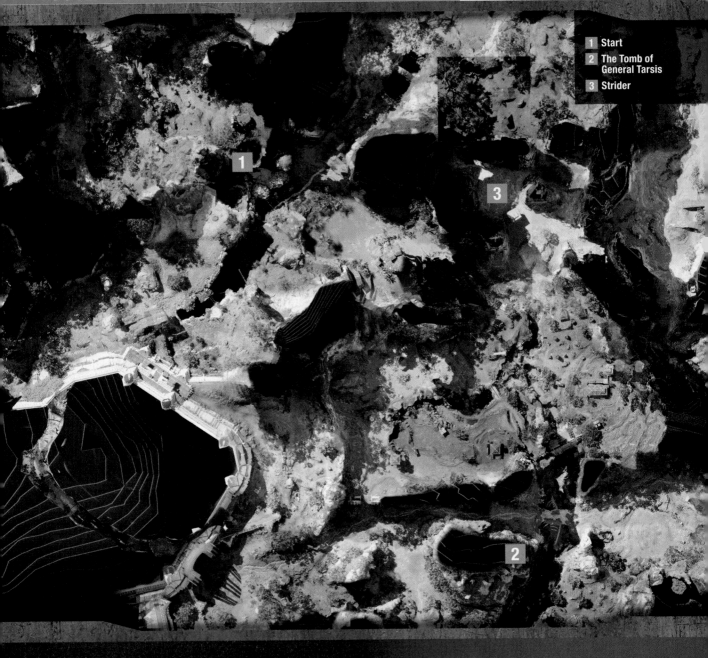

STARTING ZONE: VALLEY OF TARSIS

CYPHER: FAYE

PREREQUISITE: COMPLETE "FREEPLAY: TOMBS OF THE LEGIONNAIRES"

MAIN OBJECTIVE(S): LOOK FOR THE JAVELIN OF GENERAL TARSIS

ENEMIES

- SKORPIONS: SOLDIER, DIGESTER, WORKER

- DOMINION: SHOCKTROOPER, FROST HOUND, VALKYRIE, ELITE SHOCKTROOPER, ELITE FROST HOUND,
 ELITE VALKYRIE, BRUTE

- MISSILE TURRETS

REWARD

- SHOTGUN

- ASSAULT RIFLE

- BATTLE RIFLE

- MACHINE PISTOL

- REPEAT: ANY WEAPON X4.

1 LAUNCH EXPEDITION

Upon your return to Fort Tarsis, head to the enclave and speak to Faye about the plan. Return to your javelin and launch the expedition.

2 LOCATE THE TOMB OF GENERAL TARSIS

Fly southeast to central Valley of Tarsis. As you approach Strider Way, the compass radar begins to guide you to the tomb. If you flew through the Crop Terraces, turn left at the "T" and hug the right mountain until you reach a waterfall. Fly through the water and enter the Haven.

TOMB OF TARSIS

The resting place of Legion of Dawn leader, General Helena Tarsis. Over the years, many have searched for the tomb. In particular, Arcanist researchers have been frustrated in their attempts to discover the location of the Tomb of Tarsis. Garred's *The Volume of Tarsis* states that the general was buried in the place most beloved to her, inspiring speculation that her tomb could actually be inside the Fortress of Dawn. Other historians believe Tarsis was buried somewhere in the valley that is her namesake.

2 EXPLORE THE TOMB AND DEFEAT THE SKORPIONS

Objective markers lead you through the Haven. You immediately run into Skorpions, so take care of them as you make your way deeper inside. Clear out any remaining Skorpions, then approach the green door on the east side of the room.

DON'T MISS THE LOOT

As you explore, always be on the lookout for chests that provide weapons and Gear. These items are revealed after you complete the mission. Equip them at the Forge, or salvage them for valuable resources.

UNLOCK THE DOOR

Next, use the compass radar to find the locking mechanism directly behind you. Look on the right wall to find three pairs of plaques. Use the mechanism to match the middle two. Proceed through the door.

DEFEAT MORE SKORPIONS AND SOLVE THE THREE PEDESTALS

Battle through more Skorpions in the next room, then go north into the final chamber. After disposing of the enemy, approach another door on the far north wall. This time the radar leads you to three locking mechanisms: one just southeast of the door, another against the west wall, and a third in the far southeast corner. Enter the correct symbols at all three pedestals to unlock the door.

Southeast Corner: Standing at the pedestal, find one lying on the floor to the left and the other hanging to the right.

West Wall: From this pedestal, look back to the left toward the steps. The left plaque hangs on the left wall, and the right hangs at the top of the steps.

Near Tomb Door: The left plaque hangs just left of the pedestal. The right plaque is located on the far north wall, visible just above the banister if you back up from the pedestal.

ESCAPE THE AMBUSH AND EXIT THE TOMB

Enter the general's tomb. As you leave the Haven, Dominion have replaced the Skorpions and they immediately attack. You must defeat the Dominion, including Valkyries and a Brute, before exiting.

SIGNETS AND CROWNS

A signet is a personalized item inserted into the crown of a machine to establish a mental link between technology and the human mind. Since most machines that require a mental link have been tuned for a specific user, operating a machine with a foreign signet can be difficult and unsatisfactory.

3 REACH THE STRIDER WITH THE SIGNET

Outside the tomb, fly north, mindful of the Missile Turrets on Stone Bridge. Avoid their projectiles as you fly past, or destroy the weapons on your way to the strider in Great Falls Canyon. If you receive the "Enemy Locked On" message, get ready to barrel-roll to the side.

THE TOMB OF GENERAL TARSIS

By completing this mission, you earn the Tomb of General Tarsis Achievement/Trophy.

THE FORTRESS OF DAWN

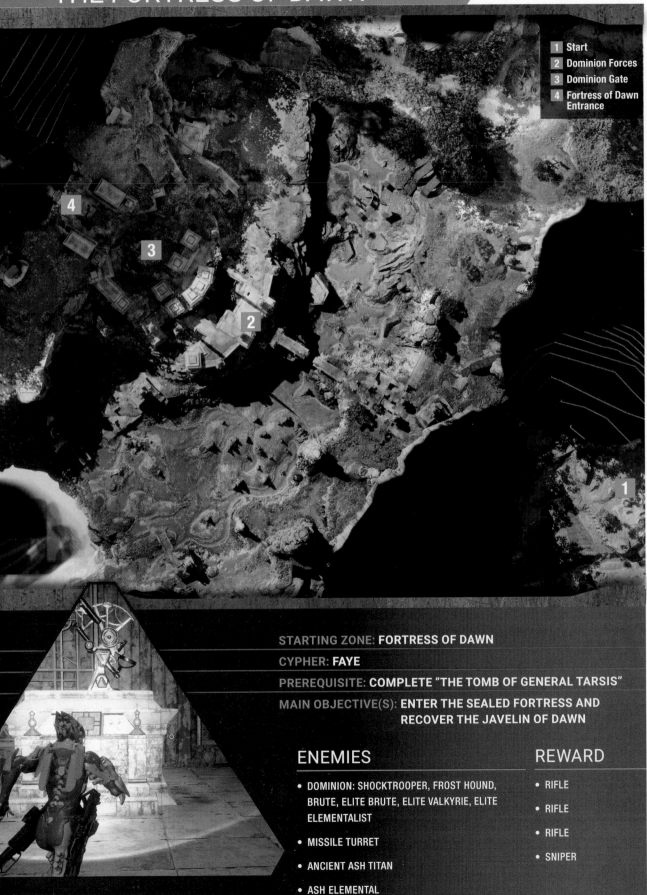

Legend:
1. Start
2. Dominion Forces
3. Dominion Gate
4. Fortress of Dawn Entrance

STARTING ZONE: FORTRESS OF DAWN

CYPHER: FAYE

PREREQUISITE: COMPLETE "THE TOMB OF GENERAL TARSIS"

MAIN OBJECTIVE(S): ENTER THE SEALED FORTRESS AND RECOVER THE JAVELIN OF DAWN

ENEMIES

- DOMINION: SHOCKTROOPER, FROST HOUND, BRUTE, ELITE BRUTE, ELITE VALKYRIE, ELITE ELEMENTALIST
- MISSILE TURRET
- ANCIENT ASH TITAN
- ASH ELEMENTAL

REWARD

- RIFLE
- RIFLE
- RIFLE
- SNIPER

1 FLY TO THE FORTRESS OF DAWN

The strider drops you off in northeastern Academy Ruins, not far from the Fortress of Dawn. Fly northwest, across Legionnaire's Ravine, into the fortress. Dominion forces have set up a grounder, disabling flight in the area.

2 CLEAR OUT DOMINION FORCES

A Missile Turret protects the entrance; use walls and steps to avoid its missiles, and fire back as it charges its next shot. Eliminate the pair of Dominion Brutes that appear, as well as all the Shocktroopers and hounds, to clear the area.

3 DESTROY FIVE ANCHORS AND THE GATE

Head left and follow the steps all the way up to a courtyard filled with more Dominion troops. A Dominion gate is responsible for bringing in the enemy, and it's connected to five anchors (marked on your HUD and map). Destroying these anchors drops the shield around the gate, allowing you to take it out. Elite Brutes and Valkyries join the Shocktroopers, so proceed carefully.

Target the objectives whenever possible, but don't lose track of the numerous Dominion troops that continue to spawn into the courtyard. There's no need to defeat all the Dominion. Have one member of the group focus on the gate from a safe location while others take on the foes. If you're going solo on a higher difficulty, you may want to eliminate tougher Dominion before destroying the objectives. If health gets low, retreat to the earlier steps.

COMPLETE THE TRIAL OF MIGHT

This pits you, or your team, against an Ancient Ash Titan. It features several attacks, along with a variety of arm gestures that signal each

move. It's vulnerable at any body part that glows.

Fire Rings: Four rings of fire emanate outward from the enemy at two heights. Avoid them by standing midway down the steps, or by jumping over the lower rings.

Fireballs: A fireball or two form above the Titan's head and launch directly at its target. Avoid this attack.

Ash Elementals: Ash Elementals spawn during hte fight. These may include a fireball just in front of the Titan's target. Destroy the Elementals as they approach.

Fire Beam: The Titan fires a powerful stream of fire directly at its target. Avoid this attack.

Ground Pound: Performed up close.

Stay on the move and collect any pickups dropped by the boss and Elementals. Its attacks become more frenzied as it nears death, culminating in a massive combo move that ends in its demise. When it slams its left foot down, followed by its right hand, sprint well out of range to

avoid going down with the boss.

Exit the gateway down the ramp and continue deeper into the fortress. Keep an eye out for chests along the way, then interact with the next statue to start the second trial, the Trial of Resolve.

4 ENTER AND SEARCH THE FORTRESS OF DAWN

With the Dominion cleared out, enter the Fortress of Dawn at the top of the staircase. The compass radar leads you to five points of interest, but only the one straight ahead is required. Located along the sides are four items that can be examined with Library entries added to your Cortex.

Interact with the statue on the right, just after the steps. Continue forward until stairs lead to landings on either side. Find a funerary urn to the left. Jump over the railing and check out the Legion engineering apparatus against the left wall. Finally, examine the ornate masonry, located just east of the main statue. Once you're ready to move on, interact with the statue in front of the next gate. Interact with it again to begin the Trial of Might.

COMPLETE THE TRIAL OF RESOLVE

You must defend three points as hordes of Dominion attack. You start out on a platform near the bottom of the steps, and the onslaught begins with Shocktroopers and Frost Hounds, followed by Brutes, Valkyries, and Elementalists.

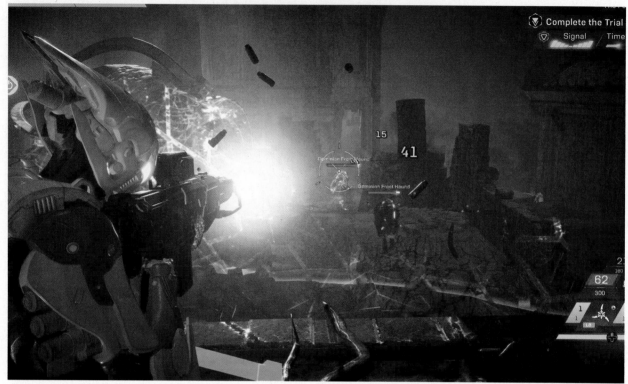

Remain inside the highlighted area as much as possible. When you step outside, progress stops. It slows down as more enemies enter the zone, so focus on foes within this area. Once the Time Remaining meter fills, the defense point moves up the steps. Defend that point, and it moves up to the third location near the top of the stairs. More Elite Dominion troops join as you proceed, making it tougher to remain in the fight. Two pillars provide a little protection, but it doesn't last long. Take advantage of easier kills and collect dropped Armor Packs. Become downed before successfully defending the final point, and you must restart from the first point. Being downed after this completes the trial.

Continue through the fortress until you reach another statue, which begins the final trial, the Trial of Valor. This ultimately completes the mission and returns you to Fort Tarsis.

THE FORTRESS OF DAWN
By completing this mission, you earn the Fortress of Dawn Achievement/Trophy.

CRAFTING THE DAWN SHIELD

1 Haluk
2 Forge

STARTING ZONE: **FORT TARSIS**

CYPHER: **–**

PREREQUISITE: **COMPLETE "THE FORTRESS OF DAWN"**

MAIN OBJECTIVE(S): **GATHER RESOURCES AND CRAFT THE DAWN SHIELD**

ENEMIES

- NONE

REWARD

- NONE

1 FIND OUT WHAT THE PROJECT NEEDS

Talk to Haluk in the Freelancers Enclave to learn what's needed to build the Dawn Shield. This kicks off "Mysterious Beginnings" and unlocks the second Stronghold, the Temple of Scar, but this quest isn't over yet. Matthias also has new quests available, as long as you completed his "Hidden Depths" mission. You must obtain Corium from any Titan or Escari, such as the ones faced during these missions and Stronghold. After you complete "Vanishing Act" or "Convergence" find Faye in the Freelancers Enclave and speak to her.

2 GATHER RESOURCES TO CRAFT THE DAWN SHIELD

Once you obtain Corium, the Dawn Shield becomes an option on your javelin when you visit the Forge. The Common Crafting Blueprint requires the following:

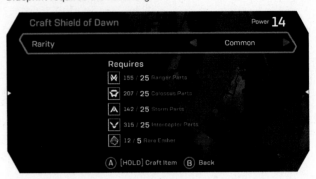

Craft Shield of Dawn	Power **14**
Rarity	◀ Common ▶

Requires

- 155 / **25** Ranger Parts
- 207 / **25** Colossus Parts
- 142 / **25** Storm Parts
- 315 / **25** Interceptor Parts
- 12 / **5** Rare Ember

Ⓐ [HOLD] Craft Item Ⓑ Back

After crafting the shield, the critical objective "Freelancer Down" begins.

MAKING PROGRESS

	ENEMIES	REWARD
STARTING ZONE: FORT TARSIS	• NONE	• NONE
CYPHER: –		
PREREQUISITE: COMPLETE "CRAFTING THE DAWN SHIELD" AND "VANISHING ACT" OR "CONVERGENCE"		
MAIN OBJECTIVE(S): CHECK PROGRESS ON THE DAWN SHIELD		

SPEAK TO FAYE

After you complete "Vanishing Act" and "Crafting the Dawn Shield," "Making Progress" becomes the active quest. Find Faye in the Freelancers Enclave and speak to her.

MYSTERIOUS BEGINNINGS

1 Start
2 Meeting Spot
3 First Camp
4 The Sovereign Mine

STARTING ZONE:
FORTRESS OF DAWN

CYPHER: FAYE

PREREQUISITE: TALK TO HALUK DURING "CRAFTING THE DAWN SHIELD"

MAIN OBJECTIVE(S):
ASSIST DAX WITH THE MYSTERY OF PEOPLE VANISHING IN THE EMERALD ABYSS

ENEMIES

- SKORPIONS: DIGESTER, WORKER, ELITE WORKER

- OUTLAWS: OUTLAW, GUNNER, ELITE OUTLAW, ELITE GUNNER

- URSIX, ANCIENT URSIX

REWARD

- RIFLE

- RIFLE

- SNIPER

- HEAVY WEAPON

1 MEET DAX AT THE BAR

Speak to Dax at the bar about finding materials needed to build the Dawn Shield. First, she wants your help with solving the mystery of people vanishing in the Emerald Abyss. Launch the expedition.

2 SPEAK TO DAX

A short flight takes you to your meeting spot in far northwestern Academy Ruins, just inside Fortress of Dawn. From there, fly northeast to a camp next to the border with Monument Watch.

3 LOCATE THE CAMP AND RESTORE POWER

Move onto the platform to the north and activate the generator. Next, head back south and interact with the archive. Faye needs time to interpret it, so defend the area from a Skorpion invasion.

4 FIND AND RECOVER THE CYPHER LINK

Follow the archive's signal into the Sovereign Mine to the north in the eastern Ruins of Shadowmark. Not too far into the cave, you find a group of Outlaws fighting an Ursix. Defeat the Ursix and then clear out any remaining Outlaws. With the area clear of enemies, the northwest cave opens up; head that way.

DEFEAT THE URSIX

Follow the objective markers deep into the mine to the final cavern to find a pair of Ursix. Try to keep both beasts in view as you fight them. Escape to the other side of the room when hurt. These enemies drop ammo and/or Armor Packs when you deplete each health bar segment, so keep look for

these items. Use your Ultimate Ability early, if possible; otherwise, you may want to save it for the next fight. After defeating the pair, an Ancient Ursix appears.

DEFEAT THE ANCIENT URSIX

This Ursix is tougher to take down than a regular Ursix, but at least there's only one this time. Evade its powerful attacks, continue to whittle down its health, and use your Ultimate whenever possible. Once it falls in defeat, collect the dropped Link.

DEAR DIARY

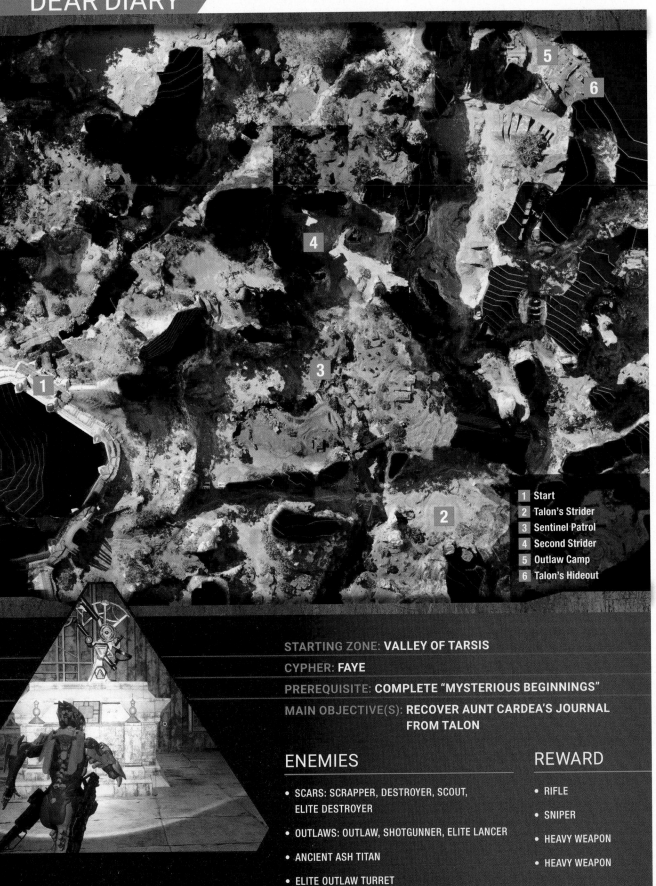

1. Start
2. Talon's Strider
3. Sentinel Patrol
4. Second Strider
5. Outlaw Camp
6. Talon's Hideout

STARTING ZONE: **VALLEY OF TARSIS**

CYPHER: **FAYE**

PREREQUISITE: **COMPLETE "MYSTERIOUS BEGINNINGS"**

MAIN OBJECTIVE(S): **RECOVER AUNT CARDEA'S JOURNAL FROM TALON**

ENEMIES

- SCARS: SCRAPPER, DESTROYER, SCOUT, ELITE DESTROYER

- OUTLAWS: OUTLAW, SHOTGUNNER, ELITE LANCER

- ANCIENT ASH TITAN

- ELITE OUTLAW TURRET

REWARD

- RIFLE

- SNIPER

- HEAVY WEAPON

- HEAVY WEAPON

1 SPEAK TO DAX AND LAUNCH EXPEDITION

This mission begins as soon as you return from "Mysterious Beginnings." Find Dax's apartment on the southwest side of Fort Tarsis. Head upstairs and speak to her to learn about the stolen journal. Launch the expedition.

2 AMBUSH TALON'S STRIDER

Fly from Fort Tarsis east into Valley of Tarsis and find the strider in Palisades of Idris. Scars and Outlaws battle around the broken-down strider. Defeat both groups, then search the cargo bay to find a map.

STRIDERS

Striders are the bloodstream of Bastion. They're used to transport people, resources, and vital supplies for short distances or during lengthy expeditions into the wilderness. A strider can house an amplifier and up to four javelins at a time. Their massive size means striders can safely navigate most common dangers, but are vulnerable to certain chimera and coordinated attacks. Most striders can withstand being on the edge of a Cataclysm, but will not maintain structural integrity within.

3 BRING THE MAP TO DAX

Find Dax northwest at the Sentinel base in northern Valley of Tarsis. Speak to her to learn about a second part of the map.

4 FIND THE OVERLAY

Head directly north into Great Falls Canyon to find another strider. A towering Ancient Ash Titan roams the area, so approach cautiously. You can stand on top of the strider to avoid its fire rings, but it can be tough to get a good shot at it. The strider must be repaired in order for you to search inside. You can complete the following steps while fending off the Titan, or kill it first. Either way, the Titan must go down.

4 RESET THE STRIDER'S POWER AND RELEASE THE SAFETY LOCK

Pick up the battery on the ground to the west and place it into the hole atop the strider. Drop off the east side to a side platform, destroy the panel cover, and interact with the panel to reset the strider's power. Lastly, jump over to a platform on the opposite side of the strider and perform the

same steps on a second panel to release the safety lock.

With power restored to the safety lock and the Titan out of the way, interact with the keypad on the east side of the cargo bay door. Step inside and retrieve the overlay.

5 TRAVEL TO TALON'S CAMP

Follow the markers northeast through East Gate and land on the Mining Platform. Assist Dax in a fight against a group of Outlaws, including five Elite Outlaw Turrets. Start with the turret on the left platform, followed by another on the central platform. With these out of the way, you can

safely flee to the left platform and spend some time fighting from this vantage point.

With the turrets destroyed, approach the door on the east side of the camp and enter Talon's Hideout.

VANISHING ACT

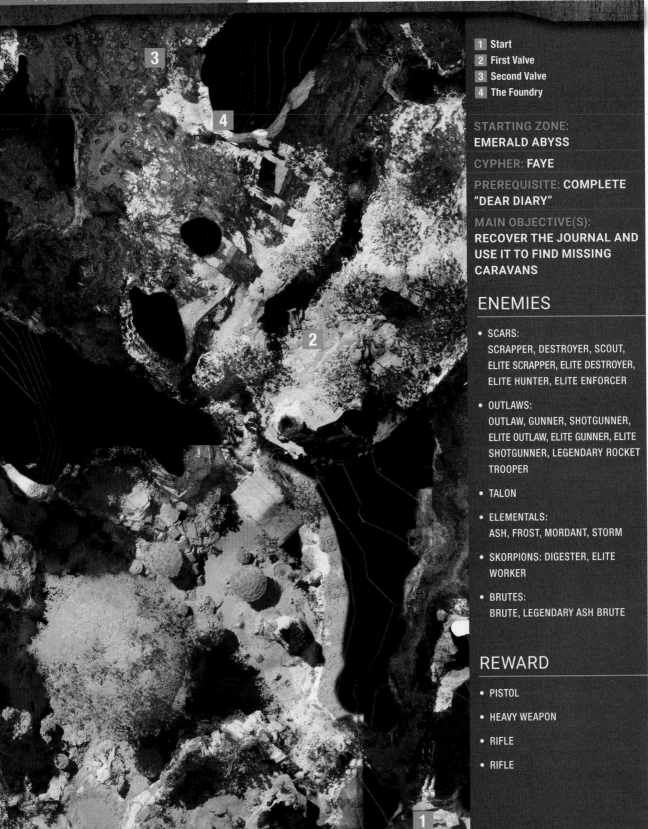

1 Start
2 First Valve
3 Second Valve
4 The Foundry

STARTING ZONE:
EMERALD ABYSS

CYPHER: **FAYE**

PREREQUISITE: **COMPLETE "DEAR DIARY"**

MAIN OBJECTIVE(S):
RECOVER THE JOURNAL AND USE IT TO FIND MISSING CARAVANS

ENEMIES

- SCARS:
 SCRAPPER, DESTROYER, SCOUT, ELITE SCRAPPER, ELITE DESTROYER, ELITE HUNTER, ELITE ENFORCER

- OUTLAWS:
 OUTLAW, GUNNER, SHOTGUNNER, ELITE OUTLAW, ELITE GUNNER, ELITE SHOTGUNNER, LEGENDARY ROCKET TROOPER

- TALON

- ELEMENTALS:
 ASH, FROST, MORDANT, STORM

- SKORPIONS: DIGESTER, ELITE WORKER

- BRUTES:
 BRUTE, LEGENDARY ASH BRUTE

REWARD

- PISTOL

- HEAVY WEAPON

- RIFLE

- RIFLE

1 RECOVER THE JOURNAL AND LAUNCH EXPEDITION

Speak to Commander Vule in the far southwest corner of Fort Tarsis, at the top of the steps. Next, take the journal to Dax and Faye just inside the bar. Launch the expedition and travel north into Emerald Abyss.

2 ACTIVATE THE FIRST VALVE

Land on top of the valve. On the ground below, a Shaper relic has gone volatile and must be silenced first. Drop to the southwest and collect the four fragments, one at a time. Deliver each one to the relic, while dealing with Scars in the area. Once all fragments are in place, grab

the echo that's left behind and take it to the top of the valve. Activate the device that appears.

3 ACTIVATE THE SECOND VALVE

Travel to the next objective marker in Mentor's Trail, Emerald Abyss to find another volatile relic...and more Scars. This time you must deliver five fragments to the Shaper relic, while avoiding or fighting a tougher group of Scars. This includes a pair of Elite Scar Enforcers. After silencing the relic, grab the echo and deliver it to the nearby valve. Activate the device.

4 SEARCH FOR THE ENERGY SOURCE INSIDE THE FOUNDRY

Fly southeast and enter the Foundry. Follow the path until you reach the main cavern, where Talon awaits. He's shielded and cannot be harmed at the moment, so don't waste your ammunition. Objective markers lead to three explosives on the outer platforms. Three Outlaws spawn near each explosive, with many more entering the arena during the fight.

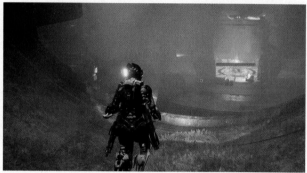

PLANT EXPLOSIVES AND ARM THEM

Immediately fly left or right and grab one of the explosives. Fight through the Outlaws as you carry it toward the center. Three locations within the inner circle are marked.

Place an explosive at each point, but be careful because you're vulnerable during this time. It's best to use equipment as cover while planting the device.

AVOID THE LOWER LEVEL

During this objective, don't drop to the lower area inside the large cavern. Your javelin will become electrocuted and sustain damage as long as you remain down there. Quickly double-jump onto the outer edge to escape.

Once the three explosives are placed, Faye begins to prime the explosives. This takes time, indicated by the Arming Explosives meter in the upper-right corner of the HUD. Remain within the highlighted area as much as possible while keeping the Outlaws out. Stay far from Talon or use equipment as protection against him, but watch out for his elemental attacks.

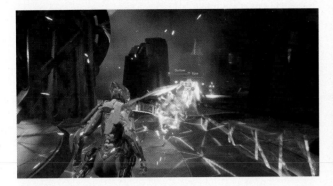

DEFEAT TALON

With the explosives armed, a three-second timer counts down to zero dropping Talon's shield and destabilizing the Foundry. Energy Grounders appear around the arena, keeping your flight in check, while Outlaws continue the bombardment.

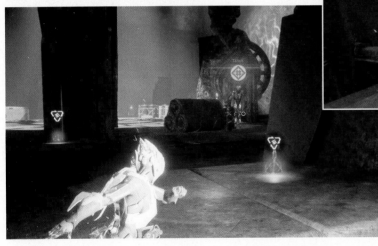

Focus your big attacks against Talon, knocking him out of the air. Once he's on the floor, finish him off.

ACTIVATE THE DEVICE

Exit via the south side and follow the corridors, avoiding more energy Grounders along the way. Follow the objective markers until you reach the final chamber. Use the radar to find an unresponsive console on the central platform. It's connected to disks along the sides of the chamber. Energy Grounders fluctuate in and out of the room, so steer clear if you wish to fly. These can be shrunk down to nothing, although it's not necessary.

Four devices are marked on your HUD. Stand next to one and look at the rotating disks on the wall. Note the highlighted symbol on the innermost disk. You want to create a line of four identical symbols outward from the central symbol. Spot the next outward symbol that matches the highlighted one. Just before they line up, hold the Activate button to align them. Since every other disk rotates the opposite direction, this spins the aligned symbols the other way. If you miss a button press, the puzzle resets and you must align all four again. Align the four symbols to complete this portion of the puzzle. Complete all four to activate the central device.

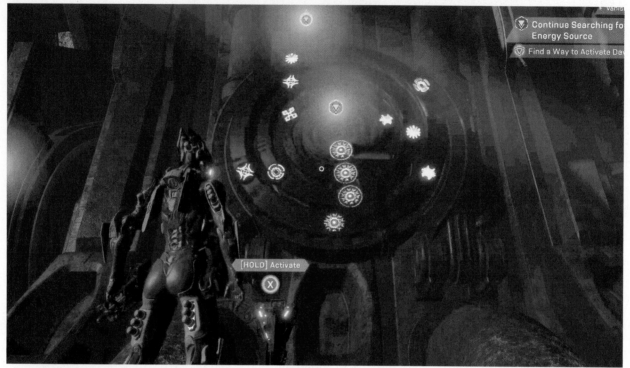

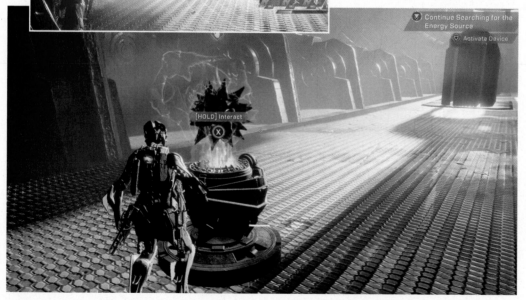

Enemies spawn into the chamber as you complete the puzzle. First is a group of elementals, followed by Skorpions, and finally a pack of Brutes—including a Legendary Ash Brute.

Interact with the device to return to Fort Tarsis. Visit Dax and Cardea at Dax's apartment to complete the mission and earn the "Dax: Emerald Abyss" Challenge. After you complete "Vanishing Act" or "Convergence" find Faye in the Freelancers Enclave and speak to her.

TRIPLE THREAT

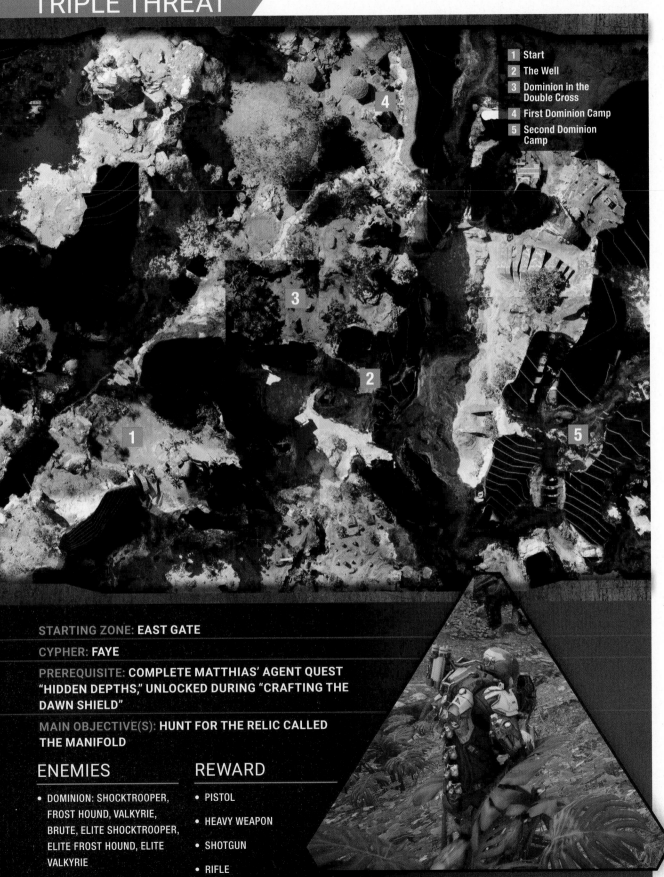

1. Start
2. The Well
3. Dominion in the Double Cross
4. First Dominion Camp
5. Second Dominion Camp

STARTING ZONE: EAST GATE

CYPHER: FAYE

PREREQUISITE: COMPLETE MATTHIAS' AGENT QUEST "HIDDEN DEPTHS," UNLOCKED DURING "CRAFTING THE DAWN SHIELD"

MAIN OBJECTIVE(S): HUNT FOR THE RELIC CALLED THE MANIFOLD

ENEMIES

- DOMINION: SHOCKTROOPER, FROST HOUND, VALKYRIE, BRUTE, ELITE SHOCKTROOPER, ELITE FROST HOUND, ELITE VALKYRIE

- GAUSS TURRET

REWARD

- PISTOL

- HEAVY WEAPON

- SHOTGUN

- RIFLE

1 SPEAK WITH MATTHIAS AND LAUNCH THE EXPEDITION

After completing Matthias' Agent Quest "Hidden Depths," speak with him again to learn about the Manifold. Launch the expedition.

2 EXPLORE THE SHAPER RUIN

The strider drops you off at the Bowl in Great Falls Canyon. Go east into East Gate and enter the Well. At the end of the corridor, you find the door locked. Return about halfway through the corridor and investigate the corpse.

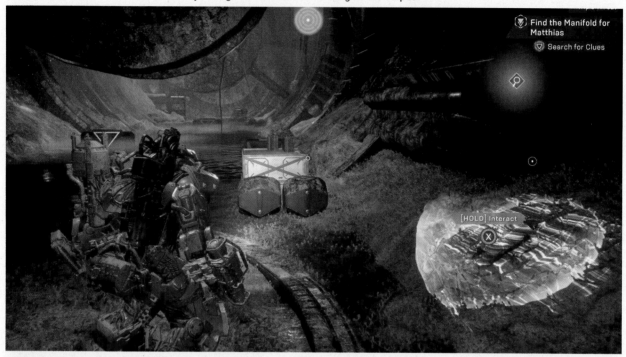

SHAPER RUINS

Massive, ancient Shaper constructs are scattered throughout our world. Ruins are classified differently from relics. Not only are ruins often an enormous size, but some do not appear to be capable of accessing the Anthem of Creation. Possibly, those ruins were used strictly for structural purposes. Determining a ruin's original or intended purpose is a matter of educated guesswork rather than proof.

3 LOCATE DOMINION AND FIND INTEL

Dominion camps may have the key to using the lock-breaker, but first you must locate the Dominion. Fly west, then north into the Double Cross to find a group of Dominion. Eliminate the foes in the area, including a Dominion Ash Valkyrie, then use the compass radar to find Dominion Intel. This recording sends you to a Dominion camp in eastern Eddian Grove.

4 RECOVER SIGNET AT FIRST DOMINION CAMP

At the Dominion camp, focus on the three Gauss Turrets first, then wipe out any remaining Dominion. A gate spawns more enemies, including a Frost Valkyrie, so remain alert. Once the area is clear, the compass radar leads you to the first signet. Interact with the item and wait for the scan to complete.

5 RECOVER SIGNET AT SECOND DOMINION CAMP

Travel southeast to the second Dominion camp in East Gate. A large group of Dominion, including Elite Valkyries and Brutes, must be dealt with first. Use the terrain as cover while eliminating the Dominion threat. Afterward, follow the compass to find the second signet. Remain in the area until the decryption is complete.

2 RETURN TO THE MANIFOLD CHAMBER

Return to the Well and activate the Dominion device next to the locked gate. Enter the chamber and defeat the Dominion trio of Valkyries. Use the machinery to isolate each one and take them down.

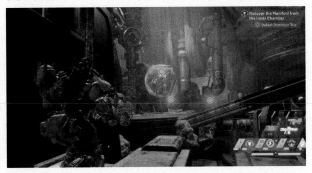

DEACTIVATE THE BARRIER AND RECOVER THE MANIFOLD

Find three panels around the perimeter of the room. The symbols displayed on these panels are partially hidden behind a moving black liquid, but can be modified by interacting with them. You must find a static glyph hidden within the chamber for each one, then change them to match.

Northeast: This symbol is on the machinery just west of the panel.

Southeast: Look underneath the bridge that leads to this panel to find the correct symbol.

Southwest: From this panel, look up to the left to spot the glyph on the wall.

With the correct symbols displayed on the three panels, the barrier around the Manifold is removed. Interact with the item to complete the mission. Deliver the item to Matthias once you return to Fort Tarsis.

INVERSE FUNCTIONS

1 Start
2 The Well
3 Arcanist Camp
4 Scar Hideout
5 Escari

STARTING ZONE:
EAST GATE

CYPHER: FAYE

PREREQUISITE:
COMPLETE "TRIPLE THREAT"

MAIN OBJECTIVE(S):
INVESTIGATE THE RELIC'S EFFECTS ON MATTHIAS

ENEMIES

- SKORPIONS:
 DIGESTER, SOLDIER,
 WORKER, ELITE WORKER

- SCARS:
 SCRAPPER, DESTROYER,
 SCOUT, HUNTER, ENFORCER,
 ELITE DESTROYER, ELITE
 ENFORCER, LUMINARY

REWARD

- PISTOL
- HEAVY WEAPON
- SNIPER
- RIFLE

1 LAUNCH THE EXPEDITION

After you deliver the Manifold to Matthias, he sends you back to the Well to investigate further. Launch the expedition.

2 ELIMINATE THE SKORPIONS FROM THE INNER CHAMBER

Enter the Well and proceed into the inner chamber. Skorpions have overtaken the ruin since your last visit. Destroy as many eggs as possbile to limit the number of Skorpions in the room. Elite Workers join the fight; quickly dispose of them, or evade their suicide attacks.

3 COLLECT SAMPLES OF DOMINION REMAINS AND DELIVER TO ARCANIST CAMP

Next, collect samples of the Dominion remains at all three locations. Exit the ruin and travel to the Arcanist camp in the Blackshore district. A group of Scars has invaded the camp, so clear them out first. Repair any downed Sentinels as you fight the foes.

4 TRAVEL TO THE SCAR HIDEOUT AND FREE ARUNA

Travel west to the Tower Road hideout and eliminate more Scars, including the hive and several Elites. Once they're defeated, free the Arcanists from the four cages.

ESCARI

A sentient manifestation of a Scar swarm. Once a swarm reaches a critical mass through consumption, it can spawn an Escari, an advanced Scar capable of speech and intelligent thought. Compared to regular Scars, Escari are individuals with unique thoughts and ambitions that are theorized to lead to Scar power struggles. These disputes make Escari eager to augment and improve themselves as they see fit.

5 FIND AND DESTROY THE ESCARI

Return to Blackshore to find the kidnapper Escari, called Luminary, along with a group of Scars. Save your big Gear attacks and Ultimate Abilities for the boss, while thinning out the weaker Scars with melee and weapon strikes. Use the large rock formation as cover. Follow the trail around the structure, keeping it between you and the Escari. Its powerful weaponry drains your health in a hurry if you remain in the open for too long. Collect Repair Packs and ammunition from defeated Scars. Eventually, the Escari collapses in defeat.

Find Aruna in the southwestern portion of Fort Tarsis and speak with her. This leads directly into the next mission, "Convergence."

CONVERGENCE

1 Start
2 Scar Ambush
3 The Necropolis

STARTING ZONE: **EAST GATE**

CYPHER: **FAYE**

PREREQUISITE: **COMPLETE "INVERSE FUNCTIONS"**

MAIN OBJECTIVE(S) **TRACK DOWN SUMNER AND THE MANIFOLD**

ENEMIES

- SCARS: SCRAPPER, DESTROYER, SCOUT, HUNTER, ENFORCER, ELITE SCRAPPER, ELITE DESTROYER, ELITE SCOUT

- ELEMENTALS: ASH, ELITE ASH, ELITE FROST, ELITE STORM

- LESSER ASH TITAN

REWARD

- PISTOL

- HEAVY WEAPON

- SHOTGUN

- SNIPER

1 SEARCH FOR SUMNER AND LAUNCH EXPEDITION

After speaking to Aruna, report your findings to Matti at Matthias' office. Head to the bar and speak to Aruna, then head to the Forge. Launch the expedition.

2 TRAVEL TO LOVER'S SPRING AND ELIMINATE SCARS

Track Sumner into Lover's Spring just inside East Gate. A pack of Scars spawns from a nearby hive, and then Elite Scars enter through a couple of gates. Also, keep an eye out for mines that litter the environment. Once all of the Scars are eliminated, inspect the crashed javelin on the western ledge.

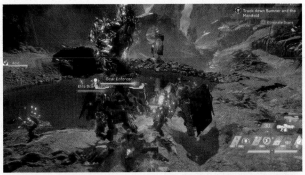

MATTHIAS' FIELDWORK

I've done a lot of fieldwork. You must if you want to see the world up close. The truth won't fall into your lap. Sometimes you need sturdy boots and a sharp knife to find it. It's not easy or safe to tell the truth, but you can't have it both ways. If you're searching for something, you can't stay in one place. So when I say there are things out there that scare me, things we don't understand, that should scare you too. I mean it.

—Arcanist Matthias Sumner

3 ENTER THE NECROPOLIS

Fly north, follow the objective marker into the hole, and fight through a pack of Elite Elementals on your way into the Necropolis. Just inside the cave, elemental Grounders electrocute anything that flies by, as a group of Ash Elementals hinders progress on foot. Take these fiery foes down from a safe distance to avoid damage from their explosions.

DEFEAT THE HOSTILE CREATURES

Another group of Elite Elementals occupies the next chamber—hitting you with Electrocute, Freeze, and Burning attacks. Manage the status effects and clear the hostiles out as you work your way back to a lone Lesser Ash Titan. Once the beast is defeated, exit via the south side and follow the corridor into the next cavern.

REACH SUMNER

Ash Elementals and Grounders unleash Burning and Electrocute attacks, with Brutes spawning in after you eliminate the former. It's not necessary to stick around for the fight, though the more health remaining when you exit the room, the better. Follow the trail into the final chamber, where Sumner toils away with the Manifold.

DEFEND SUMNER FROM TITANS

Three Lesser Ash Titans spawn into the chamber. With plenty of space and walls in between the enemies, you may be able to fight them one at a time. Clear out of an area if two Titans end up in close proximity. You may see attacks incoming from all three, so keep tabs on all of the Titans. Listen for audible cues that let you know when fireballs and rings are incoming. Also, use the short walls and varying levels of the room to avoid them.

The best vantage point for this fight is located at the cavern entrance. It's possible to fight all three enemies from the top of the waterfall, and there's space to move behind cover and avoid incoming attacks. Remember to use your Ultimate Ability whenever available, and collect the Repair Packs and ammo that drop as you remove sections of each Titan's health bar. Continue to evade the fire attacks and whittle away at the beasts' health until all three Titans have fallen.

Back at the fort, return to Matthias' lab and check on the condition of the trio.

FREELANCER DOWN

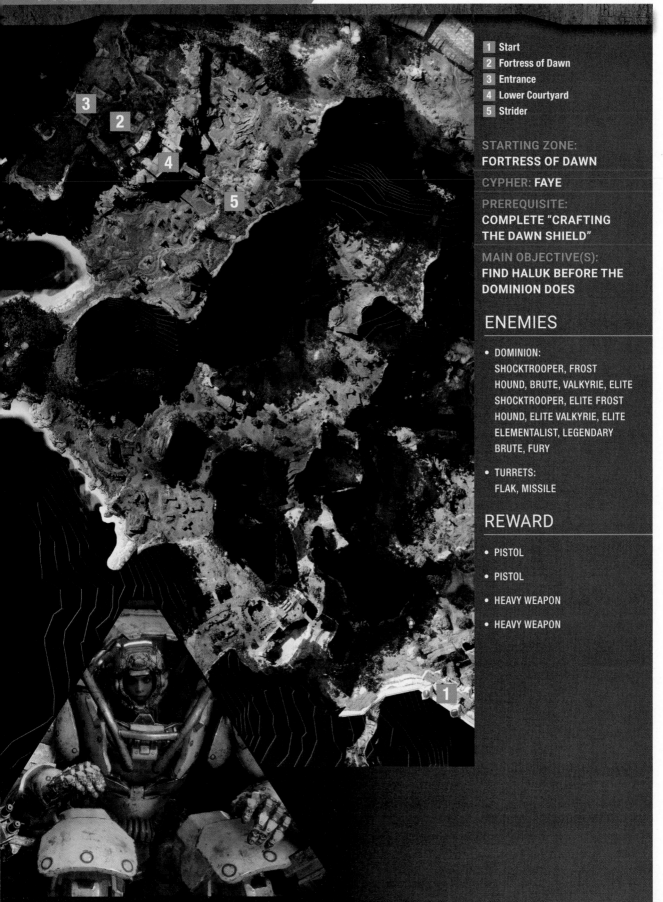

1 Start
2 Fortress of Dawn
3 Entrance
4 Lower Courtyard
5 Strider

STARTING ZONE:
FORTRESS OF DAWN

CYPHER: FAYE

PREREQUISITE:
COMPLETE "CRAFTING
THE DAWN SHIELD"

MAIN OBJECTIVE(S):
FIND HALUK BEFORE THE
DOMINION DOES

ENEMIES

- DOMINION:
 SHOCKTROOPER, FROST
 HOUND, BRUTE, VALKYRIE, ELITE
 SHOCKTROOPER, ELITE FROST
 HOUND, ELITE VALKYRIE, ELITE
 ELEMENTALIST, LEGENDARY
 BRUTE, FURY

- TURRETS:
 FLAK, MISSILE

REWARD

- PISTOL

- PISTOL

- HEAVY WEAPON

- HEAVY WEAPON

1 SEARCH FOR HALUK AND LAUNCH EXPEDITION

After crafting the Dawn Shield, speak to Faye and Haluk at the Forge. Head to the Freelancers Enclave and speak to Lucky Jak. Next, speak to Commander Vule at the top of the steps on the west side of the fort. Launch the expedition.

2 TRAVEL TO THE FORTRESS OF DAWN AND DEFEAT THE DOMINION TROOPS

Fly north into the Fortress of Dawn region and cross Legionnaire's Ravine to return to the fort, last visited during "Fortress of Dawn." A group of Dominion are stationed just outside the entrance and greet you upon your arrival. Brutes and an Elite Valkyrie should be your main focus, but it's equally important to fend off Elite Shocktroopers.

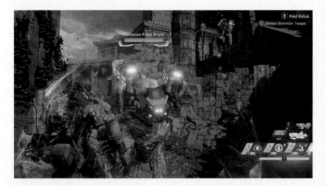

3 FIND HALUK

After defeating the Dominion troops, enter the fortress to find Haluk.

DEFEAT DOMINION TROOPS

A Dominion Fury appears between you and the exit, and it must be eliminated in order for you to get out. It's accompanied by Shocktroopers that occasionally drop Repair Packs and ammo when defeated. The Fury has a shield that must be removed before damage can be inflicted, and it has the ability to recharge the shield in an instant—hiding inside a defensive shell. The shield returns to full level, and if left unchecked, its health also regenerates—while in this shell state.

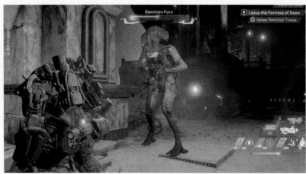

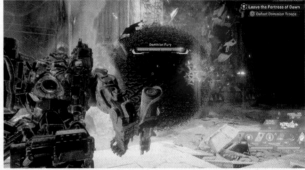

FURIES

The Dominion engage in numerous biological experiments inspired by their belief that they are meant to harness the Anthem of Creation's power. Furies are among the most visible and destructive results. Dominion defectors whisper about a factory where chosen prisoners were taken to "serve the cause" before they were exposed to the Anthem of Creation through Shaper relics.

Short bursts of gunfire are ineffective against the Fury, since you must remove its shield first. Keep pressure on the foe as long as possible in order to deplete its health. When inside its shell, it can still be damaged, so aim for its weak spot (noted by the lighter color). In its shell, it can still cause damage to nearby targets, so don't let your guard down.

Continue to eat away at the Fury's health until it finally goes down. Then exit the fortress to find Haluk and more Dominion troops. The Dominion have set up a suppressor in the area, so flight is impossible until the device is destroyed.

The courtyard is once again full of Dominion troops—including Elite Frost Hounds, Brutes, and an Elite Valkyrie. Destroy the Flak Turrets first, located on the north and south sides of the courtyard. When a Legendary Dominion Frost Brute shows up, turn your attention its way. After defeating that group, continue downhill toward the lower courtyard.

Defeat more Dominion troops in the lower courtyard. Once the Ash Valkyries are history, an objective zone appears around a generator in the center of the courtyard. Remain in in this zone and defend against more Dominion while disabling the generator. Keep enemies out of the highlighted area to speed up your progress.

Once the generator is disabled, continue to eliminate any remaining Dominion troops—including an Elite Elementalist. After you defeat the last of the enemies, flight is restored.

Cross the Legionnaire's Ravine to find the Strider. Dominion troops in the area, including three Missile Turrets, must be eliminated first. Use the varying levels of terrain and ruins to escape trouble and take on the enemy. Go after the turrets first, then defend the strider against the Dominion onslaught. Watch for a Fury to join the fight, too. Stay on the move to avoid being overwhelmed, and continue launching your strongest attacks against the beast. Defeat the remaining Dominion to complete the mission.

FREELANCER DOWN
By completing this mission, you earn the Freelancer Down Achievement/Trophy.

REPAIRS AND INSPIRATION

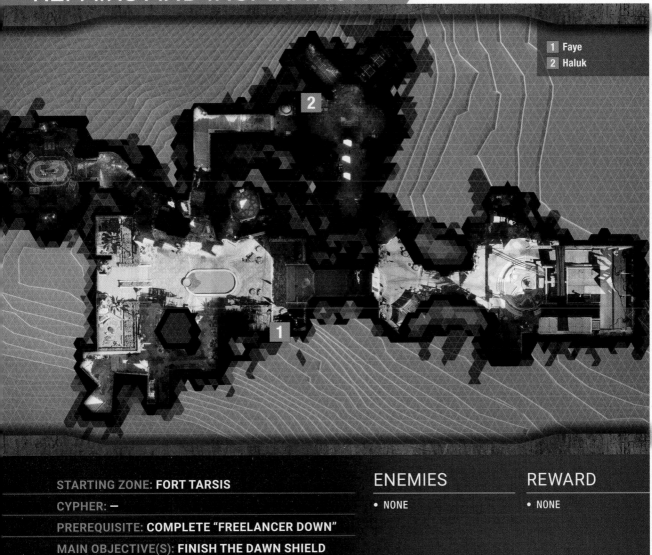

1 Faye
2 Haluk

STARTING ZONE: **FORT TARSIS**

CYPHER: —

PREREQUISITE: **COMPLETE "FREELANCER DOWN"**

MAIN OBJECTIVE(S): **FINISH THE DAWN SHIELD**

ENEMIES
- NONE

REWARD
- NONE

1 GIVE THE SEAL FRAGMENT TO FAYE

Find Faye sitting on the wall on the southwest side of the fort and speak to her.

2 FINISH THE DAWN SHIELD

Next, talk to Haluk in the Freelancers Enclave. This leads directly into the final critical objective, "Return to the Heart of Rage."

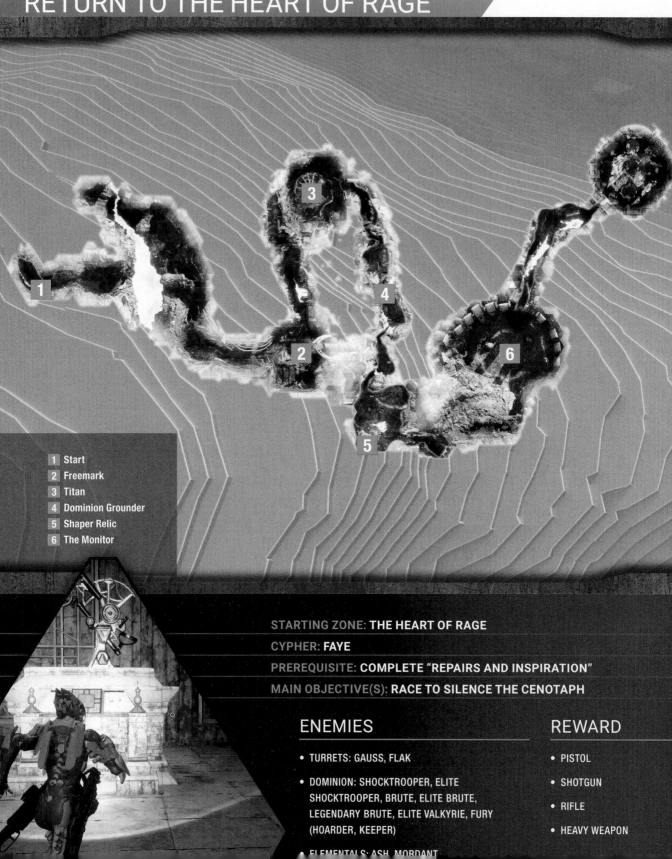

1 Start
2 Freemark
3 Titan
4 Dominion Grounder
5 Shaper Relic
6 The Monitor

STARTING ZONE: **THE HEART OF RAGE**

CYPHER: **FAYE**

PREREQUISITE: **COMPLETE "REPAIRS AND INSPIRATION"**

MAIN OBJECTIVE(S): **RACE TO SILENCE THE CENOTAPH**

ENEMIES

- TURRETS: GAUSS, FLAK

- DOMINION: SHOCKTROOPER, ELITE
 SHOCKTROOPER, BRUTE, ELITE BRUTE,
 LEGENDARY BRUTE, ELITE VALKYRIE, FURY
 (HOARDER, KEEPER)

- ELEMENTALS: ASH, MORDANT

REWARD

- PISTOL

- SHOTGUN

- RIFLE

- HEAVY WEAPON

1 PREPARE TO RETURN TO THE HEART OF RAGE

Complete any expedition, including freeplay, while the shield is completed. Return to the Forge and speak to Haluk. Launch the expedition to travel directly to the Heart of Rage. This area should look familiar—it was in the tutorial.

CENOTAPH

This large Shaper ruin destroyed the city of Freemark and produced the Heart of Rage Cataclysm when the Dominion attempted to seize control of it. Most of Freemark's population was unaware of the Cenotaph's existence until it was too late. How the Dominion knew that the Cenotaph existed remains a mystery, but there's little doubt they arrived at Freemark specifically to activate the ruin.

2 ENTER FREEMARK

Follow the objective markers east, across the lava ravine, and move up the incline on the right. A pair of Gauss Turrets greet you, along with a large group of Dominion just beyond. Destroy the turrets from a distance if possible, then move up the hill to take on the Dominion troops. A Flak Turret fires from the far side of the area, so deal with it as soon as possible. A Legendary Brute and Elite Valkyrie highlight the selection of Dominion in the area. Be ready to bust out of a frozen state if hit with their ice, and utilize the rocks and metal that extend from the ground as cover.

3 DEFEAT THE TITAN

Once the Dominion are defeated, head north and navigate across the ledges to reach the far side. A lone turret and small group of Dominion slow your progress, but shouldn't be too much trouble at this point. Stay on the path until you find an Ancient Ash Titan.

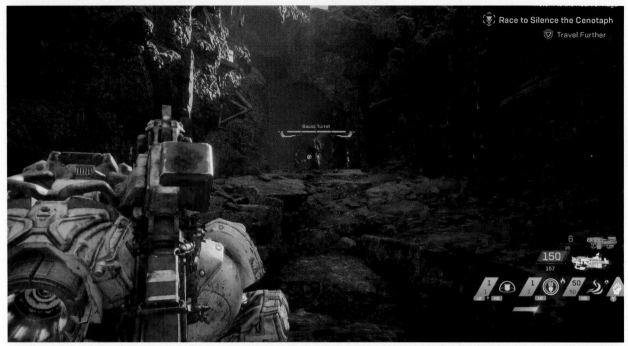

Remember to attack its weak spots as it powers up for attacks. There isn't a whole lot of space to flee from the Titan's attacks, but the ruins allow you to take cover from its fireballs and beam. Its fire rings come in sets of four, but their heights vary randomly between ground level and just over your javelin's head. Be ready to quickly take flight or time your jumps. With persistence, the mighty Titan falls.

Exit east and follow the path until you reach more Dominion troops. Dispose of yet another Gauss Turret first, then go after the Shocktroopers and Brutes.

4 DISABLE THE DOMINION GROUNDER

In the next area, a Dominion grounder restricts flight in the area. Defend the objective zone until the grounder is disabled. Enemies enter from the south, including a Legendary Brute, so remain focused in that direction. Keep enemies out of the zone for quicker progress, and use the ground as cover to avoid the Brute's elemental attacks. Once the process is complete, flight becomes available again; fly up to the southern ledge and continue your exploration.

5 SILENCE THE RELIC

At the next clearing, a volatile Shaper relic prevents you from reaching the Cenotaph. Ten echoes float high above, and they must be delivered to the relic in order to proceed. A large group of Dominion troops guards the area, with more spawning in as you work on the objective. This includes powerful Brutes and pesky Valkyries. Whenever possible, avoid their elemental

attacks and focus heavy attacks on them. It's possbile to defeat Shocktroopers in between to score Repair Packs and ammunition.

This is a challenging objective, especially when playing solo. You can choose to quickly collect the echoes while fending off the Dominion, or thin out the opposition from the entrance while grabbing echoes in between kills. Either way, you must silence the relic and defeat any remaining Dominion.

KILL THE DOMINION FURIES

With the relic silenced and the Dominion troops defeated, the gate still doesn't open. Instead, two Dominion Furies (Hoarder and Keeper) spawn into the area. Focus on one Fury at a time to get through its shield. Flee to the entry point if health gets dangerously low. These guys drop keys when defeated, thereby opening the exit. Follow the path until you reach a weakened stone wall; bust through to find the Cenotaph and the Monitor.

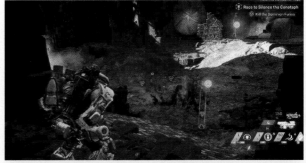

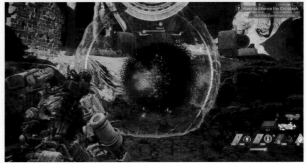

6 DEFEAT THE MONITOR

The Monitor fight has 3 phases based on the elements fire, acid, and electric. In each stage he is fully immune to the element he is controlling and resistant to physical and ice attacks. So using fire or acid in the electric phase, fire or electric in the acid phase, or electric and acid in the fire phase will ensure maximum damage.

The Monitor has 3 weak points, one on the back of its neck and two on each side of its torso. When one of these weak points sustains enough damage, it bursts and no longer serves as a weak spot. Destroy all 3 weak points to cause massive damage. At this point, he teleports to the arena center, and the weak points reappear.

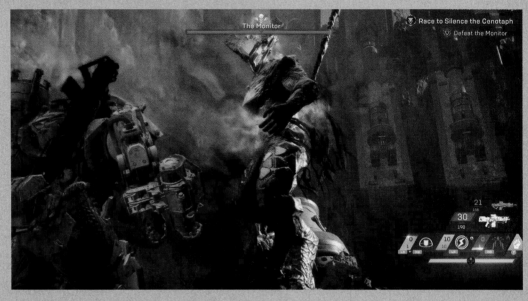

PHASE 1: FIRE

The first phase takes place in a circular arena with a pair of pistons jutting out of the ground.

The Monitor wields a massive sword that hits extremely hard. Fortunately, his movements are slow and telegraphed, just don't lose track of him. His melee attacks include a devastating overhead slam, a horizontal sweep, and a powerful close-range slam. All of these, if left unchecked, can knock off a sizable chunk of armor. He also has a leap attack that deals massive damage to one player.

Watch for the boss to lift his left hand high into the air. This signals an incoming fire strike that causes damage on impact and adds the Burning effect.

Balls of fire occasionally drop into the arena, one in the center and the rest around the perimeter. They all detonate at the same time, after approximately 12 seconds. Quickly shoot as many as you can, focusing on the nearest first. The closer you are to one of these explosions, the more initial damage caused. You are also hit with Burning, which continues damage over time.

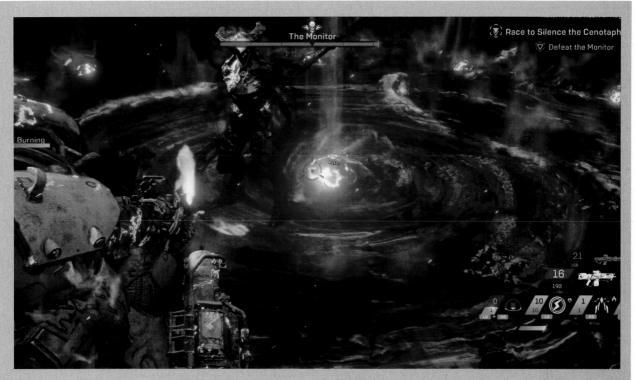

Aim for the Monitor's glowing midsection or the top of his head for the most damage. The two pistons offer the best vantage points. Fly between the two locations as the boss closes in. Reduce his health to around 75% and the boss teleports away; follow him north into the second arena.

PHASE 2: ACID

While the first phase was all about fire, phase 2 introduces acidic attacks. The Monitor remains within the acidic areas, while you should stick to the five platforms as much as possible. Stay alert, as his attacks come quicker in this area, and he now has the ability to teleport around the arena.

When he thrusts his left hand toward his target, a flurry of green balls are launched straight ahead—inflicting Acid when contact is made. With a direct hit, this has the ability to cause lethal damage. When you see this coming, move to another platform to avoid the attack.

If the Monitor lifts his left hand into the air, quickly flee the area. A ball of acid appears at your location. This causes damage and inflicts Acid, if you remain.

When the boss punches the ground, explosions randomly detonate all around the arena. This causes damage if caught nearby.

Stay on the move, while hitting the boss with your most powerful attacks. With around 1/2 health left, the Monitor spawns a group of mordant elementals. Get in a few more hits before the boss flees to the third area. Avoid the elementals as much as possible, and take them down to produce valuable pickups. Watch out for the acidic clouds they leave behind. Then, follow the boss back into the first arena.

PHASE 3: ELECTRIC

The Monitor's moves become more frenetic and aggressive in the electric phase. The Monitor has his usual melee attacks, but also possesses some new ones.

A projectile attack quickly fires three seeking missiles at every player. Be ready to evade these projectiles.

A new warp attack throws his weapon up in the air, which lands on a player for minor damage. Shortly after it lands though, the Monitor warps to that location and explodes for massive damage. If you are hit with this attack, clear out of the area to avoid the big one.

Watch out for the boss to pound the ground in front with his weapon, sending out waves of electricity along the ground. Jump, or fly away, to avoid the electrocution attacks.

As the Monitor weakens, four areas open up, which grants double damage for anyone inside. If there are four players and each is inside one of these areas, the damage increases to five times. Continue to attack the Monitor's weak points until he reaches about 1/4 health and finally falls in defeat.

CELEBRATE!

Back at Fort Tarsis, speak to your crew to complete the critical path.

RETURN TO THE HEART OF RAGE
By completing this mission, the Return to the Heart of Rage Achievement/Trophy is earned.

CHALLENGES OF THE LEGIONNAIRES

1 Bard
2 Launch Expedition

1

2

STARTING ZONE: —

CYPHER: —

PREREQUISITE: **COMPLETE THE CRITICAL OBJECTIVE "RETURN TO THE HEART OF RAGE"**

MAIN OBJECTIVE(S): **LEARN THE TALE OF GENERAL TARSIS COMPLETE THE CHALLENGES OF THE LEGIONNAIRES**

REWARD

- VARIOUS

1 LEARN THE TALE OF GENERAL TARSIS

Talk to the Bard on the west side of Fort Tarsis to learn about the Path of the Legionnaires.

2 COMPLETE THE CHALLENGE OF VALOR

Completion of the critical path does not mean the game is over. There are countless hours of gameplay available for your pilot. Strongholds, World Events, Agent Quests, and Agent Contracts all present their own challenges. You are now on the Path of the Legionnaires.

A new Challenge of Valor begins, which can be viewed on the wall behind the Bard. Completing the Challenge of Valor unlocks the Challenge of Might, followed by the Challenge of Resolve.

CHALLENGE OF VALOR: **PROVE YOUR VALOR BY COMPLETING EVENTS IN FREEPLAY, STRONGHOLDS, AND CONTRACTS, AND BY REINFORCING OTHER FREELANCERS.**

EVENTS: **COMPLETE 100 WORLD EVENTS.**

STRONGHOLDS: **COMPLETE 25 STRONGHOLDS.**

CONTRACTS: **COMPLETE 25 CONTRACTS.**

REINFORCEMENTS: **REINFORCE FREELANCERS 25 TIMES.**

CHALLENGE OF MIGHT: **PROVE YOUR MIGHT BY DEFEATING ENEMIES FROM DOMINION, SCAR, AND OUTLAW FACTIONS; DEFEAT ELITE AND LEGENDARY ENEMIES.**

DOMINION: **DEFEAT 2500 DOMINION ENEMIES**

SCAR: **DEFEAT 2500 SCAR ENEMIES.**

OUTLAW: **DEFEAT 2500 OUTLAW ENEMIES.**

ELITE: **DEFEAT 2500 ELITE ENEMIES.**

LEGENDARY: **DEFEAT 2500 LEGENDARY ENEMIES.**

CHALLENGE OF RESOLVE: **PROVE YOUR RESOLVE BY COMPLETING DAILY AND WEEKLY**

AGENT QUESTS

BRIN: PREVENTATIVE PRECAUTIONS

1 Start
2 Arcanist Base
3 Scar Camp
4 Scar Cave

STARTING ZONE:
ACADEMY RUINS

AGENT: BRIN

PREREQUISITE:
COMPLETE "INCURSION"

MAIN OBJECTIVE(S):
**LOCATE THE MISSING
ARCANIST MACHINERY**

ENEMIES

- SCARS: SCRAPPER,
 DESTROYER, SCOUT, ELITE
 SCOUT, HUNTER, ELITE
 HUNTER, ENFORCER

- SKORPIONS: DIGESTER,
 WORKER

REWARD

- FIRST TIME: ANY WEAPON X2,
 UNIQUE GEAR

- REPEAT: ANY WEAPON X2

1 LAUNCH EXPEDITION

After completing "Lending a Hand," speak to Brin at the top of the western steps to begin "Preventative Precautions."

2 INVESTIGATE SCAR PRESENCE AT AN ARCANIST BASE

Jump off the left side of the platforms and fly northwest to the Arcanist base in Academy Ruins. Approach cautiously, as a pack of Scars is ready to destroy any invaders. Scar Scrappers, Destroyers, and a Scout target you immediately. Eliminate the Scout first, or it continues to pelt you with sniper shots. When a Scar Hunter joins the fight, focus your attention that way.

3 SEARCH FOR MISSING ARCANIST MACHINERY AT THE SCAR CAMP

Your next destination is a nearby Scar camp to the north in the Garrison at Velathra. Once you arrive, a radar helps you find three salvage piles, while several Scar Scrappers hinder your progress. After you search all three salvage piles unsuccessfully, Brin suggests searching a Scar camp a short distance to the north.

4 LOCATE MISSING MACHINERY INSIDE THE SCAR CAVE

Head north and enter the Hollow. Keep an eye out for resource nodes and supply caches as you navigate through the cave. When you reach the big cavern, eliminate the Scar Scrappers, Destroyers, Scouts, and Elite Scar Hunter. Stay behind cover when possible, or the Hunter will tear through your health with its powerful weapon. Hit the Hunter with Gear attacks to bring it down.

SECURE THE SHAPER RELIC

Continue out the north side and follow the path into a second cavern to find the stolen Arcanist machinery hooked up to a Shaper relic. Fight off Scar Scrappers, Destroyers, and an Enforcer. The Enforcer should be your focus while fending off the weaker Scars. When a Scar Scout joins the fight, switch your focus its way.

After a period of time, the relic ejects three fragments and begins to produce Digesters and Workers. A search radar leads you to the fragments; collect each one and insert them into the relic to silence it. Skorpions and Scars continue to attack throughout this objective, so stay alert. Once the relic is silenced, you return to Fort Tarsis.

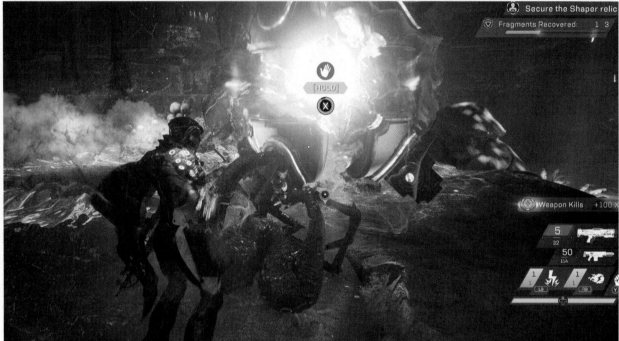

STAY CLEAR OF WORKERS

A Worker pursues you until it's within range, then detonates itself. Kill these guys from a distance, or be ready to evade the explosion.

Speak to Brin to complete the Agent Quest. Her first contract becomes available at this point. Access it on her bulletin board.

CAUTIOUS COOPERATION

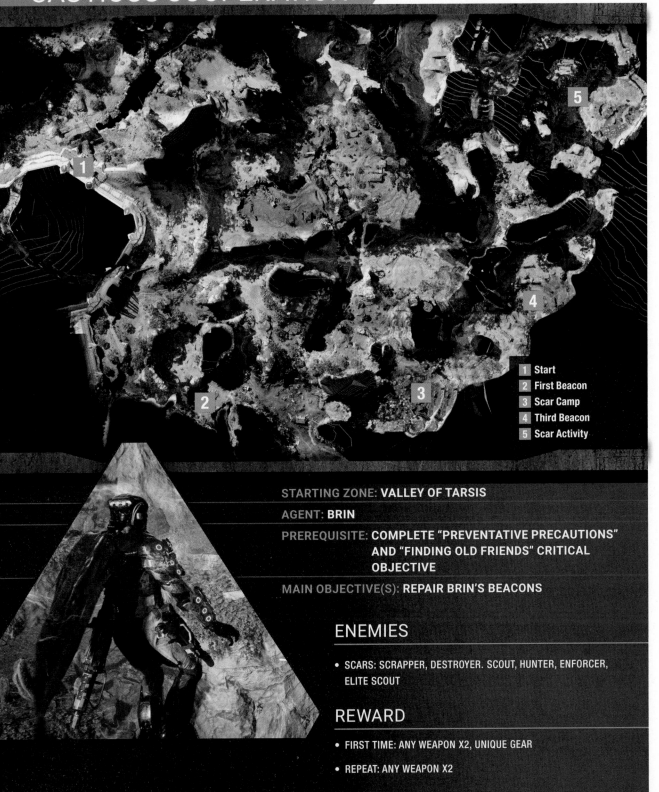

1 Start
2 First Beacon
3 Scar Camp
4 Third Beacon
5 Scar Activity

STARTING ZONE: VALLEY OF TARSIS

AGENT: BRIN

**PREREQUISITE: COMPLETE "PREVENTATIVE PRECAUTIONS"
AND "FINDING OLD FRIENDS" CRITICAL
OBJECTIVE**

MAIN OBJECTIVE(S): REPAIR BRIN'S BEACONS

ENEMIES

- SCARS: SCRAPPER, DESTROYER. SCOUT, HUNTER, ENFORCER,
ELITE SCOUT

REWARD

- FIRST TIME: ANY WEAPON X2, UNIQUE GEAR

- REPEAT: ANY WEAPON X2

1 LAUNCH EXPEDITION

After completing Brin's Agent Contract "Scar Control," speak to her to begin "Cautious Cooperation."

2 LOCATE AND ACTIVATE THE FIRST BEACON

Brin needs you to repair her beacons, located around Bastion. Follow the signals to the first beacon in southeastern Valley of Tarsis. Activate the beacon and remain nearby until the process is complete.

3 TRAVEL TO THE SCAR CAMP AND ELIMINATE SCARS

Travel directly east to a Scar camp in the Breach and the defeat the Scars there. Focus first on the Elite Scar Scout as you approach, then continue to eliminate the Scars around the camp, including an Enforcer, Hunter, and Scout. From range, obliterate them from atop the central tower. If close range is your preference, use the camp walls to escape trouble.

ACTIVATE THE SECOND BEACON

After eliminating the Scar presence, activate the second beacon. It's located on the south side of the camp.

4 LOCATE AND ACTIVATE THE THIRD BEACON

The third and final damaged beacon is located northeast in southern Eastern Reach. Activate the beacon and wait for the process to complete.

5 INVESTIGATE BEACON READING AND ELIMINATE SCAR PRESENCE

Next, travel north to Scar's Duskheap to investigate a Scar presence. Enter the camp and defeat the Scars inside. You must deal with a wide variety of Scars, including a Machine Gun Turret, Enforcer, Hunter, and Scout. Eliminate the turret as soon as you can, or your movement around the camp is severely hampered.

RECOVER FRAGMENTS AND DEFEAT REMAINING SCARS

After you clear out the Scars, the Shaper relic goes volatile. Recover the four fragments and insert them back into the relic, as Ash Elementals spawn from the device. More Scars also join the mix after two fragments are placed. Once the relic is silenced, defeat the remaining Scars, then tag the silenced relic.

A SIMPLE JOB

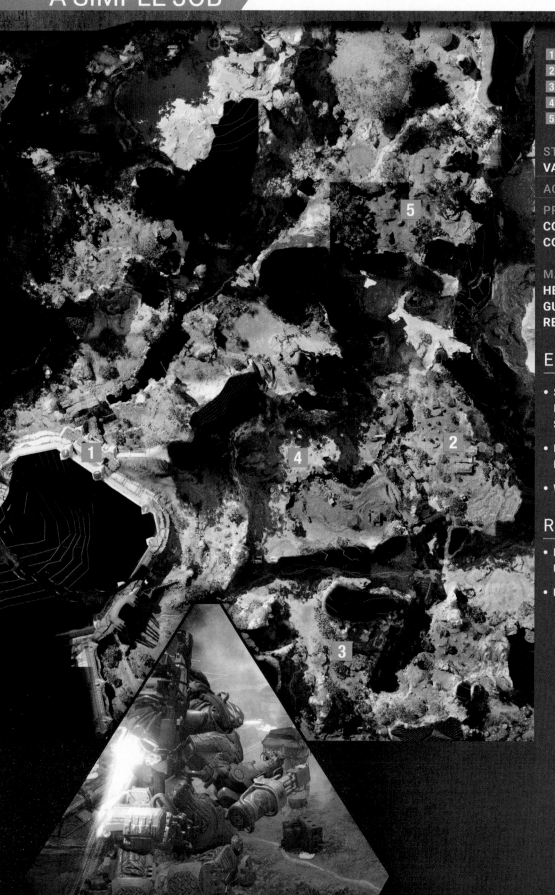

STARTING ZONE:
VALLEY OF TARSIS

AGENT: BRIN

PREREQUISITE:
COMPLETE "CAUTIOUS COOPERATION"

MAIN OBJECTIVE(S):
HELP SENTINELS GUARD THE SHAPER RELIC

ENEMIES

- SCARS: SCRAPPER, DESTROYER, ENFORCER, SCOUT

- ELITE SCARS: SCRAPPER, HUNTER, SCOUT, ENFORCER

- WOLVEN: WOLVEN, FROST

REWARD

- FIRST TIME: ANY WEAPON X2, UNIQUE GEAR

- REPEAT: ANY WEAPON X2

1 LAUNCH EXPEDITION

After completing the second set of three Agent Quests, speak to Brin to begin "A Simple Job."

2 INSPECT THE RELIC AT THE SENTINEL BASE

Travel to the Sentinel base in northern Valley of Tarsis and inspect the Shaper relic.

3 INVESTIGATE THE UNRESPONSIVE GENERATOR

Next, travel south to find a downed Sentinel next to the generator. Get the Sentinel up as soon as you arrive, then prepare to defend against a Scar onslaught. A pair of Elite Scar Hunters and a Scar Enforcer should be the focus of your big attacks.

RETURN TO THE SENTINEL BASE AND DEFEND THE SHAPER RELIC

After defeating the Scars at the generator, return to the Sentinel base; another large group of Scars attacks the Sentinels guarding the relic. Immediately dive in and assist with the fight. Stay on the move and avoid being surrounded. Numerous Scars must be dealt with, including various Elites (Enforcers, Hunters, Scouts, and Scrappers). Use your full array of weaponry to take them down, and be ready to flee the area if health gets low.

DESTROY SCAR HIVES

During the fight, three Scar Hives are marked on your HUD. Deal with them before they produce too many foes—while also eliminating the Scar threat. Don't lose track of the enemy, though; be ready to evade when focused on a hive. Throughout the battle, keep an eye out for downed Sentinels, and get them on their feet as soon as you can. Defeat any remaining Scars.

4 HELP SENTINELS DEFEND THE ARCANISTS FROM SCARS

With that threat dealt with, your attention is needed farther west, where Arcanists are under attack. Defeat more Scars as they spawn from a gate; Wolven may also join the fight.

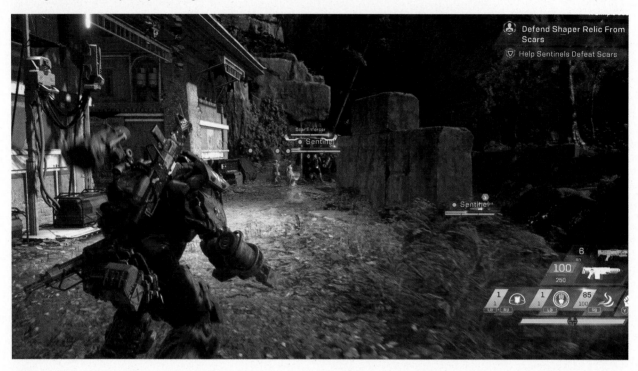

2 USE THE SHAPER RELIC TO LURE SCARS

Brin comes up with the idea to lure the Scars away with the Shaper relic. Return to the relic, pick it up, and flee to the north.

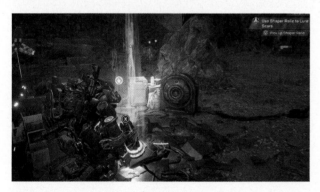

STOP THE SCARS AND SHAPER RELIC THREATS

Four fragments break off the relic while it starts spawning Wolven and Frost Wolven. Deal with the enemies while returning the fragments to the relic. Scars join the fight not long after you begin the repair. The two groups fight each other. Focus on recovering the pieces and take the path of least resistance between the relic and fragments. With the Shaper relic repaired, defeat the remaining Scars to complete the mission.

5 MOVE THE RELIC TO A SAFE LOCATION

A safe location is marked on your HUD, so head that way. As you carry the relic, you're unable to fly. Several Scars dot the path north, so deal with them or sprint by. Set the Shaper relic down at the objective marker.

ENEMY MINE

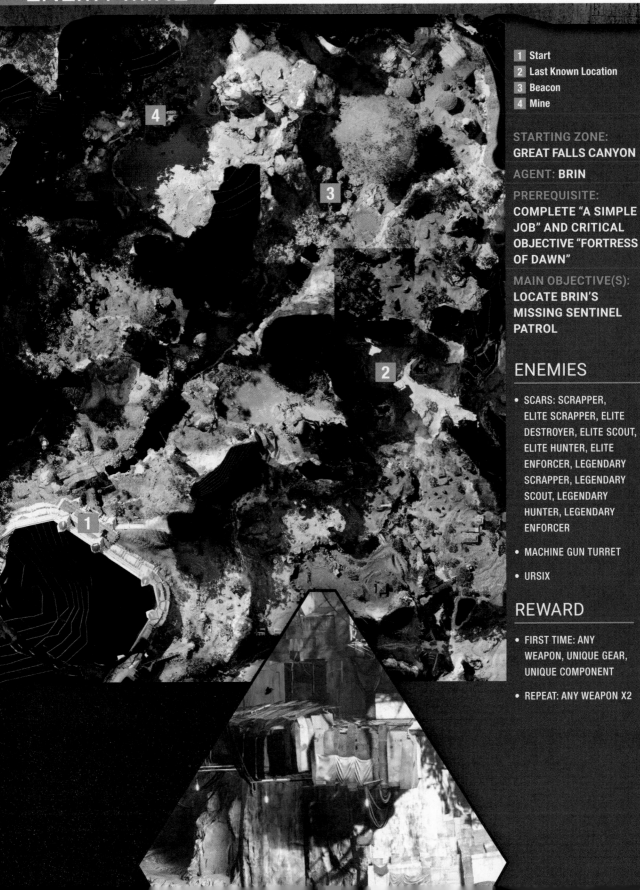

STARTING ZONE:
GREAT FALLS CANYON

AGENT: BRIN

PREREQUISITE:
COMPLETE "A SIMPLE JOB" AND CRITICAL OBJECTIVE "FORTRESS OF DAWN"

MAIN OBJECTIVE(S):
LOCATE BRIN'S MISSING SENTINEL PATROL

ENEMIES

- SCARS: SCRAPPER, ELITE SCRAPPER, ELITE DESTROYER, ELITE SCOUT, ELITE HUNTER, ELITE ENFORCER, LEGENDARY SCRAPPER, LEGENDARY SCOUT, LEGENDARY HUNTER, LEGENDARY ENFORCER

- MACHINE GUN TURRET

- URSIX

REWARD

- FIRST TIME: ANY WEAPON, UNIQUE GEAR, UNIQUE COMPONENT

- REPEAT: ANY WEAPON X2

1 LAUNCH EXPEDITION AND TRAVEL TO LAST KNOWN LOCATION

As long as you've completed the "Fortress of Dawn" objective, speak to Brin after completing her "A Simple Job" contract and launch the expedition. Travel to the Sentinels' last known position in Great Falls Canyon.

2 DEFEAT THE SCARS

A large group made up mostly of Elite Scars, along with a Legendary Enforcer for good measure, greets you upon your arrival. If soloing the mission, land on the lone tower in the area and immediately destroy the three Scar Hives. Next, focus your attacks on the Scars with range, such as Scouts, Scrappers, and Destroyers. Pay attention to where gunfire hits you, and eliminate snipers. Then work on the powerful Enforcers. If an Enforcer is close enough to the tower, it can get its flames up to you, so be careful. Inevitably, you must come down from the tower in order to refill ammo and recoup armor, and it can be tough to get shots on an Enforcer from above. Don't let the Scars surround and overwhelm you. There are multiple outlets to the area, so fly around to another side to gain access to pickups.

Once the battle is complete, search the area for signs of Sentinels. Investigate the equipment near the tower to get the next location.

3 FOLLOW THE BEACON TRAIL

Follow the beacon trail north into Eddian Grove. Investigate more equipment to pick up the next beacon. This one leads to an abandoned mine directly west of your location.

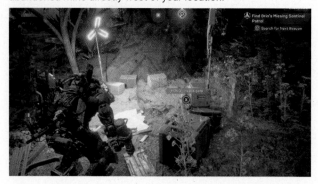

4 LOCATE THE MINE AND GET THROUGH THE BARRICADE

Cautiously enter the Blackshore district, as more Scars resist your search. A barricade blocks the mine's entrance, so you must find an explosive to destroy it. A Machine Gun Turret, Elite Scouts, and Elite Hunters should be your primary targets. A water tower provides a vantage point. A couple of hives continue to pump out Scars, so deal with them early.

As you approach the mine entrance, Brin suggests finding an explosive to destroy the barricade. Find a pile of bombs on the north side and carry one to the barricade. Plant it, then defend the area while it's armed. Hives appear to the left and along the lower level ahead, and they spawn numerous Scars. Stand your ground as much as possible, but move out to collect pickups when the need arises. Once the explosive is armed, flee the area before it detonates. Then quickly enter the Mandible.

COLLECT THE SENTINELS' SIGNETS

Drop to the lower level and find a member of Brin's Sentinel patrol inside the corridor to the right. Repair him and continue into the main cavern. A large group of Scars occupies the room. Fight through the enemies as you search for signets on the corpses of the fallen Sentinels; the compass leads you to the nearest one. The Scars have built walkways on multiple levels in the cavern, so you may need to search above or below your current location.

One signet is missing from the body. This brings in a targeted Scar, a Legendary Scar Enforcer. It drops the missing signet when defeated.

SEARCH FOR SENTINELS DEEPER IN THE MINE

Follow the east passageway to explore deeper; look out for mines along the way. Take down an Ursix in the next area, then search for more Sentinels. Pass through a doorway on the east side and interact with the javelin next to the inert relic.

1 Start
2 Scar Compound
3 Damaris the Escari

STARTING ZONE:
EAST GATE

AGENT: BRIN

PREREQUISITE:
COMPLETE "ENEMY MINE" AND CONTRACT "SCAR CONTROL"

MAIN OBJECTIVE(S):
LOCATE BRIN'S FINAL MISSING SENTINEL

ENEMIES

- SCARS: SCRAPPER, HUNTER, ENFORCER, ELITE SCRAPPER, ELITE DESTROYER, ELITE SCOUT, ELITE HUNTER, LEGENDARY ENFORCER, DAMARIS THE ESCARI

- TURRETS: MACHINE GUN, GRENADE

REWARD

- FIRST TIME: ANY WEAPON, UNIQUE GEAR, UNIQUE COMPONENT

- REPEAT: ANY WEAPON X2

1 LAUNCH EXPEDITION

As long as you've completed Brin's contract "Scar Control," speak to her to learn about a possible location of the sixth Sentinel. Launch the expedition and fly into northern East Gate.

2 TRAVEL TO THE SIGNAL SOURCE AND DESTROY SCAR DEFENSES

Approach the Scar compound in Skystone Pass cautiously. A pair of turrets guard the west side of the camp, with a large group of Scars close by—all of which must be defeated in order for you to complete the first objective. Eliminate the turrets and Elite Scouts early on, or use the installations as cover to avoid their ranged attacks.

DESTROY SCAR HIVES AND DEFEAT REMAINING ENEMIES

Once the initial group of Scars is cleared out, four hives appear along the ground level of the compound. This brings another large group of Scars, including a Legendary Enforcer. Make the hives your main focus, but put some space between you and the big guy. When you destroy the four hives, an entrance is revealed to Scar Tunnels underneath the compound. First you must defeat any remaining Scars.

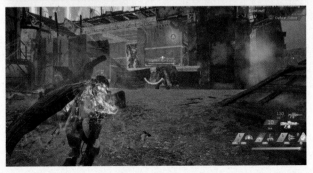

SEARCH THE SCAR TUNNELS FOR THE SENTINEL

Find the Scar Tunnels entrance where one of the hives stood and enter. Follow the passage until you find another group of Scars. Use the multiple levels and walls to avoid being surrounded, and pick off the enemies. Watch out for the Elite Hunter's lethal machine gun. Once the Scars are eliminated, find the Sentinel inside a cage and free him.

3 DEFEAT THE ESCARI

Exit the tunnels and follow the Escari signal into western Emerald Abyss to find Damaris the Escari. This fight is between you and the Escari alone. Stay on the move to avoid its massive attacks, and hit it with g ear and Ultimate Abilities whenever available. It drops power-ups as you eliminate segments of its health, so move in for the items if necessary. Escape into the water if your health gets dangerously low. Eventually, the enemy drops in defeat—finishing the mission.

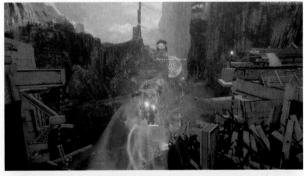

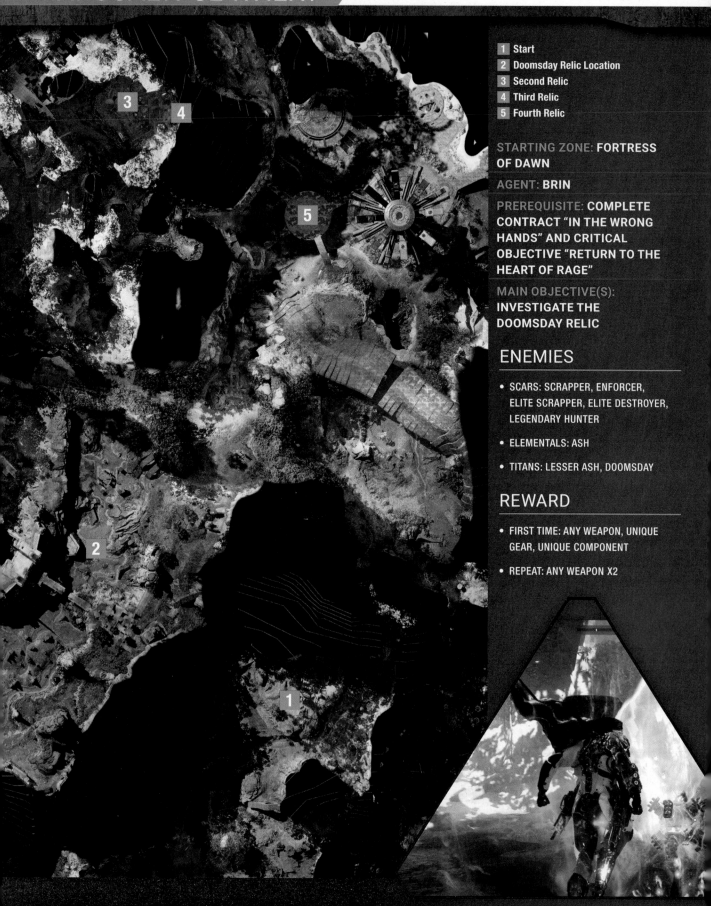

1	Start
2	Doomsday Relic Location
3	Second Relic
4	Third Relic
5	Fourth Relic

STARTING ZONE: FORTRESS OF DAWN

AGENT: BRIN

PREREQUISITE: COMPLETE CONTRACT "IN THE WRONG HANDS" AND CRITICAL OBJECTIVE "RETURN TO THE HEART OF RAGE"

MAIN OBJECTIVE(S): INVESTIGATE THE DOOMSDAY RELIC

ENEMIES

- SCARS: SCRAPPER, ENFORCER, ELITE SCRAPPER, ELITE DESTROYER, LEGENDARY HUNTER

- ELEMENTALS: ASH

- TITANS: LESSER ASH, DOOMSDAY

REWARD

- FIRST TIME: ANY WEAPON, UNIQUE GEAR, UNIQUE COMPONENT

- REPEAT: ANY WEAPON X2

1 LAUNCH EXPEDITION

Brin's next Agent Quest becomes available once you complete the final critical objective and her "In the Wrong Hands" contract. She requests that you investigate a doomsday relic to the north. Launch the expedition.

2 TRAVEL TO THE RELIC

Travel northwest into Fortress of Dawn and drop into Legionnaire's Ravine to find...nothing. Follow the compass north and search within the ruins to find the relic covered up by a munitions stockpile. Destroy the explosives to expose the relic.

3 SILENCE THE DOOMSDAY RELIC

Head north into the Helena's Walk district of Ruins of Shadowmark. Defeat the group of Elite Scars and Scar Enforcers. At this point, the relic goes volatile and begins spawning Ash Elementals, with more Scars joining the fight. Find the three fragments scattered around the ruins and return them to silence the relic. Once the relic is silenced, eliminate any remaining Scars, including a Legendary Scar Hunter, before moving on.

4 SILENCE THE SECOND RELIC

Another nearby relic goes volatile, with five fragments scattered around the ruins. Watch your step; this relic produces a Lesser Ash Titan, which is joined by more Scars. Don't lose track of the Titan as you collect the fragments and return them to the relic. Rings and balls of fire make this objective a bigger challenge. Silencing the relic causes the Titan to die and the Scars to retreat, so make that your focus.

5 STOP ANOTHER SCAR DOOMSDAY RELIC

Fly southeast to the Iron Serpent, as yet another doomsday relic goes volatile. The violent eruption releases eight echoes into the air and spawns a mighty Doomsday Titan. Silencing the relic doesn't kill off this Titan, so it must be defeated—either before or after you deliver the echoes.

The echoes float above eight pillars. If you decide to collect them before defeating the Titan, keep the boss in sight as you fly through the echoes, and wait for the enemy to relax before delivering them to the relic. Time your flights with the Titan's attacks, and use the monument as cover to avoid taking damage.

Use the open space to evade the beast's fire attacks, and if ranged attacks are an option, spend some time attacking from the top of the massive structure. Aim for the Titan's glowing weak spots and launch your Ultimate Ability whenever available. The Titan's attacks become more frenzied as its health gets low. This culminates in a combination of its fire beam and fire rings, as it prematurely detonates itself. Clear out of the area to avoid going down with it.

With all eight echoes delivered and the Titan defeated, the mission is a success.

1 Start
2 The Monument
3 Underwater Strider
4 Scar Camp
5 Dominion Camp

STARTING ZONE:
MONUMENT WATCH

AGENT: **BRIN**

PREREQUISITE:
**COMPLETE
"APOCALYPSE WHEN?"**

MAIN OBJECTIVE(S):
**SECURE THE
DOOMSDAY RELIC**

ENEMIES

- SCARS: DESTROYER,
 ELITE SCRAPPER, ELITE
 DESTROYER, ELITE SCOUT,
 ELITE HUNTER, ELITE
 ENFORCER, LEGENDARY
 HUNTER, LEGENDARY
 ENFORCER

- DOMINION: BRUTE, ELITE
 SHOCKTROOPER, ELITE
 FROST HOUND, ELITE
 BRUTE, ELITE VALKYRIE,
 LEGENDARY BRUTE, THE
 PRIDE OF FROSTKELN, THE
 BANE OF FREEMARK

REWARD

- FIRST TIME: ANY WEAPON,
 UNIQUE GEAR, UNIQUE
 COMPONENT

- REPEAT: ANY WEAPON X2

1 LAUNCH EXPEDITION

Grab this quest just after completing "Apocalypse When?" Speak to Brin and a couple of her fellow Sentinels to learn that we're not done with the doomsday relic. Launch the expedition and fly north to the Monument in Monument Watch.

2 DEFEAT SCARS AND DOMINION

Join the Sentinels inside the Monument, as they're already taking on Dominion and Scar troops. Elite Dominion Brutes and Valkyries, combined with Elite Scar Enforcers and Destroyers, create a challenging fight, even with the Sentinels' help. Move in and out of the structure to avoid taking too much damage, and keep an eye out for Repair Packs left over from defeated foes. If possible, get any downed Sentinels back on their feet. Continue the fight until all foes are eliminated.

3 PLACE THE BEACON ON THE SUNKEN STRIDER

Brin asks you to place a beacon on a nearby strider. Fly south and dive into the lake. Swim underneath the strider and interact with it to place the beacon.

4 RECOVER THE RELIC FRAGMENT LOOTED BY SCARS

After learning about a missing relic fragment, fly over to the Scar camp at the Drill, located southeast of the Monument. This group includes Elite Hunters and a Legendary Enforcer. You can fight from atop the structure, but watch out for Scars that join you. With the Scars defeated, find the missing fragment and carry it to the inert relic inside the Monument.

5 RECOVER THE RELIC FRAGMENT LOOTED BY THE DOMINION

Next, travel northwest to Crescent Lake to find a Dominion camp, where another fragment is held. Elite Valkyries and a Legendary Brute highlight this group of enemies. If possible, save your Ultimate Ability for the powerful Brute. A tower and rock structures provide vantage points for ranged combat. After taking care of the Dominion, collect the fragment and carry it back to the relic in the Monument.

2 DEFEND THE DOOMSDAY RELIC AGAINST SCARS

The complete relic attracts a large group of Scars. Once again, Sentinels assist in the fight, so repair them whenever possible. A Legendary Scar Hunter and Enforcer, along with several Elite Scars, must be dealt with to complete the mission. Stay on the move, in and out of the Monument, to avoid being overwhelmed. Platforms on the outside of the structure allow you to fight from relative safety, but this limits your view.

DEFEND THE DOOMSDAY RELIC AGAINST DOMINION TROOPS

Defeat the Scars and a squad of Dominion troops attacks. Watch out for their elemental abilities, and again, stay on the move. Elite Dominion Frost Hounds, Brutes, and Valkyries all send storm and frost attacks your way. Take down this group, but the fight still isn't over.

DEFEAT THE FURIES

The Dominion sends a pair of Furies your way, named the Pride of Frostkeln and the Bane of Freemark. Start out by repairing any downed Sentinels, then go after one of the Furies. Keep up a consistent, strong attack against the enemy in order to get through its shield. When it goes into its shell, continue attacking the bright spot. Don't let them both attack at once, and flee outside when health dips low. Once the two beasts are defeated, the Doomsday relic is finally safe.

Speak to Brin at the Fort Tarsis bar to complete the mission.

MATTHIAS: SEE IN THE DARK

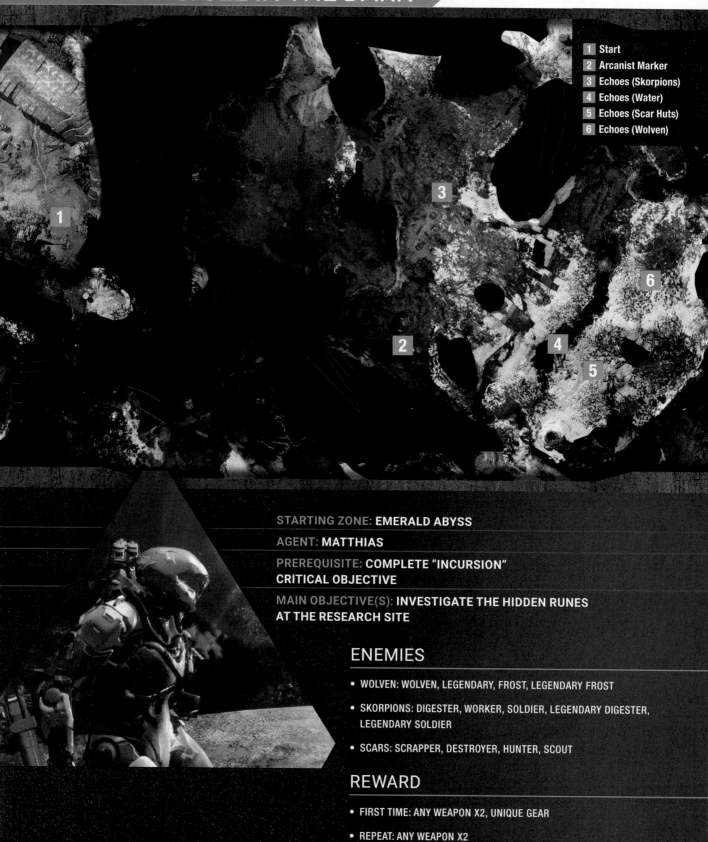

1 Start
2 Arcanist Marker
3 Echoes (Skorpions)
4 Echoes (Water)
5 Echoes (Scar Huts)
6 Echoes (Wolven)

STARTING ZONE: **EMERALD ABYSS**

AGENT: **MATTHIAS**

PREREQUISITE: **COMPLETE "INCURSION" CRITICAL OBJECTIVE**

MAIN OBJECTIVE(S): **INVESTIGATE THE HIDDEN RUNES AT THE RESEARCH SITE**

ENEMIES

- WOLVEN: WOLVEN, LEGENDARY, FROST, LEGENDARY FROST

- SKORPIONS: DIGESTER, WORKER, SOLDIER, LEGENDARY DIGESTER, LEGENDARY SOLDIER

- SCARS: SCRAPPER, DESTROYER, HUNTER, SCOUT

REWARD

- FIRST TIME: ANY WEAPON X2, UNIQUE GEAR

- REPEAT: ANY WEAPON X2

1 LAUNCH EXPEDITION

After completing "Lending a Hand," speak to Matthias in his office to begin "See in the Dark."

2 INVESTIGATE THE RESEARCH SITE

You start out at the northern end of High Road, en route to a research site to the east in Emerald Abyss. Fly through the Shaper tunnel to Abyssal Loch and then into the Guardians of Dunar. Clear out the pack of Wolven, then use the radar to locate an Arcanist marker. Examine the device.

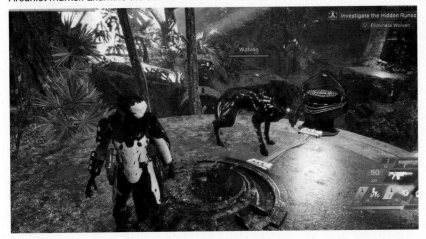

A Shaper object across from the marker requires twelve echoes. Utilize the radar to find echoes scattered around the region. Collect them and return back to the Shaper object. The first one is next to the object.

DON'T DILLY-DALLY FOR TOO LONG

Move quickly between echoes and back to the Shaper object. Echoes don't hang on indefinitely; wait too long and they return to their original locations.

3 WATCH FOR SKORPIONS

A few are near the stream to the north; watch out for Digesters and Workers in the area. Shoot the Skorpion eggs from a distance to limit their numbers and reveal a couple of hidden echoes.

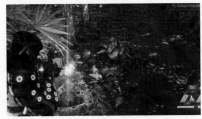

4 EASTERN WATERS

A pair of echoes is around the water, east of the Shaper object. Find one on the shore, while the second is below water directly west of the Scar village.

5 SCAR HUTS

East of the Shaper object, on the opposite side of the big body of water, two echoes are locked up in huts with a pack of Scars protecting the area. Scar Scrappers and Destroyers are joined by a Scar Hunter and two Scouts. If you get one or two of the tougher Scars together, launch your Ultimate Ability to obliterate them. Kill off the Scars, then unlock each hut and collect the echoes from inside.

6 BEWARE OF WOLVEN

Two echoes sit in the open on the far east side of the region, just across the water. A small pack of Wolven also occupies the area.

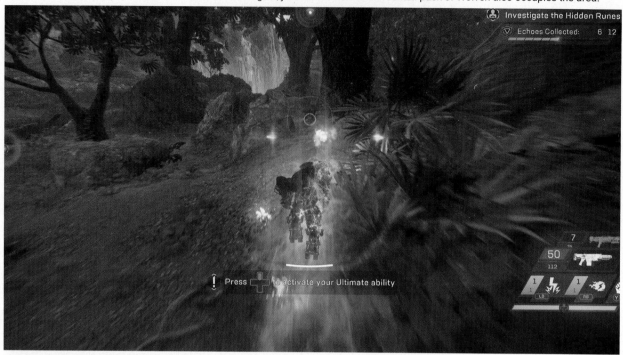

2 INVESTIGATE THE HIDDEN RUNES

After all 12 echoes are returned to the Shaper object, a group of Skorpion Digesters, Workers, and Soldiers—including Legendary level

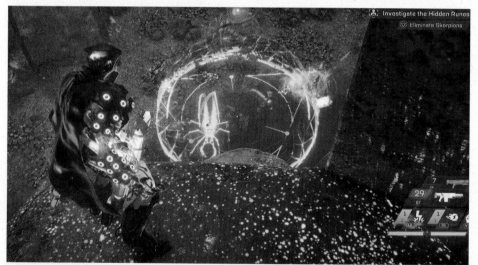

foes—attacks your position. Either pick them off from your perch, or dive down and take them on up close. With the Skorpions destroyed, interact with the Arcanist marker again to reveal six runes in the immediate area. Quickly examine all six runes to return to Fort Tarsis.

Speak to Matthias in his office to complete the mission. This unlocks Matthias' first contract.

RUNES

Speaking to Matthias, you learn about more Arcanist Runes around Bastion. Keep an eye out for these glowing runes. The Hidden Messages Challenge can now be completed.

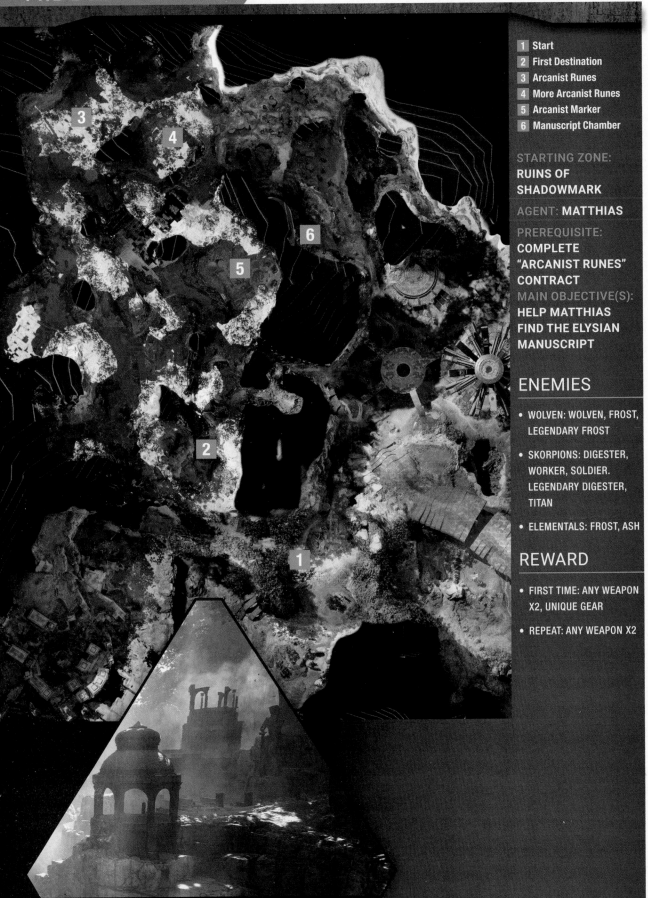

1. Start
2. First Destination
3. Arcanist Runes
4. More Arcanist Runes
5. Arcanist Marker
6. Manuscript Chamber

STARTING ZONE:
RUINS OF SHADOWMARK

AGENT: MATTHIAS

PREREQUISITE:
COMPLETE "ARCANIST RUNES" CONTRACT

MAIN OBJECTIVE(S):
HELP MATTHIAS FIND THE ELYSIAN MANUSCRIPT

ENEMIES

- WOLVEN: WOLVEN, FROST, LEGENDARY FROST

- SKORPIONS: DIGESTER, WORKER, SOLDIER. LEGENDARY DIGESTER, TITAN

- ELEMENTALS: FROST, ASH

REWARD

- FIRST TIME: ANY WEAPON X2, UNIQUE GEAR

- REPEAT: ANY WEAPON X2

1 LAUNCH EXPEDITION

After completing Matthias' contract "Arcanist Runes," speak to him in his office to begin "Hidden Depths."

2 FIND THE SECRET ARCANIST RUNES

The strider drops you off in northwest High Road, not far from your first destination just inside Ruins of Shadowmark.

3 COLLECT THE SIX RUNES

Continue farther northwest into the region to find the correct location in the Dawn Gates. Use the radar to find and examine the six runes. Watch out for anrisaur in the area.

4 CONTINUE SEARCH FOR SECRET ARCANIST RUNES AND COLLECT FIVE RUNES

Travel directly east to the next location at Shadowmark. Wolven and Frost Wolven, including a Legendary Frost Wolven, occupy the area. Fend them off as you collect the five runes.

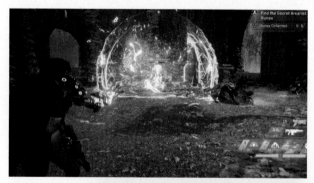

5 FOLLOW CLUES IN THE RUNES AND ACTIVATE AN ARCANIST MARKER

The runes lead to a new spot in Helena's Walk, southeast of your current location. Activate the Arcanist marker and defend it against an onslaught of Skorpions while Matthias reads the clues. Make quick work of the foes, as enemy interference slows objective progress.

6 FOLLOW CLUES TO THE MANUSCRIPT CHAMBER

Head northeast into Shadowmark and dive into the water. Enter an opening at the bottom and follow the path into the chamber; enter the Vault.

ELIMINATE THE SKORPIONS AND DESTROY THE SAFEGUARDS AROUND THE MANUSCRIPT

Follow the cave until you reach a large cavern, and eliminate the Skorpions that inhabit the room, including an Elite Digester. With the threat out of the way, find the door on the south side and land on the pillar in front of it. Turn toward the door and spot the two black plaques on the wall. Turn the two pedestals located on the pillar so they match the two on the wall. Proceed through the open door.

Continue to follow the trail into the final chamber, where the manuscript is not only protected by a barrier, but also by a menacing Titan.

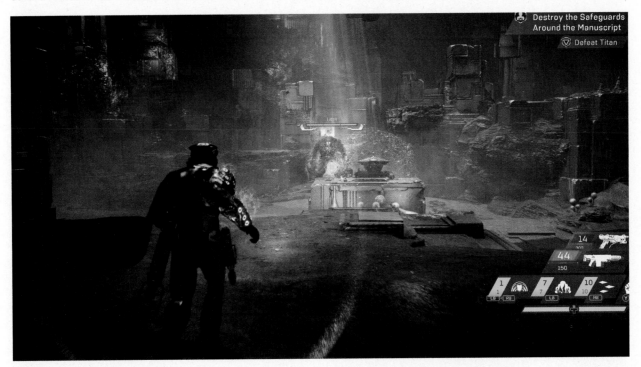

DEFEAT THE TITAN

The Titan has a whole lot of health, so be ready for a lengthy fight. Also, Frost and Ash Elementals spawn throughout the battle. Destroy the Elementals from range, or evade them just before they detonate. Whenever possible, use Gear attacks and your Ultimate Ability against the boss. He has two fire abilities: a fireball he tosses into the air before it launches at its target, and

a ring of fire that radiates outward on the ground from the Titan. Evade to the side to avoid the former, and hover in the air to avoid the latter.

The Titan is tagged with an objective marker, making it easy to keep track of his position. He tends to remain in the middle of the room while the Elementals attempt to flush you out of hiding. Keep up your assault on the beast until he finally falls in defeat.

DISABLE THE BARRIER

A pair of pedestals, similar to the ones used to unlock the door, appear on each side of the manuscript repository. Turn the pedestals until they match the plaques circled in these images. Open the container to retrieve the manuscript and return to Fort Tarsis. Speak to Matthias to complete the mission.

ELYSIAN SECRETS

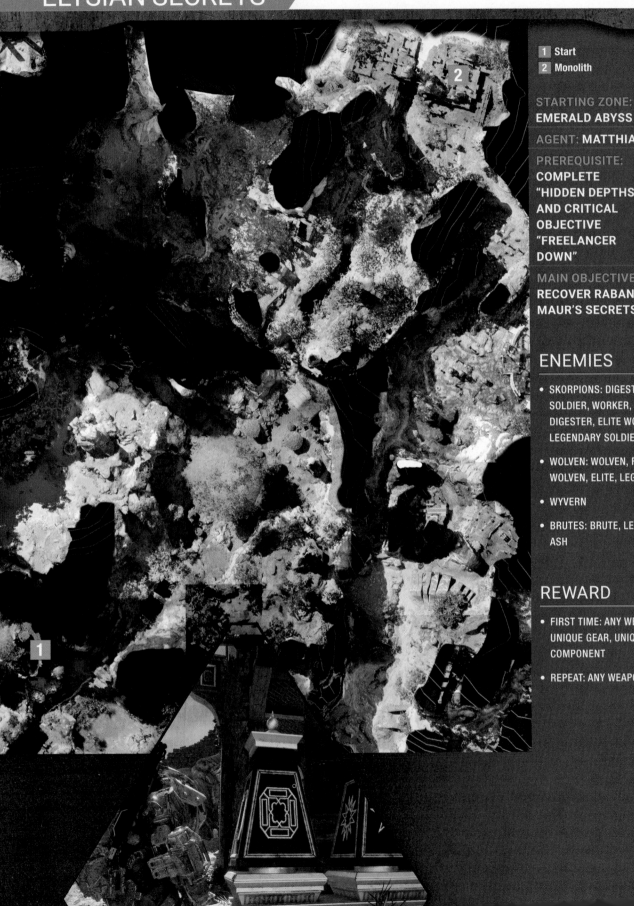

1 Start
2 Monolith

STARTING ZONE:
EMERALD ABYSS

AGENT: **MATTHIAS**

PREREQUISITE:
**COMPLETE
"HIDDEN DEPTHS"
AND CRITICAL
OBJECTIVE
"FREELANCER
DOWN"**

MAIN OBJECTIVE(S):
**RECOVER RABAN
MAUR'S SECRETS**

ENEMIES

- SKORPIONS: DIGESTER, SOLDIER, WORKER, ELITE DIGESTER, ELITE WORKER, LEGENDARY SOLDIER

- WOLVEN: WOLVEN, FROST WOLVEN, ELITE, LEGENDARY

- WYVERN

- BRUTES: BRUTE, LEGENDARY ASH

REWARD

- FIRST TIME: ANY WEAPON, UNIQUE GEAR, UNIQUE COMPONENT

- REPEAT: ANY WEAPON X2

1 LAUNCH EXPEDITION

As long as you've completed the "Hidden Depths" Agent Quest and progressed past "Freelancer Down" in the critical path, Matthias wants you to look into Raban Maur's secrets. Launch the expedition to get started.

2 INVESTIGATE THE PILLARS

Make the long trip up to northern Emerald Abyss, into the Sanctuary of Dunar district. If you enter the area from the west, destroy Skorpion eggs and the enemies that spawn from them. As you move into the ruins, a pack of Wolven attacks, including a Legendary Wolven. Defeat the entire pack to progress.

FIRST ENERGY STONE

Next, investigate the pillar, located at the objective marker, to activate a nearby pedestal. Match the symbols on the pedestal with the plaques on the nearby ruins. Hang out in the objective zone until the charging process is complete, then pick up the stone. Four plates are marked with objective markers. Place the stone on one of these plates. You're halfway there.

SECOND ENERGY STONE

Travel to the west side of the ruins, where two more pedestals display a pair of symbols each. These must be modified to match symbols found on the surrounding ruins. Remain alert, as Skorpions pester you throughout. For the northern pedestal, both symbols can be seen through the demolished wall on the right. Find the symbols for the southern pedestal on a wall just east of the pedestal. Once that part is solved, find the second stone east of your current location. Allow it to charge, while Skorpions proceed to attack, then carry it to one of the remaining plates.

THIRD ENERGY STONE

Pedestals for the third key are on the lower level of the ruins in front of the Tomb of Cariff. Look at the tomb's entrance to spot eight symbols. You want to change the pedestals to match the top-left and lower-right pairs. Stand near the stone that appears at the top of the steps until it's fully charged, carry it to the upper level, and place it on a plate.

FOURTH ENERGY STONE

Three pedestals are on the south side of the ruins, where Wyverns fly overhead. Fend them off as you change the symbols to match those on the ruins. Refer to the accompanying screenshots for the correct symbols.

Find the symbols for the northeastern pedestal on the partial archway to the north and the right wall.

Symbols for the middle pedestal are behind you when you're facing it. One leans against the statue, while the other rests next to the right wall.

For the southern pedestal, the left symbol is at the base of the statue ahead, and the other one hangs on a partial wall at the top of the steps to the right.

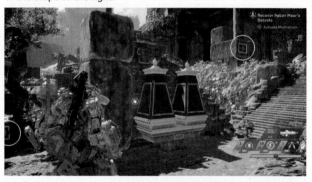

Stand within the objective zone and fend off the incoming Elite Skorpions until the final stone has charged. Carry it up to the final plate and interact with the monolith. Successfully defend the area against Brutes and Wolven, which also includes Legendary Ash Brutes. Interact with and swipe the chest contents.

Back at Fort Tarsis, speak to Erryl to complete the mission.

ANCIENT FOOTSTEPS

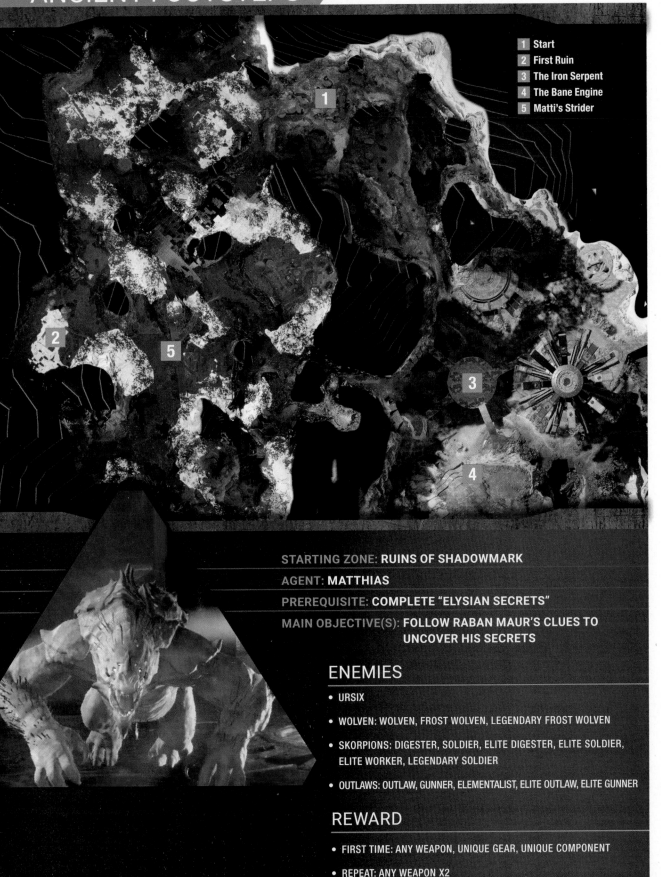

1 Start
2 First Ruin
3 The Iron Serpent
4 The Bane Engine
5 Matti's Strider

STARTING ZONE: **RUINS OF SHADOWMARK**

AGENT: **MATTHIAS**

PREREQUISITE: **COMPLETE "ELYSIAN SECRETS"**

MAIN OBJECTIVE(S): **FOLLOW RABAN MAUR'S CLUES TO UNCOVER HIS SECRETS**

ENEMIES

- URSIX

- WOLVEN: WOLVEN, FROST WOLVEN, LEGENDARY FROST WOLVEN

- SKORPIONS: DIGESTER, SOLDIER, ELITE DIGESTER, ELITE SOLDIER, ELITE WORKER, LEGENDARY SOLDIER

- OUTLAWS: OUTLAW, GUNNER, ELEMENTALIST, ELITE OUTLAW, ELITE GUNNER

REWARD

- FIRST TIME: ANY WEAPON, UNIQUE GEAR, UNIQUE COMPONENT

- REPEAT: ANY WEAPON X2

1 LAUNCH EXPEDITION

After completing "Elysian Secrets," speak to Matti to begin the next mission, and then launch the expedition.

2 COLLECT RUNES AT THE FIRST RUIN

You begin in northern Bastion, not too far from your first destination in Strider Alley. Use the compass radar to track down the five runes, which are located on the walls of the ruin. Plants in the area release gaseous clouds that inflict Acid on contact. Avoid the clouds as much as possible, but small interactions won't cause excessive damage.

3 COLLECT RUNES AT THE IRON SERPENT

Next, fly east to the Iron Serpent in Monument Watch. Six runes are around the area. An Ursix attempts to keep you from collecting the two on the central pillars. It's best to defeat the beast first, but it's not necessary. Wolven attack while you collect two runes at the Monument, one of which is on the upper level. Skorpions hatch inside the northern structure, where two more runes are located.

4 | EXPLORE THE ANCIENT COMPLEX

Enter the Bane Engine and navigate through the passageway into the main chamber. Eliminate Skorpions and use the radar to search for Maur's signs. Find and activate a vault on the southeast platform. This causes eight attunement points to appear and a one-minute timer to begin its countdown. You must touch all eight of these points before the timer hits zero, so immediately take flight. Ignore the Skorpions as much as possible.

A few of the points are in the air, but most sit along the platforms, where Skorpions attempt to slow your progress. After successfully getting all eight points within the time limit, interact with the vault again to continue the attunement progress. Next, remain inside the objective zone while defending against a continued onslaught of enemies. Once the process is complete, open the vault and return to the surface.

5 | RESCUE MATTI

Fly west to Tracks of Midderon in Ruins of Shadowmark and defeat the Outlaws surrounding the strider. Next, use the radar to track down the battery and place it into the slot on top of the strider.

TELL ME MAUR

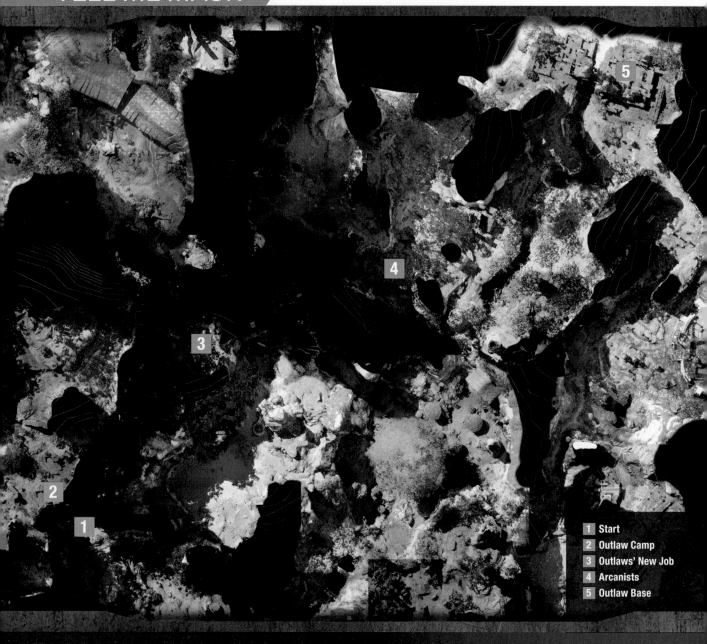

1 Start
2 Outlaw Camp
3 Outlaws' New Job
4 Arcanists
5 Outlaw Base

STARTING ZONE: **ACADEMY RUINS**

AGENT: **MATTHIAS**

PREREQUISITE: **COMPLETE CONTRACT "ARCHIVE HUNT"**

MAIN OBJECTIVE(S): **INVESTIGATE THE OUTLAWS WHO ATTACKED MATTI'S STRIDER**

ENEMIES

- SCARS: SCRAPPER, DESTROYER, HUNTER, ELITE SCRAPPER, ELITE SCOUT, ELITE HUNTER, LEGENDARY ENFORCER

- OUTLAWS: GUNNER, ELEMENTALIST, ELITE OUTLAW, ELITE SHOTGUNNER, ELITE GUNNER, ELITE ROCKET TROOPER, ELITE ELEMENTALIST, LEGENDARY GUNNER, LEGENDARY SHOTGUNNER, OUTLAW TURRET, MYSTERIOUS FIGURE

REWARD

- FIRST TIME: ANY WEAPON, UNIQUE GEAR, UNIQUE COMPONENT

- REPEAT: ANY WEAPON X2

1 LAUNCH EXPEDITION

After completing Matthias' second contract, "Archive Hunt," speak to Sumner at his office to begin the quest, then launch the expedition. A strider takes you up High Road, dropping you off near your next destination, which is just inside Academy Ruins at the Garrison at Velathra.

2 TRAVEL TO THE OUTLAW CAMP

At the Outlaw camp, defeat the group of Scars, including numerous Elites and a Legendary Enforcer. Pull the Scars away from the camp if you become overwhelmed. Once they're eliminated, follow the radar to two clues: a recording and a map.

3 INVESTIGATE THE OUTLAWS' NEW JOB AND STOP THEM

Travel up High Road to the Outlaws' new job at Tower Road. Defeat the Outlaws, including a Legendary Gunner. With that threat neutralized, search the area for a recording. Continue searching to find a map that points to the Outlaws' next location in Emerald Abyss.

4 SAVE THE ARCANISTS FROM THE OUTLAWS

Travel to the Arcanist site in Guardians of Dunar, but don't push too far in. Spend some time picking off Outlaws from afar, if possible. Elite Gunners and Elementalists make the fight tougher than it may appear at first. Cautiously work your way toward the next objective, or quickly fly to the Arcanists and hold your position from there. Once you drop the Elementalists and a Legendary Shotgunner, the objective is complete.

5 TRAVEL TO THE OUTLAW BASE AND DESTROY THEIR EQUIPMENT

With the Arcanists safe, fly northeast toward the Tomb of Cariff, but approach the area with caution. More Outlaws, in addition to three turrets, guard the area. Use ruins as cover while taking the defenses down first.

Your objective calls for destroying the Outlaws' equipment, which is located in six caches. Use your radar to find the nearest one. Watch out for Elite Rocket Troopers; make them a priority when in sight.

DEFEAT THE MYSTERIOUS FIGURE

After destroying the equipment, a Mysterious Figure shows up.

Take down the boss and any remaining Outlaws. Then search for another recording, which is hidden under a canopy.

SECRETS OF THE AUSPEX

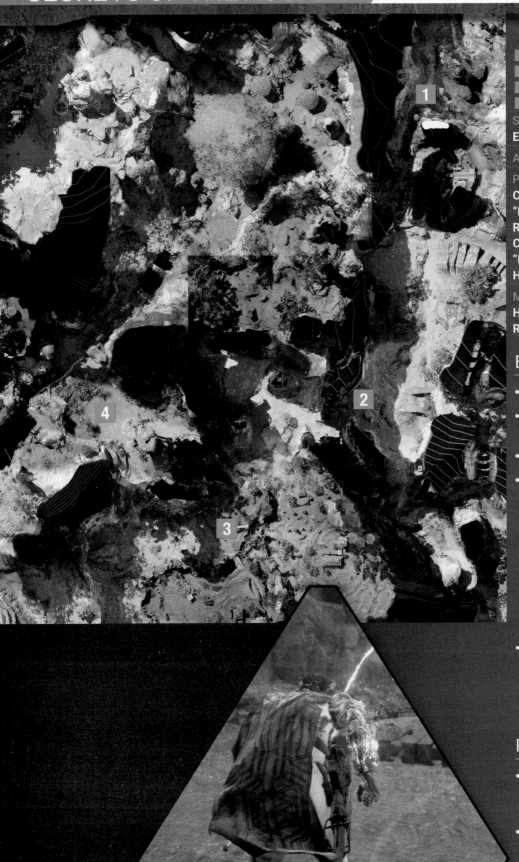

1 Start
2 Auspex
3 Place Auspex
4 Safe Location

STARTING ZONE:
EAST GATE

AGENT: MATTHIAS

PREREQUISITE:
**COMPLETE CONTRACT
"DECRYPTION
RESEARCH" AND
CRITICAL OBJECTIVE
"RETURN TO THE
HEART OF RAGE"**

MAIN OBJECTIVE(S):
**HELP THE TRIO
RECOVER THE AUSPEX**

ENEMIES

- WYVERN

- BRUTES: BRUTE, ASH,
 LEGENDARY ASH

- ELEMENTALS: ASH, FROST

- OUTLAWS: OUTLAW,
 GUNNER, ELITE OUTLAW,
 ELITE SHOTGUNNER, ELITE
 ROCKET TROOPER, ELITE
 LANCER, LEGENDARY
 SHOTGUNNER, LEGENDARY
 ROCKET TROOPER,
 LEGENDARY LANCER,
 MYSTERIOUS FIGURE,
 AGENT OF THE SYMPOSIUM

- SCARS: SCRAPPER, ELITE
 SCRAPPER, LEGENDARY
 SCOUT, LEGENDARY
 HUNTER, LEGENDARY
 ENFORCER

REWARD

- FIRST TIME: ANY WEAPON,
 UNIQUE GEAR, UNIQUE
 COMPONENT

- REPEAT: ANY WEAPON X2

1 LAUNCH EXPEDITION

As long as you've completed the final critical objective, "Return to the Heart of Rage" and Matthias' contract "Decryption Research," speak to the trio in Matthias' office to begin this quest. Launch the expedition.

2 PLANT THE TRANSMITTER

Travel south to Lover's Spring and fend off the Wyvern above while waiting for information from the trio. Once instructed to do so, plant the transmitter at the point marked on your HUD. Now you must defend the objective zone until the scan is complete. Brutes, including Legendary Ash Brutes, and Ash Elementals, join the Wyvern. Hit them early and hard as they approach. They fight amongst themselves a bit, so let that happen whenever possible.

With the scan complete, the Auspex reveals itself, but it must be stabilized before transport. Fight your way through the wildlife and collect the five echoes (three at a time) that are scattered around the immediate area, and deliver them to the Auspex.

Watch out for Grounders that zap flying javelins out of the air, overheating them in the process. The Grounders can be shrunk with gunfire.

134

3 DELIVER THE AUSPEX TO SAFETY

Pick up the stabilized Auspex and head toward the next objective marker in northern Valley of Tarsis. As usual, flight is prohibited while carrying objects. Outlaws get in your way throughout the journey. Watch for gates to appear along the route ahead, and either steer clear of the enemies or fight through them.

On the west side of Honor Valley, place the Auspex at the spot marked on your HUD. This creates an objective zone, which must be defended against the continued Outlaw onslaught. Pay particular attention to the Legendary and Elite Outlaw Lancers.

Energy imbalances from the Auspex also cause elementals to spawn into the area. The battle gets tough, but hold your ground within the zone as much as possible to continue your objective progress.

4 CONTINUE DELIVERING THE AUSPEX TO SAFETY

After progress is complete, continue to fight back the enemy until you get an opportunity to pick up the Auspex again. Carry it northwest to a safe location in the Bowl district. Place it on the marked stone platform and get ready for a massive battle with assistance from a few Sentinels. It's not necessary to remain close to the Auspex, but you should check in on the area from time to time.

KEEP THE SENTINELS IN THE FIGHT

The Sentinels help fight the enemy. If one goes down, it isn't too long before the soldier is out of the battle for good. You should quickly repair the soldier; just be smart about doing so. If your health is low and the downed Sentinel is surrounded, it's best to wait for a better opportunity. Look for easy kills close by and collect any dropped Repair Packs. Or, at least wait for your shield to restore fully.

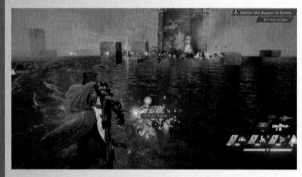

Outlaws attack from all sides of the pond, including powerful enemies such as Legendary Lancers and Legendary Rocket Troopers that cherry-pick from the water's edge. Use the compass to find the highest concentration of enemies, and keep them from getting close to the Auspex. A ranged fighter can fight from the top of the tower; just be sure to scan all around the water. Rectangular pillars jut from the water, providing cover against ranged foes. This is a lengthy fight, so it's vital to take out the weaker Outlaws periodically for Repair Packs and ammunition.

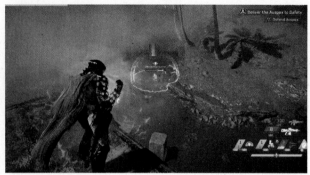

After a while, Scars take interest and spawn in at three nearby hives. Take them down immediately and look out for Legendary Scars, such as an Enforcer, Hunter, and Scout. The fight gets extremely chaotic, so stay on the move and flee to a safe location along the perimeter when your health gets low.

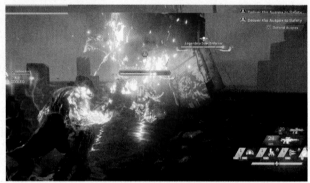

DEFEAT THE AGENT OF SYMPOSIUM

After you defeat the Scars, the Agent of Symposium appears accompanied by a pair of Mysterious Figures. Ash Elementals also spawn from the unstable Auspex. Similar to Elementalists, these special Outlaws can hover in the air and attack with a variety of elemental abilities. Keep pressure on the Agent in order to get through his shield and finish him off with big attacks.

Talk to the trio once you arrive back at Fort Tarsis to wrap up their Agent Quests.

YARROW: WHAT FREELANCERS DO

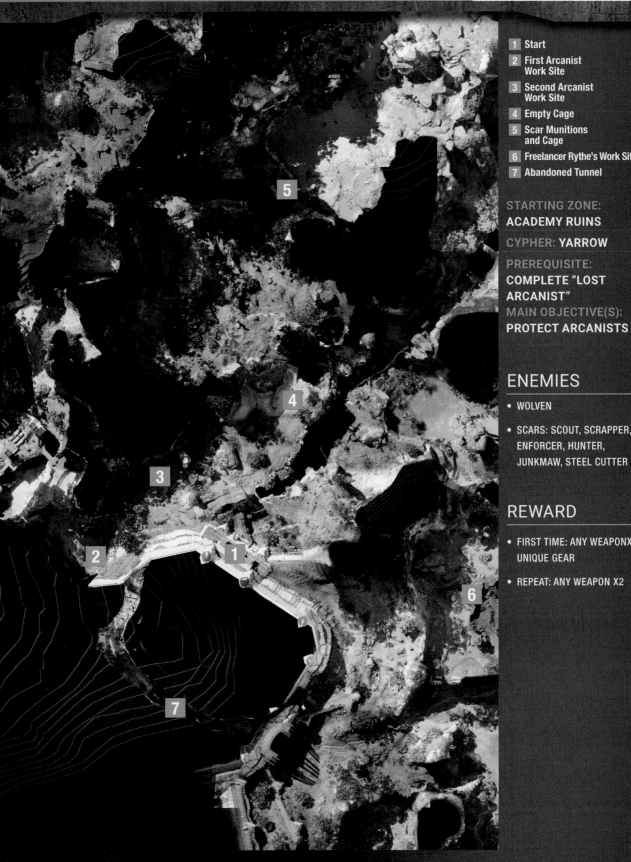

1 **Start**

2 **First Arcanist Work Site**

3 **Second Arcanist Work Site**

4 **Empty Cage**

5 **Scar Munitions and Cage**

6 **Freelancer Rythe's Work Site**

7 **Abandoned Tunnel**

STARTING ZONE:
ACADEMY RUINS

CYPHER: **YARROW**

PREREQUISITE:
COMPLETE "LOST ARCANIST"

MAIN OBJECTIVE(S):
PROTECT ARCANISTS

ENEMIES

- WOLVEN

- SCARS: SCOUT, SCRAPPER, ENFORCER, HUNTER, JUNKMAW, STEEL CUTTER

REWARD

- FIRST TIME: ANY WEAPONX2, UNIQUE GEAR

- REPEAT: ANY WEAPON X2

1 LAUNCH EXPEDITION

After completing "Lending a Hand," speak to Yarrow in the Freelancers Enclave to begin "What Freelancers Do."

2 PROTECT ARCANISTS

The first Arcanist work site is a short distance to the east, just inside Tarsis Forest. Check the abandoned equipment, then protect the Arcanists by killing the attacking Wolven and Frost Wolven.

3 SEARCH SECOND WORK SITE

Once work progress is complete at the first site, find a second Arcanist work site to the northeast. This one has been scavenged and abandoned. Activate the equipment.

4 INVESTIGATE THE CAGE

Cautiously approach a Scar cage directly east. A few Scrappers, a Scout, and an Enforcer patrol the area. Finish off the Scars, then investigate the cage.

5 DESTROY THE MUNITIONS AND RESCUE THE ARCANISTS

Track the missing Arcanists north until you spot a munitions stockpile ahead, hidden inside a shack. A Machine Gun Turret guards the munitions, while Scar Scrappers spawn from two gates. Destroy the turret from a safe distance first, using the environment to protect yourself against its gunfire. Then approach the area carefully and focus fire at the stockpile while fending off Scars.

With the first munitions out of the way, continue to fight through Scar Scrappers and drop to the lower level. There, a second munitions stockpile

sits near a cage filled with the Arcanists. Once both stockpiles are destroyed, unlock the cage to rescue them. Be careful, as the Scrappers are joined by Junkmaw, a special Scar Hunter. Focus your attention on him first before disposing of the remaining foes.

6 SEARCH FREELANCER RYTHE'S WORK SITE

With your job done, fly southeast past Fort Tarsis to Freelancer Rythe's work site on the northwest side of Valley of Tarsis. Gates spew out a large number of Scars, including Scrappers, Destroyers, Scouts, a Hunter, and an Enforcer. This is the final battle of the mission, so release your Ultimate Ability against the tougher foes. Focus your attention on the Hunter and Enforcer first, then finish off the remaining Scars. Investigate the site.

7 LOCATE FREELANCER RYTHE AND THE ARCANISTS

Fly southwest toward Fort Tarsis and enter the abandoned tunnel that runs beneath. Once you find Rythe and the Arcanists, help her finish off Steel Cutter.

TARSIS BYPASS

Said to have been home to the dreaded Ezurite Anzu, this passageway has a secret entrance to Forest Tarsis and is patrolled bi-weekly to keep creatures from building homes here. In 324 LV, the bypass was home to a family of tesilars, whose electromagnetic fields caused javelins, striders, and household appliances to malfunction. These tesilars were the inspiration for the much-beloved **Tessi the Tesilar** series.

Speak to Yarrow at the Freelancers Enclave once you return to Fort Tarsis to complete the mission. This unlocks Yarrow's first contract.

A FAVOR TO ASK

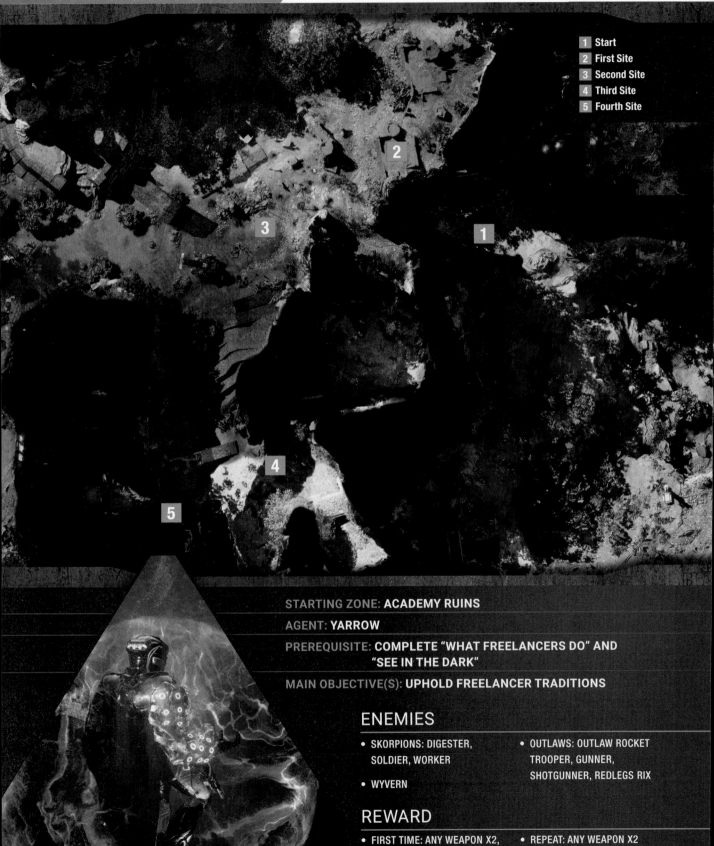

1	Start
2	First Site
3	Second Site
4	Third Site
5	Fourth Site

STARTING ZONE: ACADEMY RUINS

AGENT: YARROW

PREREQUISITE: COMPLETE "WHAT FREELANCERS DO" AND "SEE IN THE DARK"

MAIN OBJECTIVE(S): UPHOLD FREELANCER TRADITIONS

ENEMIES

- SKORPIONS: DIGESTER, SOLDIER, WORKER
- WYVERN
- OUTLAWS: OUTLAW ROCKET TROOPER, GUNNER, SHOTGUNNER, REDLEGS RIX

REWARD

- FIRST TIME: ANY WEAPON X2, UNIQUE GEAR
- REPEAT: ANY WEAPON X2

1 LAUNCH EXPEDITION

After completing Yarrow's contract "Protection Duty," speak to him in the Freelancers Enclave to begin "A Favor to Ask."

2 LOCATE THE FIRST SITE AND ELIMINATE THE 12 PREDATORS

The strider drops you off partway up High Road, a short distance from your destination in northeast Academy Ruins. Eliminate the Skorpions that inhabit the area. Remember: the more eggs destroyed, the fewer enemies to kill. Once all 12 predators are taken care of, light a fire at the memorial on the north side of the ruins.

3 CLEAR THE MEMORIAL SITE AND RETRIEVE FOUR LINKS

Travel a short distance southwest to find the next site. Clear out the Wyverns and Skorpions that infest the memorial site. Once complete, use the radar to find and retrieve four links in the area. Once they're recovered, light the memorial located on the east side of the area.

4 CLEAR THE THIRD MEMORIAL SITE AND RETRIEVE THREE STOLEN EQUIPMENT PILES

South of your location, you find those responsible—the Outlaws. Three piles of stolen equipment are marked on your HUD and map. Pick off the Outlaws and collect the items. The Outlaws keep coming, so retrieve the stolen equipment while under fire.

After retrieving the final equipment pile, don't let your guard down. A big group of Outlaws, including leader Redlegs Rix, spawns in the water to the west. If possible, use area-of-effect attacks to quickly take them out.

5 VISIT THE FOURTH SITE

After eliminating the Outlaws, fly a short distance west to find the final site at the Solarium Court. Light the fire to return to Fort Tarsis. Speak with Yarrow at the Freelancers Enclave to complete the mission.

A CRY FOR HELP

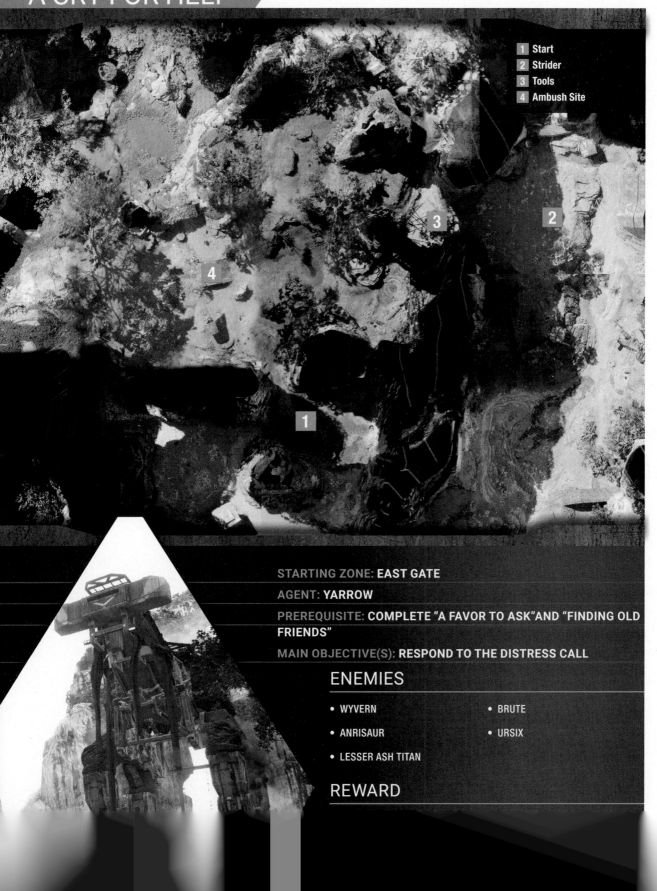

1 Start
2 Strider
3 Tools
4 Ambush Site

STARTING ZONE: EAST GATE

AGENT: YARROW

PREREQUISITE: COMPLETE "A FAVOR TO ASK" AND "FINDING OLD FRIENDS"

MAIN OBJECTIVE(S): RESPOND TO THE DISTRESS CALL

ENEMIES

- WYVERN
- ANRISAUR
- LESSER ASH TITAN
- BRUTE
- URSIX

REWARD

1 LAUNCH EXPEDITION

After completing Brin's quest "A Simple Job," speak to Yarrow in the Freelancers Enclave to begin "A Cry for Help."

2 LOCATE STRIDER

Fly north into Great Falls Canyon to find a broken-down strider in a clearing of Silent Path. Eliminate the Wyverns that fly above; get a better view by landing on top of the strider. With the Wyverns out of the way, check on the strider by entering the compartment and speaking to Freelancer Diggs.

3 FIND FOUR TOOLS TO REPAIR THE STRIDER

Head west using the radar to find four tools required to repair the strider; all four are located along the trail. Watch for anrisaur as you collect the tools and return to Freelancer Diggs once you have all four.

4 SEARCH THE AMBUSH SITE

A missing strut leads you to the ambush site, located further west in Great Falls Canyon. When you arrive at the location, you're greeted by a Lesser Ash Titan and another flock of Wyverns. Blast the big guy with your most powerful attacks, while evading its fireball and fire ring attacks. When up close, it punches the ground in front, causing massive damage when contact is made.

If the Wyverns are too much of a nuisance, move behind an obstacle and pick them off first. Note that it isn't necessary to defeat the enemies before searching the site. The radar leads you to piles of debris left over from the ambush. Search each one until you find the strut (north side of the site).

2 RETURN THE STRUT TO THE STRIDER

Return the strut to the strider, but watch out for Brutes along the way. Wolven and Frost Wolven now occupy the surrounding area. Quickly deliver the strut to Diggs, then defend the strider against the Wolven until they have been defeated.

DEFEAT THE URSIX

Next, an Ursix shows up. If things get rough, fly to the top of the strider and fire down on the Ursix. Defeat the beast and return to Diggs. Clear out of the area to earn your reward.

Back at Fort Tarsis, speak to Yarrow to complete the mission.

OVERDUE

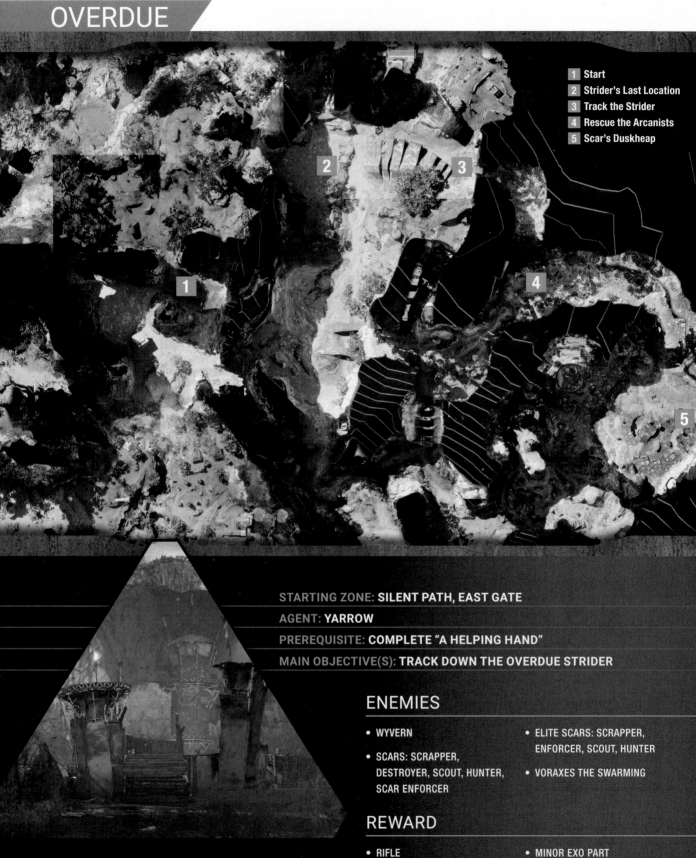

1 **Start**
2 **Strider's Last Location**
3 **Track the Strider**
4 **Rescue the Arcanists**
5 **Scar's Duskheap**

STARTING ZONE: SILENT PATH, EAST GATE

AGENT: YARROW

PREREQUISITE: COMPLETE "A HELPING HAND"

MAIN OBJECTIVE(S): TRACK DOWN THE OVERDUE STRIDER

ENEMIES

- WYVERN

- SCARS: SCRAPPER, DESTROYER, SCOUT, HUNTER, SCAR ENFORCER

- ELITE SCARS: SCRAPPER, ENFORCER, SCOUT, HUNTER

- VORAXES THE SWARMING

REWARD

- RIFLE

- MINOR EXO PART

- UNIQUE GEAR

1 LAUNCH EXPEDITION

After completing the contract "A Helping Hand," visit Yarrow in the Freelancers Enclave to begin the Agent Quest "Overdue."

2 INVESTIGATE THE STRIDER'S LAST KNOWN LOCATION

Visit the location where you found Freelancer Diggs and his strider in the Agent Quest "A Cry for Help." Eliminate the Wyverns that fly above, then use the radar to track the strider northeast, south through the water, and then up to the trail above.

3 EXAMINE THE STRIDER AND FOLLOW THE SCAVENGERS' TRAIL

Enter the strider cargo bay to the north and interact with the debris inside. Exit through the other side and follow the Scavengers' trail into the hole on the side of the cliff.

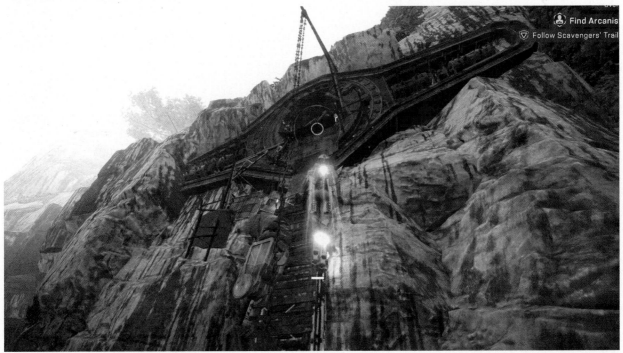

4 RESCUE THE ARCANISTS

Follow the path into Headless Hollow to find the missing Arcanists locked inside cages and a large group of Scars, including an Elite Enforcer and Scout. Once the enemy is eliminated, open both cages to release the Arcanists.

5 INVESTIGATE THE ARCANISTS' CLAIMS

Next, follow the signal east and then south to Scar's Duskheap. Draw out the Scar Leader by eliminating the Scars within the camp. This includes Elite Scrappers and a couple of Elite Hunters. Destroy the Scar Hives that appear in the camp. Once they're destroyed, an entrance is revealed that leads down to Scar Mine. Investigate the entrance to enter the mine.

SEARCH FOR EVIDENCE AND ELIMINATE TARGETED SCAR LEADER

Once inside the hideout, fight off more Scar combatants as you follow the radar to a pile of stolen cargo in the main cavern. This brings out the Scar Leader, Voraxes the Swarming.

This guy has a large amount of health and is equipped with a powerful machine gun, a salvo of rockets, and an equally strong energy weapon. Going in with an Ultimate Ability at the ready and another player is ideal. Scar Scrappers, Destroyers, Scouts, and Hunters spawn in the cavern throughout the fight. Use stalagmites and pillars as cover from its weapon fire and release your most powerful attacks once they're ready. The boss targets you with its red beam. Attack during the charge time, but duck behind cover before it fires. Fend off the weaker foes with your guns, but focus your attention on the boss. Keep the big pillar between you and the boss while attacking from each side. Eventually, it falls in defeat and you're sent back to Fort Tarsis.

Follow up with Yarrow to complete the mission.

TEMPTING TARGET

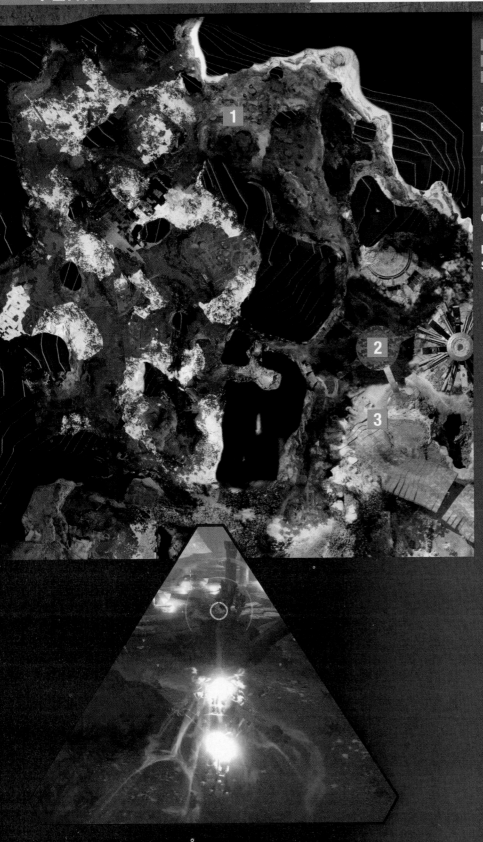

1 Start
2 Research Camp
3 The Bane Engine

STARTING ZONE:
RUINS OF SHADOWMARK

AGENT: YARROW

PREREQUISITE: COMPLETE "OVERDUE"

MAIN OBJECTIVE(S):
CHECK ON RESEARCH CAMP

ENSURE ARCANISTS REMAIN SAFE AFTER DISCOVERY

ENEMIES

- OUTLAWS: OUTLAW, GUNNER, SHOTGUNNER, ROCKET TROOPER, ELITE GUNNER, ELITE OUTLAW, ELITE ROCKET TROOPER, FIRE-FACED KERNS

REWARD

- FIRST TIME: ANY WEAPON, UNIQUE GEAR, UNIQUE COMPONENT

- REPEAT: ANY WEAPON X2

1 LAUNCH EXPEDITION

After completing Yarrow's "Overdue" Agent Quest, attempt any other expedition. When you return to Fort Tarsis, Yarrow has a new quest for you.

2 RESEARCH CAMP

You start out in the northern Ruins of Shadowmark, but you need to reach the Iron Serpent in Monument Watch to check on a research camp. Eliminate the Outlaws when you arrive, but watch for Rocket Troopers atop the towers.

Next, use the radar to search for three clues to the whereabouts of the researchers. Investigate the journal pages and drawings, then listen to the recording.

3 ENTER AND INVESTIGATE THE SHAPER RUIN

Fly south and interact with the door to enter the Bane Engine. Take out the two Elite Outlaw Gunners on your way to the main cavern. Deal with more Outlaws, including a number of Elites. With the enemies out of the way, collect the four echoes around the perimeter of the room and deliver them to the Shaper ruin on the south side of the cavern. The bright light emanating from the echoes makes them easy to spot. Once the echoes are dropped off at the ruin, the nearby door opens.

3 FIND THE RESEARCHERS

Before proceeding through the opening, take note of the two glyphs on the ramp, or at least remember the two colors. These are required to disable the Shaper lock. Inside the tunnel, detonate the mines that litter the floor, or carefully avoid them.

Next, spot the glyphs on the left and right walls. By hovering in front of each one, you can interact with them to flip through four different glyphs. When you set them to the ones noted on the entrance ramp, the door ahead opens. Find the Arcanists inside.

3 PROTECT THE RESEARCHERS

Return to the main cavern to face off against another selection of Outlaws. After a while, the Outlaw Leader, Fire-Faced Kerns, appears. He's well-shielded and has the ability to hover in the air and launch a shock orb that hits with the Electrocuted effect. Defeat the boss to complete the objective and return to the fort.

Follow up with Yarrow at Fort Tarsis to complete this Agent Quest.

BAD DEAL

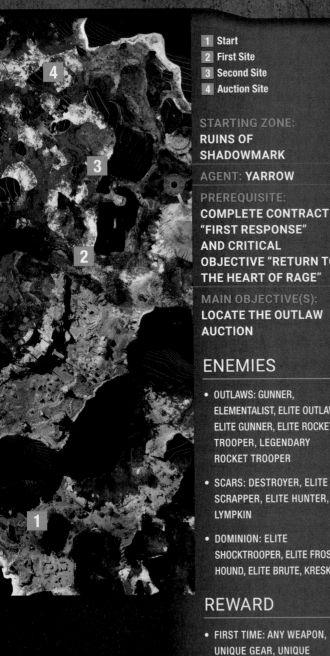

1 Start
2 First Site
3 Second Site
4 Auction Site

STARTING ZONE:
RUINS OF SHADOWMARK

AGENT: YARROW

PREREQUISITE:
COMPLETE CONTRACT "FIRST RESPONSE" AND CRITICAL OBJECTIVE "RETURN TO THE HEART OF RAGE"

MAIN OBJECTIVE(S):
LOCATE THE OUTLAW AUCTION

ENEMIES

- OUTLAWS: GUNNER, ELEMENTALIST, ELITE OUTLAW, ELITE GUNNER, ELITE ROCKET TROOPER, LEGENDARY ROCKET TROOPER

- SCARS: DESTROYER, ELITE SCRAPPER, ELITE HUNTER, LYMPKIN

- DOMINION: ELITE SHOCKTROOPER, ELITE FROST HOUND, ELITE BRUTE, KRESKY

REWARD

- FIRST TIME: ANY WEAPON, UNIQUE GEAR, UNIQUE COMPONENT

- REPEAT: ANY WEAPON X2

1 LAUNCH EXPEDITION

After completing the critical path and Yarrow's "First Response" contract, speak to Yarrow in the Freelancers Enclave to begin his next mission. Launch the expedition.

2 TRAVEL TO THE AUCTION SITE

Fly north through the entire length of Fortress of Dawn and set down in Tracks of Midderon at the top of the steps. Locate the equipment and a partial map.

3 INVESTIGATE THE SITE FROM THE MAP

Continue north to the site noted on the map. Interact with the equipment inside one of the ruins. In a planned ambush, Outlaws charge your location. As you battle them, watch out for the familiar laser sights from the Elite Rocket Troopers and evade their projectiles. Eliminate every last ambusher to acquire a Freelancer link, which points to another site.

4 LOCATE AND DISRUPT THE AUCTION

The site is marked on your map, so make your way farther north into the Dawn Gates to find a large number of Outlaws. Start picking these guys off early to lessen their numbers. Area-of-effect abilities are great for clearing them out. A Legendary Rocket Trooper can cause trouble if left unchecked. Finish off the Elite Outlaw troops and Elementalists, while recovering the three fragments on the piles of auction items. These fragments are easy to find, as there are objective markers noting each location.

ELIMINATE THE SCAR BUYER

Once the Outlaws are eliminated, the Scar buyer spawns from a hive—along with a lot of firepower. Lympkin, a powerful Enforcer, should be your main focus, but you must deal with the entire crew.

If possible, pull smaller groups of enemies away from the pack. If you're lucky, maybe you can isolate the buyer.

ELIMINATE THE DOMINION BUYER

The Outlaws and Scars have been defeated. That leaves one faction: the Dominion. The Dominion buyer, Kresky, is your target and most similar to a Storm Valkyrie. Again, the buyer brings a large squad of troops. Avoid being surrounded and stay on the move. Once the boss is defeated, you must continue to eliminate the remaining Dominion troops.

Follow up with Yarrow back at the fort to complete the mission.

IMPOSTOR!

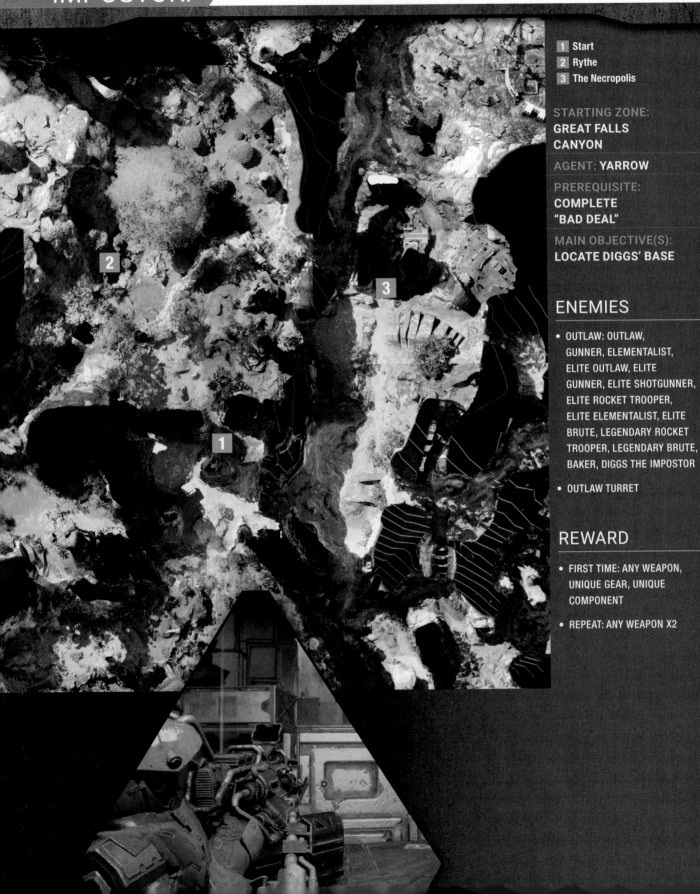

1 Start
2 Rythe
3 The Necropolis

STARTING ZONE:
GREAT FALLS CANYON

AGENT: **YARROW**

PREREQUISITE:
COMPLETE "BAD DEAL"

MAIN OBJECTIVE(S):
LOCATE DIGGS' BASE

ENEMIES

- OUTLAW: OUTLAW, GUNNER, ELEMENTALIST, ELITE OUTLAW, ELITE GUNNER, ELITE SHOTGUNNER, ELITE ROCKET TROOPER, ELITE ELEMENTALIST, ELITE BRUTE, LEGENDARY ROCKET TROOPER, LEGENDARY BRUTE, BAKER, DIGGS THE IMPOSTOR

- OUTLAW TURRET

REWARD

- FIRST TIME: ANY WEAPON, UNIQUE GEAR, UNIQUE COMPONENT

- REPEAT: ANY WEAPON X2

1 LAUNCH EXPEDITION

Speak to Yarrow and Freelancer Rythe after completing the "Bad Deal" quest. It's time to track down Diggs, so launch the expedition. You begin in Korox Shallows in southeast Great Falls Canyon.

2 MEET RYTHE IN EDDIAN GROVE

Travel northwest through Great Falls Canyon to the west side of Eddian Grove. Rythe currently battles a group of Outlaws, so help her out. Repair the Freelancer if she goes down. Watch out for Legendary and Elite Outlaw Rocket Troopers, but make sure they don't get any surprise shots on you. When Baker shows up, take him down to complete the objective.

3 ENTER THE NECROPOLIS AND INVESTIGATE THE OUTLAW DEN

Fly east just inside East Gate and enter the Necropolis. Follow the cave until you reach a group of Outlaws and a turret. Peek around the corner and take down the big gun first, then eliminate the troops (including a pair of Elite Rocket Troopers on the right). After clearing out the enemy, destroy the power supply behind Freelancer Hopkins to release him.

ELIMINATE OUTLAWS

Two more Freelancers are held in the next room, surrounded by a tougher group of Outlaws. Release Freelancers Kriss atop the central platform, and Maa, located in the left corner, as soon as possible. Next, start eradicating the large group of Elite Outlaws, including Shotgunners and Elementalists. Stay on the move as you loop between the lower and upper levels. Repair downed Freelancers whenever the need arises. Once you complete the objective, proceed out the southwest doorway.

The next chamber holds a small number of Brutes: one Legendary and three Elite. Avoid their elemental attacks whenever possible, and hit them hard with your most powerful abilities. It doesn't help to let a Brute's shield regenerate without reducing its armor, so focus on one Brute at a time. The three Freelancers continue to support. If you spot one down, swiftly repair the javelin. It isn't necessary to defeat the Brutes; continue to explore the Outlaw den once you're ready to resume.

DRAW OUT AND DEFEAT DIGGS

Follow the passageway into the final chamber. In order to draw out Diggs, you must defeat the initial group of Outlaws. Elite Outlaws, Gunners, Shotgunners, and Elementalists all attempt to keep you and the four Freelancers away from their boss. When Diggs emerges, he's marked with a target. The special Lancer has the ability to fire a salvo of rockets, so be ready to evade the attack and use columns as cover. Continue to pound Diggs with your biggest attacks until he finally falls.

Back at Fort Tarsis, speak with Yarrow to complete the quest.

AGENT CONTRACTS

POSSIBLE OBJECTIVES

For all 15 Agent Contracts, we provide a list of possible objectives. These represent a sampling of available objectives during these contracts. As you progress through an agent's contracts, the selection of objectives grows. The fourth and fifth contracts for each agent include tougher variants of previous objectives. These contracts are also repeatable during the endgame.

BRIN

FACTION: SENTINELS

LOCATION: FAR WEST SIDE OF FORT, AT TOP OF STEPS

Pirndei Bletch: Always test the load before lifting. Is that so hard to remember?

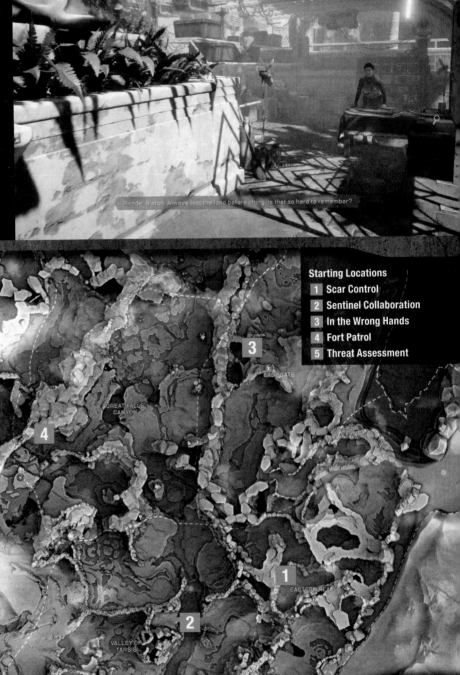

Starting Locations

1. Scar Control
2. Sentinel Collaboration
3. In the Wrong Hands
4. Fort Patrol
5. Threat Assessment

SCAR CONTROL

STARTING POINT: THE LOST ROAD, EASTERN REACH

PRIMARY REGIONS: EASTERN REACH, EAST GATE

PREREQUISITE: COMPLETE AGENT QUEST "PREVENTATIVE PRECAUTIONS"

MAIN OBJECTIVE(S): ELIMINATE THE SCAR THREAT

REWARD

- FIRST TIME: ANY WEAPON, UNIQUE GEAR

- REPEAT: ANY WEAPON

Hit the Scar operation now to stop them from threatening Fort Tarsis. You must complete three tasks in Bastion to complete the contract.

POSSIBLE OBJECTIVES

MAIN OBJECTIVE	ENEMY	HOW TO COMPLETE
Eliminate Scar Hives	Scars	Destroy three hives, then defeat remaining enemies.
Rescue Arcanist Civilians	Scars	Free the civilians then clear remaining enemies.
Find and Recover Data from Arcanist Device	Scars	Find Arcanist device, activate it, and defend the area until data recovered. Defeat remaining enemies.
Silence Volatile Shaper Relic	Scars	Defeat enemies near Shaper relic, while recovering and delivering six fragments.
Destroy Scar Weapon Stockpiles	Scars	Destroy five stockpiles, then defeat remaining enemies.
Collect Fallen Sentinels' Signets	Scars, Wolven	Fight off Scars while recovering four signets. Wolven join Scars with some fighting amongst the two sides. After signets are recovered, you may need to defeat two Scar Leaders and the remaining enemies.
Eliminate Two Scar Leaders	Scars	Eliminate targeted Scars.
Aid Sentinels in Combat	Scars	Assist Sentinels against Scars. Repair downed Sentinels and destroy hives as soon as possible. Without hives, defeat targeted Scar (Elite Scar Hunter) along with remaining Scars.

SENTINEL COLLABORATION

STARTING POINT: STONE BRIDGE, VALLEY OF TARSIS

PRIMARY REGION: VALLEY OF TARSIS

PREREQUISITE: COMPLETE AGENT QUEST "ENEMY MINE"

MAIN OBJECTIVE(S): AID AND REINFORCE SENTINEL PATROLS

REWARD

- FIRST TIME: ANY WEAPON, UNIQUE GEAR
- REPEAT: ANY WEAPON

Aid and reinforce Sentinel patrols as they search for threats to Fort Tarsis. You must complete three tasks in Bastion to complete the contract.

POSSIBLE OBJECTIVES

MAIN OBJECTIVE	ENEMY	HOW TO COMPLETE
Find Missing Sentinel Patrol	Scars	Free the Sentinels that have been trapped by the Scar.
Find Missing Sentinel Patrol	Skorpions	Rescue Sentinels trapped in Skorpion webbing.
Collect Fallen Sentinels' Signets	Scars, Wolven	Find and collect all signets from the fallen Sentinels.
Help Ambushed Sentinels	Scars	Assist Sentinels with destroying two turrets. Defeat remaining enemies, including targeted enemy. Repair downed Sentinel javelins to get them back in the fight.
Support Sentinel Assault Team's Raid	Skorpions	Destroy all Skorpion eggs in the area and eliminate remaining Skorpions.
Support Sentinel Assault Team's Raid	Scar	Destroy Scar stcckpiles by finding three explosives and planting them at three stockpile locations. When a bomb is planted, arm the bomb. Once armed, a timer begins and the bomb explodes, destroying the stockpile when it reaches zero. Destroy all three and elminate the remaining enemies.
Support Sentinel Assault Team's Raid	Scar	Destroy the Scar Bunkers (3) and eliminate remaining Scar.
Help Ambushed Sentinels	Dominion	Assist Sentinels by defeating a group of Dominion ambushers and eliminate the targeted enemy. Repair downed Sentinels to get them back in the fight.

IN THE WRONG HANDS

STARTING POINT: SILENT PATH, EAST GATE

PRIMARY REGION: EMERALD ABYSS

PREREQUISITE: COMPLETE AGENT QUEST "RESEARCH AND RESCUE"

MAIN OBJECTIVE(S): RECOVER SHAPER FRAGMENTS TO AVOID MISUSE

REWARD

- FIRST TIME: ANY WEAPON, UNIQUE GEAR
- REPEAT: ANY WEAPON

Silence Shaper relics and recover their fragments to keep them from being misused. You must complete three tasks in Bastion to complete the contract.

POSSIBLE OBJECTIVES

MAIN OBJECTIVE	ENEMY	HOW TO COMPLETE
Silence Volatile Shaper Relic	Elementals	Recover and replace all of the Shaper fragments to stabilize the Shaper relic, then eliminate all remaining enemies.
Silence Volatile Shaper Relic	Dominion, Wolven, Anrisaur, Brute, Skorpion	Recover and replace all of the Shaper fragments to stabilize the Shaper relic, then eliminate all remaining enemies.
Gather Shaper Data from Arcanist Beacons	Outlaws, Anrisaur	Assist Sentinels with defeating Outlaws. Activate beacon and defend area. Defeat Outlaws. Travel to second beacon, activate it, and defend area. Defeat remaining enemies. Repair downed Sentinels.
Protect Sentinel Cargo	Scars	Assist Sentinels with defeating Scars (hives). Repair downed Sentinels to get them back in fight. Defeat Escari.
Recover Shaper Fragments	Scars, Seeker Mines, Scar Grenadier	Find and collect all Shaper fragment pieces.
Recover Shaper Fragments	Scar, Scar Turrets	Find and collect all Shaper fragment pieces, destroy Scar turrets and eliminate targeted Scar.
Recover Shaper Fragment from Dominion Spy	Dominion	Search for three clues. Follow clues into Eddian Grove, Great Falls Canyon. Defeat enemies to draw out spy. Spy (Elite Valkyrie) is joined by a Fury and more Dominion. Collect Shaper fragment dropped by spy.
Shut Down Dominion Gate	Dominion	Destroy six anchors. Destroy two anchors beside gate. Defeat remaining enemies.

FORT PATROL

STARTING POINT: TEARS OF LIATRELLE, GREAT FALLS CANYON

PRIMARY REGION: VARIOUS

PREREQUISITE: COMPLETE AGENT CONTRACT "ONE OF US"

MAIN OBJECTIVE(S): COMPLETE SENTINEL CONTRACTS

REWARD

- FIRST TIME: ANY WEAPON, UNIQUE GEAR, UNIQUE COMPONENT
- REPEAT: ANY WEAPON X2

Assist Sentinel Brin as she finds and stops threats to Fort Tarsis. This contract features tougher variants of many events within Brin's previous contracts. This contract becomes repeatable during the endgame. You must complete all contracts first.

POSSIBLE OBJECTIVES

MAIN OBJECTIVE	ENEMY	HOW TO COMPLETE
Collect Fallen Sentinels' Signets	Scars, Wolven	Recover four signets.
Rescue Arcanist Civilians	Scar	Rescue Arcanists from Scar cages and eliminate remaining Scar.
Destroy Scar Weapon Stockpiles	Scars	Destroy five stockpiles. Defeat remaining enemies.
Find and Recover Data from Arcanist Device	Scars	Find and activate Arcanist device. Defend area while data recovered. Defeat remaining enemies.
Rescue Sentinels from Skorpions	Skorpions	Rescue four Sentinels by destroying webbing. Repair downed Sentinels. Defeat remaining enemies.
Rescue Sentinels from Scars	Scars	Rescue four Sentinels (destroy power supplies). Watch for mines and repair downed Sentinels to get them back in fight. Defeat remaining enemies.
Help Ambushed Sentinels	Dominion	Assist Sentinels by defeating a group of Dominion ambushers and eliminate a targeted enemy. Repair downed Sentinels to get the back into the fight.
Help Ambushed Sentinels	Dominion	Defeat Dominion enemies. Repair downed Sentinels. Defeat Dominion target (Legendary Valkyrie or Brute). Defeat remaining enemies.
Gather Shaper Data from Arcanist Beacons	Outlaws	Defeat Outlaws. Repair downed Sentinels. Activate beacon and defend the large objective zone until scan complete. Defeat remaining Outlaws. Travel to second beacon and activate it. Defend zone against more Outlaws and anrisaur. Defeat remaining enemies.
Recover Shaper Fragments	Scars	Recover six fragments. Watch for mines and seekers.
Silence Volatile Shaper Relic (fragments)	Scars, Skorpions	Defeat enemies near relic. Deliver six fragments to relic. Skorpions spawn from relic while volatile. Defeat targeted Scar (Legendary Scar Enforcer). Defeat remaining enemies.
Silence Volatile Shaper Relic (fragments)	Dominion, Wolven, Skorpions, Anrisaur, Brutes	Defeat enemies. Return six fragments to Shaper relic. Defeat remaining enemies (Dominion).
Silence Volatile Shaper Relic (echoes)	Elementals	Deliver echoes to volatile Shaper relic. Ash Elementals spawn from relic. Nodes zap you out of the air. Defeat remaining enemies.
Support Sentinel Assault Team's Raid	Scars	Join Sentinels as they destroy three hives. It isn't necessary to join them first; you can go straight to the hives. Defeat remaining enemies.
Support Sentinel Assault Team's Raid	Scars	Join Sentinels as they destroy three Scar stockpiles. Pick up an explosive and place it next to one of the stockpiles. Defend the area while it's armed, then flee the area before detonation. Do this for all three stockpiles, then defeat the remaining Scars.

LEGENDARY CONTRACT: THREAT ASSESSMENT

STARTING POINT: SANADEEN'S PASS, ACADEMY RUINS

PRIMARY REGION: VARIOUS

PREREQUISITE: COMPLETE FORT PATROL

MAIN OBJECTIVE(S): COMPLETE SENTINEL CONTRACTS

REWARD

- FIRST TIME: ANY WEAPON, UNIQUE GEAR, UNIQUE COMPONENT

- REPEAT: ANY WEAPON X2

Assist Sentinel Brin as she finds and stops threats to Fort Tarsis. This contract features tougher variants of many events within Brin's previous contracts. This contract becomes repeatable during the endgame but can only be done a limited number of times per week. You must complete all contracts first.

POSSIBLE OBJECTIVES

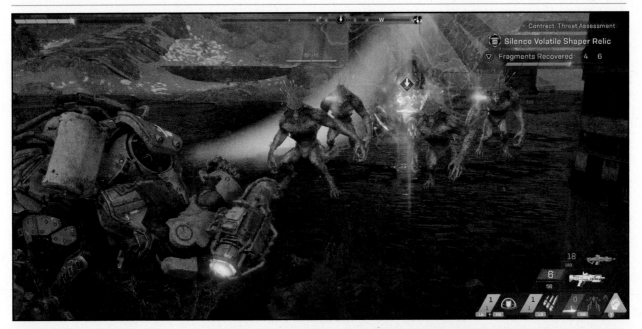

MAIN OBJECTIVE	ENEMY	HOW TO COMPLETE
Eliminate Two Scar Leaders	Scars	Defeat two targeted Scar Leaders (Legendary Enforcer and Hunter). Defeat remaining enemies.
Gather Shaper Data from Arcanist Beacons	Outlaws, Anrisaur	Defeat Outlaws. Activate beacon. Defend area while data scanned. Defeat remaining Outlaws. Travel to second beacon. Defend area against Outlaws. Repair downed Sentinels. Defeat remaining enemies.
Help Ambushed Sentinels	Dominion	Defeat Dominion enemies. Defeat Dominion target (Legendary Valkyrie). Defeat remaining enemies. Repair downed Sentinels.
Protect Sentinels' Cargo	Scars	Defeat Scars. Defend cargo from Scars.
Recover a Shaper Fragment from a Dominion Spy	Dominion	Search camp for three clues. Locate Dominion spy in new location. Defeat enemies to draw out spies (Legendary Valkyrie and Fury). Collect Shaper fragment.
Shut Down Dominion Gate	Dominion	Destroy six anchors. Destroy two anchors beside gate. Defeat remaining enemies.
Silence Volatile Shaper Relic	Dominion, Wolven, Skorpions, Anrisaur, Brute	Return six fragments to Shaper relic. Defeat remaining enemies (Dominion).
Support Sentinel Assault Team's Raid	Skorpions	Assist Sentinels as they destroy Skorpion eggs. Defeat remaining Skorpions. Repair downed Sentinels.
Find Missing Sentinel Patrol	Scar	Free captured Sentinels from Scar cages and destroy the Scar hives, then eliminate all remaining enemies.
Destroy Scar Weapon Stockpiles	Scar	Destroy Scar weapon stockpiles, then eliminate remaining enemies.
Silence Volatile Shaper Relic (fragments)	Scar, Skorpion	Defeat enemies near relic. Deliver six fragments to the relic. Skorpions spawn from relic while it's volatile. Defeat targeted Legendary Scar, then defeat remaining enemies.
Support Sentinel Assault Team's Raid	Scar	Destroy Scar stockpiles by finding three explosives and planting them at three stockpile locations. When a bomb is planted, arm the bomb. Once armed, a timer begins and the bomb explodes, destroying the stockpile when it reaches zero. Destroy all three and eliminate the remaining enemies.
Recover Shaper Fragments	Scar, Scar Turrets	Find and collect all Shaper fragment pieces; destroy Scar and eliminate targeted Scar.

MATTHIAS

FACTION: ARCANISTS

LOCATION: WEST SIDE OF FORT INSIDE OFFICE, JUST NORTH OF COMMON AREA

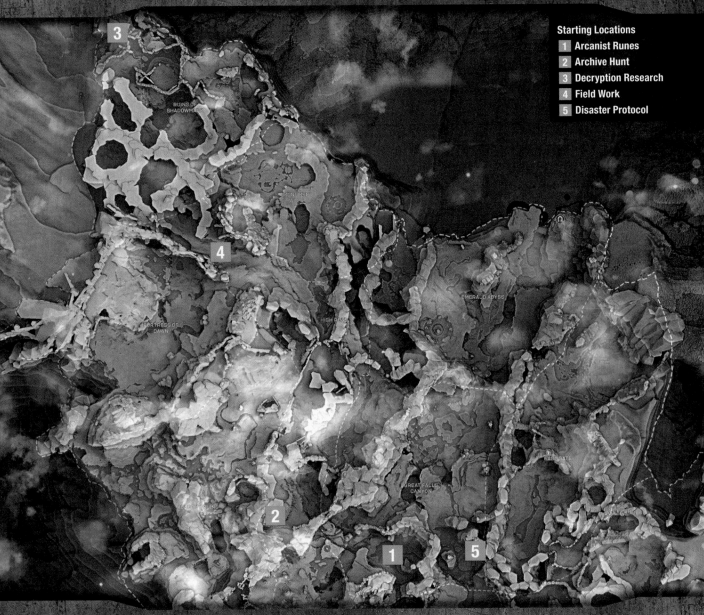

Starting Locations

1. Arcanist Runes
2. Archive Hunt
3. Decryption Research
4. Field Work
5. Disaster Protocol

ARCANIST RUNES

REWARD

STARTING POINT: THE BOWL, GREAT FALLS CANYON

PRIMARY REGION: GREAT FALLS CANYON

PREREQUISITE: COMPLETE AGENT QUEST "SEE IN THE DARK"

MAIN OBJECTIVE(S): ASSIST MATTHIAS WITH FIELD RESEARCH

- FIRST TIME: ANY WEAPON, UNIQUE GEAR
- REPEAT: ANY WEAPON

Recover runes for Matthias as he continues his search for the Elysian manuscript. You must complete three tasks in Bastion to complete the contract.

POSSIBLE OBJECTIVES

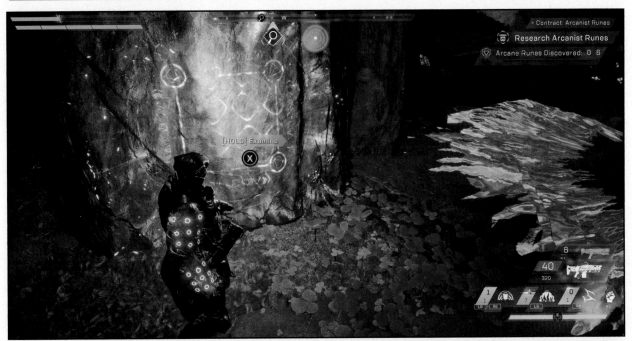

MAIN OBJECTIVE	ENEMY	HOW TO COMPLETE
Repair Arcanist Research Beacons	Anrisaur	Repair beacons and eliminate nearby Anrisaur.
Ensure Planned Field Site Is Secure	Scars	Eliminate Scars from area. Defeat targeted Scar (Legendary Scar Hunter).
Investigate Former Scar Camp	Wolven	Recover six fragments while fending off Wolven and Frost Wolven. The area may be mined, so watch your step. Shoot mines that sit near a fragment from afar.
Investigate Unknown Disturbance	Ursix, Wolven	Recover six fragments and return them to the Shaper relic. Defeat Ursix, as well as Wolven that spawn. Fragments and Ursix can be dealt with in either order, but both must be done. Avoid meeting up with Ursix at relic.
Investigate Unusual Disturbance	Wolven	Recover six fragments and return them to the Shaper relic. Fend off the Wolven and Frost Wolven.
Recover Arcanist Records at Site	Skorpions	Remain near records and defend against Skorpions. Remember, the more enemies within the circle, the slower it progresses. No need to clear out remaining enemies.
Recover Arcanist Runes in the Area	Skorpions or Scars	Discover six Arcanist runes while fending off Skorpions or Scars. If the former, clear out as many eggs as possible beforehand. Eliminate Scars from area.
Research Arcanist Runes	Scars	Discover six Arcanist runes while defeating Scars. No need to defeat remaining enemies.

ARCHIVE HUNT

STARTING POINT: WATCHTOWER OF ARATH, HIGH ROAD

PRIMARY REGIONS: ACADEMY RUINS, HIGH ROAD

PREREQUISITE: COMPLETE AGENT QUEST "ANCIENT FOOTSTEPS"

MAIN OBJECTIVE(S): INVESTIGATE ARCANIST SECRETS

REWARD

- FIRST TIME: ANY WEAPON, UNIQUE GEAR
- REPEAT: ANY WEAPON

As more and more Arcanists retreat to Fort Tarsis, they need your help even more with their search for Raban Maur's archive. You must complete three tasks in Bastion to complete the contract.

POSSIBLE OBJECTIVES

MAIN OBJECTIVE	ENEMY	HOW TO COMPLETE
Ensure Research Site Is Secure	Skorpions	Eliminate enemies.
Investigate Unusual Disturbance	Ursix, Wyvern or Skorpions	Recover six Shaper relic fragments and defeat the beast.
Recover Historical Documents	Wolven	Defend archive against enemies.
Investigate Failing Arcanist Beacons	Scar	Repair the beacons and eliminate Scar in the area.
Recover Dangerous Shaper Fragments	Skorpion, Skorpion Eggs	Find and collect all Shaper Fragments.
Ensure Area Is Clear of Predators	Wolven, Wyverns	Eliminate all Wolven and Wyverns in the area.
Recover Arcanist Records	Brute, Brute (Fire), Wolven, Wolven (Frost)	Complete the Arcanist time trial by collecting all the signals. Once collected, defend the area while you attune the vault. Once attuned, eliminate remaining enemies.
Investigate Strange Disturbance	Scar	Collect and deposit all Shaper fragments to the relic. Eliminate Scar and targeted Scar.

DECRYPTION RESEARCH

STARTING POINT: **THE DAWN GATES, RUINS OF SHADOWMARK**

PRIMARY REGION: **RUINS OF SHADOWMARK**

PREREQUISITE: **COMPLETE AGENT QUEST "TELL ME MAUR"**

MAIN OBJECTIVE(S): **LOCATE GROUP OF MISSING RESEARCHERS**

REWARD

- FIRST TIME: ANY WEAPON, UNIQUE GEAR

- REPEAT: ANY WEAPON

Assist Matthias and his colleagues with their work and help uncover the truth. You must complete three tasks in Bastion to complete the contract.

POSSIBLE OBJECTIVES

MAIN OBJECTIVE	ENEMY	HOW TO COMPLETE
Investigate Missing Arcanist	Wolven, Titan	Eliminate threat (Wolven, then Lesser Ash Titan). Ensure Arcanist safety by unlocking their cage.
Recover Arcane Runes	Anrisaur	Collect all the arcanist runes.
Locate Missing Arcanists in the Area	Skorpions	Rescue four Arcanists from webbing. Eliminate remaining Skorpions.
Recover Ancient Arcane Runes	Skorpions	Collect all the arcanist runes.
Investigate Strange Disturbance	Brutes, Scars	Return six fragments to Shaper relic. Brutes spawn from relic. Three Scar Hives appear after returning three fragments.
Recover Lost Historical Records	Wolven, Skorpions	Locate energy source. Activate vault. Attune the vault by passing through eight attunement points in 1:00. Fight Wolven during attunement, and Skorpions during defense of vault.
Investigate Failing Devices	Ursix, Skorpions	Power three devices and eliminate predators (Elite Ursix).
Investigate Dangerous Activity	Dominion, Titan	Destroy five machines within 2:00, or Ancient Ash Titan awakens.

FIELD WORK

STARTING POINT: GIANT'S CROSSROADS, HIGH ROAD

PRIMARY REGION: VARIOUS

PREREQUISITE: COMPLETE AGENT QUEST "SECRETS OF THE AUSPEX"

MAIN OBJECTIVE(S): COMPLETE ARCANIST CONTRACTS

REWARD

- FIRST TIME: ANY WEAPON, UNIQUE GEAR, UNIQUE COMPONENT
- REPEAT: ANY WEAPON X2

Use your skills and experience to further the Arcanists' work outside the walls of Fort Tarsis. This contract features tougher variants of many events within Matthias' previous contracts. This contract becomes repeatable during the endgame. You must complete all contracts first.

POSSIBLE OBJECTIVES

MAIN OBJECTIVE	ENEMY	HOW TO COMPLETE
Recover Arcanist Lost Research	Wolven	Defend archive while data recovered.
Investigate Failing Devices	Scars	Power three devices. Eliminate the Scars.
Recover All Shaper Fragments	Skorpions	Recover six fragments.
Investigate Failing Monitoring Devices	Anrisaur, Dominion	Power three devices. Clear out wildlife. Eliminate Dominion.
Ensure Recovery of Lost Research	Skorpions	Defend archive while data recovered. Skorpions very aggressive.
Investigate the Unusual Disturbance	Dominion, Skorpions, Brutes, Ursix, Elementals	Deliver six fragments to Shaper relic. You must deal with a couple different enemy types, such as Brutes and Dominion or Elite Ursix with Ash Elementals. Silence the relic to stop the wildlife from spawning.
Investigate Potential Research Site	Wolven, Wyvern	Eliminate all wildlife.
Investigate Potential Research Site	Skorpions	Eliminate the Skorpions.
Investigate Unusual Disturbance	Skorpions, Dominion	Collect and deposit all Shaper fragments into the relic to silence it. Eliminate all the remaining Dominion.
Recover and Catalog Arcanist Runes	Skorpions, Titans	Discover six Arcanist runes. Eliminate predators. Defeat Skorpions, then two Lesser Ash Titans.
Recover Arcanist Runes to Aid Research	Scars	Discover six Arcanist runes. Eliminate the Scars.
Recover Lost Historical Documents	Wolven, Wolven (Frost), Brute, Brute (Fire)	Complete the Arcanist time trial by collecting all the signals. Once collected, defend the area while you attune the vault. Once it's attuned, eliminate remaining enemies.
Silence Relic and Ensure Safety of Area	Scars, Elementals	Defeat the Scars. Return six fragments to Shaper relic. Ash Elementals spawn from relic and Scars gate into area as you return fragments. Look out for Legendary Enforcer and Elite Luminary, though it isn't necessary to defeat them. Quickly gather the fragments and silence the relic.
Ensure Area Is Secure for Research Site	Scars	Clear Scars from area. Defeat targeted Scar (Legendary Hunter).

LEGENDARY CONTRACT: DISASTER PROTOCOL

STARTING POINT: **KOROX SHALLOWS, GREAT FALLS CANYON**

PRIMARY REGION: **VARIOUS**

PREREQUISITE: **COMPLETE "FIELD WORK"**

MAIN OBJECTIVE(S): **COMPLETE ARCANIST CONTRACTS**

REWARD

- FIRST TIME: ANY WEAPON, UNIQUE GEAR, UNIQUE COMPONENT
- REPEAT: ANY WEAPON X2

Use your skills and experience to further the Arcanists' work outside the walls of Fort Tarsis. This contract features tougher variants of many events within Matthias' previous contracts. This contract becomes repeatable during the endgame but can only be done a limited number of times per week. You must complete all contracts first.

POSSIBLE OBJECTIVES

MAIN OBJECTIVE	ENEMY	HOW TO COMPLETE
Secure Area for Potential Research Site	Scars	Eliminate Scars. Eliminate targeted Scar (Legendary Enforcer). Defeat remaining enemies.
Investigate Former Scar Camp	Wolven	Gather six fragments.
Investigate Disturbance in the Area	Wolven, Skorpions, Brutes, or Ursix	Silence volatile Shaper relic by returning six fragments. If present, defeat Elite Ursix.
Recover the Lost Research	Skorpions	Defend archive against enemies until scan is complete.
Investigate Disturbance in the Area	Wolven, Wolven (Frost), Skorpions, Brute	Collect and deposit all fragments of the relic to silence it.
Investigate Missing Arcanist	Wolven, Titan	Eliminate all enemies and free the arcanist.
Recover Lost Arcanist Runes	Skorpions, Dominion	Find and Collect all the Arcanist Runes.
Recover Lost Arcanist Runes	Brute, Titan	Find and Collect all the Arcanist Runes.
Find Missing Arcanist Researchers	Skorpions	Free four Arcanists from webbing. Eliminate Skorpions.
Secure Area for Research Site	Skorpions	Secure the site by eliminating all Skorpions in the area.
Investigate Failing Research Devices and Stabilize the Area	Titan, Elementals	Power three devices. Eliminate predators (Lesser Ash Titan, Elementals). If alone, it's best to take down the Titan(s) first, due to the time it takes to interact with each device. You may see up to three Titans.
Investigate Dangerous Energy Readings	Dominion, Titan	Destroy five machines within 2:00. Defeat remaining enemies.
Secure Area for Potential Research Site	Scar	Eliminate Scar and targetted Scar.

YARROW

FACTION: FREELANCERS

LOCATION: FREELANCERS ENCLAVE, NEXT TO BULLETIN BOARD

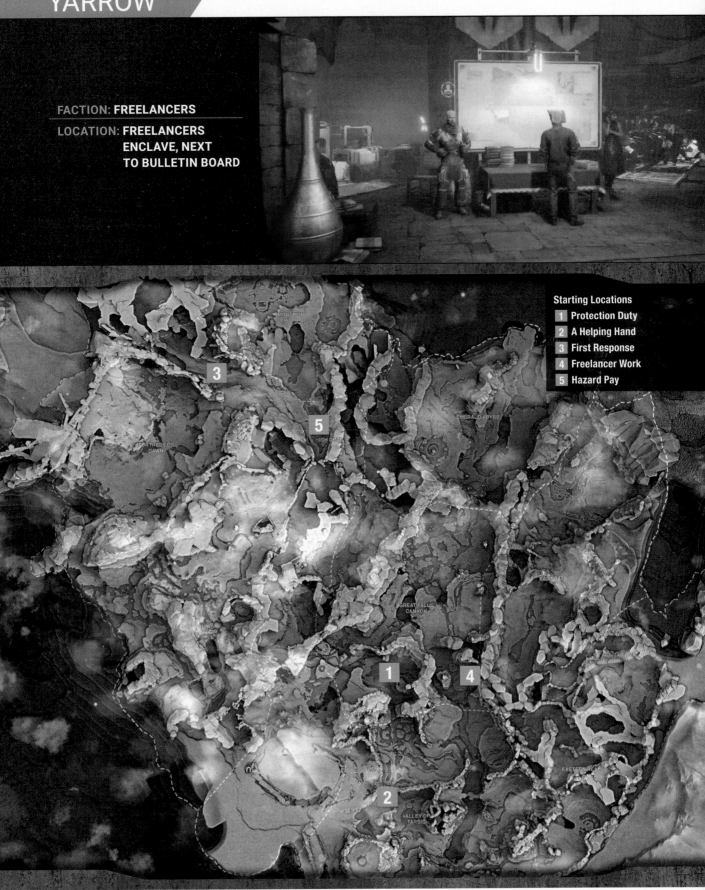

Starting Locations

1. Protection Duty
2. A Helping Hand
3. First Response
4. Freelancer Work
5. Hazard Pay

PROTECTION DUTY

STARTING POINT: THE BOWL, GREAT FALLS CANYON

PRIMARY REGION: GREAT FALLS CANYON

PREREQUISITE: COMPLETE AGENT QUEST "WHAT FREELANCERS DO"

MAIN OBJECTIVE(S): ENSURE THE SAFETY OF CITIZENS BEYOND THE WALL

REWARD

- FIRST TIME: ANY WEAPON, UNIQUE GEAR

- REPEAT: ANY WEAPON

Show people what a Freelancer does by completing Yarrow's contracts. You must complete three tasks in Bastion to complete the contract.

POSSIBLE OBJECTIVES

MAIN OBJECTIVE	ENEMY	HOW TO COMPLETE
Assist the Freelancer	Scars	Assist Freelancer against Scars, including reinforcements. Eliminate the targeted Scar.
Assist the Sentinels	Scars	Assist the three Sentinels against the Scar invasion.
Defeat the Outlaws	Outlaws	Destroy two Outlaw Turrets and eliminate Outlaws.
Help the Freelancers	Scars	Rescue four Freelancers by destroying their shackles (power supply behind the Freelancer). Once freed, they assist in fighting. Defeat the Scars. May include a final objective: eliminate targeted Scar. Eliminate Scar reinforcements.
Investigate Missing Freelancers	Scars	Defeat the Scar Enforcer and recover the link (use radar). Once recovered, complete the Freelancer's contract to destroy three Scar caches. Pick up an explosive from link location and place it at each cache. Defend the area while it's armed. Defeat remaining Scars.
Recover Stolen Supplies	Outlaws	Locate stolen supplies. Eliminate Outlaws and recover the supplies (use radar).
Rescue the Arcanists	Skorpions	Rescue four Arcanists by destroying the webbing that holds them in place. Eliminate remaining Skorpions.

A HELPING HAND

STARTING POINT: STRIDER WAY, VALLEY OF TARSIS

PRIMARY REGION: VALLEY OF TARSIS

PREREQUISITE: COMPLETE AGENT QUEST "A CRY FOR HELP"

MAIN OBJECTIVE(S): COMPLETE AGENT QUEST "A CRY FOR HELP"

REWARD

- FIRST TIME: ANY WEAPON, UNIQUE GEAR
- REPEAT: ANY WEAPON

Assist other Freelancers and disrupt Outlaw plans by completing Yarrow's contracts. You must complete three tasks in Bastion to complete the contract.

POSSIBLE OBJECTIVES

MAIN OBJECTIVE	ENEMY	HOW TO COMPLETE
Assist Sentinels in the Field	Outlaws	Free two Sentinels being held in Outlaw cages. Then destroy four stockpiles. Eliminate targeted Outlaw and reinforcements. Repair downed Sentinels to get them back in fight.
Recover Freelancer Gear Lost in the Field	Outlaws	Recover four Gear with use of radar. Eliminate Outlaws.
Recover Lost Freelancer Gear	Outlaws, Wolven	Recover five Gear with use of radar. Outlaws and possible Wolven occupy area. Eliminate remaining Outlaws.
Recover Supplies Stolen from Cargo Strider	Outlaws	Eliminate Outlaws. Then search area and collect the supplies.
Sabotage Outlaw Plans to Establish a Camp	Outlaws	Destroy the two Outlaw Turrets. Eliminate Outlaws.
Search for Missing Freelancer	Scars	Search area using radar and recover link by defending area against Scars. Eliminate Scars. Complete the Freelancer's contract (new objective).
Search for and Assist Ambushed Sentinels	Skorpions	Rescue four Sentinels and assist in fight. Eliminate Skorpions.
Stop the Rampaging Beast	Wolven, Ursix	Use radar to search for clues (Wolven in area). Hunt down beast in new location. Defeat the Ursix.

FIRST RESPONSE

STARTING POINT: GIANT'S CROSSROAD, HIGH ROAD

PRIMARY REGION: RUINS OF SHADOWMARK

PREREQUISITE: COMPLETE AGENT QUEST "TEMPTING TARGET"

MAIN OBJECTIVE(S):
DISRUPT OUTLAW INFLUENCE BY COMPLETING CONTRACTS

REWARD

- FIRST TIME: ANY WEAPON, UNIQUE GEAR
- REPEAT: ANY WEAPON

Disrupt the Outlaws' plans and complete contracts they could exploit. You must complete three tasks in Bastion to complete the contract.

POSSIBLE OBJECTIVES

MAIN OBJECTIVE	ENEMY	HOW TO COMPLETE
Assist a Corvus Agent on Assignment	Skorpions, Outlaw	Help Corvus agent eliminate Skorpions. Then defeat Outlaw ambushers. Deal with the Elementalists as soon as possible.
Assist a Fellow Freelancer	Scars	Eliminate the Scar threat and then the Scar reinforcements.
Assist Arcanists with Field Work	Outlaws, Skorpions	Eliminate Outlaw threat. Sentinels assist against the threat; repair them when down. Defend the Arcanists next to the door. Repair two generators when down. Return to the Arcanists and defend against Outlaws until progress is complete. Eliminate remaining Outlaws. Enter and investigate the ruins (The Sovereign Mine). Eliminate the Skorpions. Leave the ruins.
Ensure Safety of Arcanists During Test	Scars	Assist Sentinel with defending Arcanists; remain nearby until scan complete. Defeat Scar onslaught, including the hives they originate from. Eliminate remaining hostiles.
Investigate a Freelancer's Disappearance	Scars	Use the radar to search the area. Clear out the Scars, including Elite Scar Enforcer, and interact with the Freelancer. Pick up one of the explosives next to the body and place it by one of the three Scar caches, noted by the radar. Defend the area while the explosive is armed. Do this for all three caches to complete the objective. Then eliminate Scar reinforcements.
Rescue Crew of Fallen Strider	Outlaws	Use radar to recover the strider battery while dealing with Outlaws in the area. Replace the battery on top of strider. Restart power by landing on side platform of strider, shooting the panel cover, and interacting with it. Then rescue the crew of the fallen strider by releasing the safety hatch. This is done in the same manner, but on the other side of the strider. Eliminate remaining Outlaws, including the leader, Legendary Outlaw Lancer. Once the Outlaws are defeated, free the trapped crew by interacting with the switch on the side of the cargo bay door.
Track Down a Known Outlaw Leader	Outlaws	Eliminate Outlaws at camp, then the targeted Elite Outlaw Lancer. Defeat remaining Outlaws. Use the explosive barrels to your advantage; just be sure to avoid taking damage from them.
Track Down Rampaging Beast	Ursix	Use the radar to find the clue while fending off Wolven. Then hunt down the beast in the new location. Stop the rampage by defeating the beast.

FREELANCER WORK

STARTING POINT: KOROX SHALLOWS, GREAT FALLS CANYON

PRIMARY REGION: VARIOUS

PREREQUISITE: COMPLETE AGENT QUEST "IMPOSTOR"

MAIN OBJECTIVE(S): COMPLETE FREELANCER CONTRACTS

REWARD

- FIRST TIME: ANY WEAPON, UNIQUE GEAR, UNIQUE COMPONENT

- REPEAT: ANY WEAPON X2

New contracts are posted each day, showing that public trust in Freelancers is being restored. This contract features tougher variants of many events within Yarrow's previous contracts. This contract becomes repeatable during the endgame. You must complete all contracts first.

POSSIBLE OBJECTIVES

MAIN OBJECTIVE	ENEMY	HOW TO COMPLETE
Rescue Arcanist Researcher in the Field	Skorpions	Rescue four Arcanists from webbing. Eliminate Skorpions.
Investigate Freelancer Disappearance	Scars	Search area for Freelancer. Recover link from body (defend area from Scars). Eliminate Scars.
Recover Lost Freelancer Gear	Outlaws, Wolven	Recover five Gear. Defeat remaining Outlaws.
Ensure Security for Arcanist Conducting Tests	Scars	Defend Arcanist until scan complete. Eliminate remaining hostiles. Locate second site. Eliminate Scars. Defend objective zone until scan complete. Eliminate remaining Scars.
Assist Ambushed Sentinel Patrol	Skorpions	Rescue four Sentinels from webbing. Eliminate Skorpions. Repair downed Sentinels to get them back in fight.
Assist Sentinels on Patrol	Scars	Eliminate Scars. Repair downed Sentinels.
Recover Supplies Stolen from Cargo Strider	Outlaws	Eliminate Outlaws. Locate and recover supplies.
Investigate Missing Freelancer	Scars	Search area for Freelancer. Recover link from body. Use explosives to destroy three Scar caches. Defend each area while explosive armed, then clear out to avoid detonation. Eliminate Scar reinforcements.
Stop Infamous Outlaw Leader	Outlaws	Eliminate Outlaws. Eliminate targeted Outlaw Leader (Legendary Lancer).
Track Down and Stop Rampaging Beast	Wolven, Ursix	Search for one to three clues at first location. Hunt down beast at second location. Stop rampage (defeat Ursix and Elite Ursix).
Locate and Assist Overdue Sentinels	Outlaws	Free two Sentinels from cages. Destroy four stockpiles. Eliminate targeted Outlaw (Legendary Elementalist). Defeat Outlaw reinforcements.
Assist Fellow Freelancer in the Field	Scars	Eliminate Scars. Defeat Scar reinforcements. Eliminate targeted Scar Leader (Luminary Escari).
Assist Fellow Freelancer in the Field	Scars	Eliminate Scars, Defeat Scar Reinforcements, Eliminate targeted Scar.

LEGENDARY CONTRACT: HAZARD PAY

STARTING POINT: THE HUREEN SLIDE, HIGH ROAD

PRIMARY REGION: VARIOUS

PREREQUISITE: COMPLETE CONTRACT "FREELANCER WORK"

MAIN OBJECTIVE(S): COMPLETE FREELANCER CONTRACTS

REWARD

- FIRST TIME: ANY WEAPON, UNIQUE GEAR, UNIQUE COMPONENT

- REPEAT: ANY WEAPON X2

These contracts are extremely dangerous, intended only for highly skilled Freelancers with a wealth of experience. This contract features tougher variants from many events within Yarrow's previous contracts. This contract becomes repeatable during the endgame, but can only be done a limited number of times per week. You must complete all contracts first.

POSSIBLE OBJECTIVES

MAIN OBJECTIVE	ENEMY	HOW TO COMPLETE
Assist Freelancer on a Contract	Scars	Eliminate Scars. Eliminate Scar reinforcements (hives). Eliminate targeted Scar Leader (Elite Luminary, Legendary Enforcer or Legendary Hunter). Defeat remaining enemies.
Confront Outlaw Threat	Outlaws	Destroy the two turrets. Eliminate Outlaws.
Ensure Arcanist Safety During Tests	Outlaws, Titans	Eliminate Outlaws. Repair downed Sentinel. Defend Arcanists within objective zone. Repair two generators when down, then continue defending Arcanists. Defeat remaining Outlaws. Enter and investigate the ruins. Defeat the Elite Lesser Ash Titans inside. Space is tight; fortunately, their fire rings are limited to ground level. Exit the ruins.
Recover Freelancer Gear Lost in the Field	Outlaws	Recover four Gear. Defeat Outlaws.
Recover Lost Freelancer Gear	Wolven, Outlaws	Recover five Gear.
Help the Freelancers	Scars	Rescue four Freelancers (destroy power supplies). Eliminate targeted Scar (Legendary Enforcer). Defeat Scar reinforcements.
Assist the Corvus Agent in the Field	Skorpions, Outlaws	Eliminate Skorpions. Eliminate Outlaw ambushers.
Assist Ambushed Sentinels on Patrol	Scars	Eliminate Scars. Repair downed Sentinels.
Search for Missing Freelancer	Scars	Search area for Freelancer. Recover link (defend area). Eliminate Scars.
Assist Freelancer on a Contract	Scars	Eliminate Scars, defeat Scar Reinforcements, and eliminate targeted Scar.
Stop a Rampaging Beast	Wolven, Ursix	Find and investigate two or three clues. Hunt down beasts (two Elite Ursix). Use ruins as cover as you avoid their attacks.
Rescue the Strider Crew	Outlaws	Recover and replace battery. Restart power (destroy and interact with panel on left platform). Release safety hatch (panel on right platform). Eliminate remaining Outlaws. Free trapped crew (access panel on cargo bay door).
Rescue Sentinels on Patrol	Outlaw, Outlaw Lancer, Outlaw Elementalist	Free caged Sentinels and destroy the Outlaw stockpiles. Eliminate targeted Outlaw and remaining Outlaw enemies.

FREEPLAY

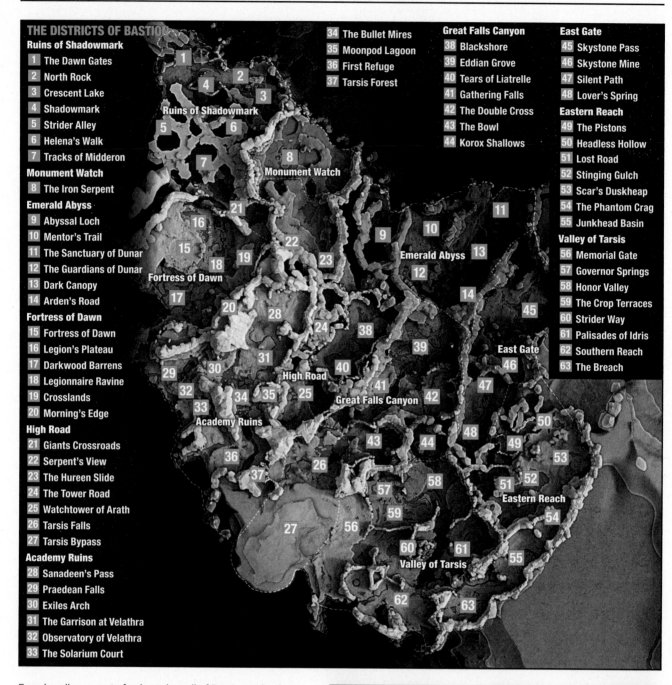

THE DISTRICTS OF BASTION

Ruins of Shadowmark
1 The Dawn Gates
2 North Rock
3 Crescent Lake
4 Shadowmark
5 Strider Alley
6 Helena's Walk
7 Tracks of Midderon

Monument Watch
8 The Iron Serpent

Emerald Abyss
9 Abyssal Loch
10 Mentor's Trail
11 The Sanctuary of Dunar
12 The Guardians of Dunar
13 Dark Canopy
14 Arden's Road

Fortress of Dawn
15 Fortress of Dawn
16 Legion's Plateau
17 Darkwood Barrens
18 Legionnaire Ravine
19 Crosslands
20 Morning's Edge

High Road
21 Giants Crossroads
22 Serpent's View
23 The Hureen Slide
24 The Tower Road
25 Watchtower of Arath
26 Tarsis Falls
27 Tarsis Bypass

Academy Ruins
28 Sanadeen's Pass
29 Praedean Falls
30 Exiles Arch
31 The Garrison at Velathra
32 Observatory of Velathra
33 The Solarium Court

34 The Bullet Mires
35 Moonpod Lagoon
36 First Refuge
37 Tarsis Forest

Great Falls Canyon
38 Blackshore
39 Eddian Grove
40 Tears of Liatrelle
41 Gathering Falls
42 The Double Cross
43 The Bowl
44 Korox Shallows

East Gate
45 Skystone Pass
46 Skystone Mine
47 Silent Path
48 Lover's Spring

Eastern Reach
49 The Pistons
50 Headless Hollow
51 Lost Road
52 Stinging Gulch
53 Scar's Duskheap
54 The Phantom Crag
55 Junkhead Basin

Valley of Tarsis
56 Memorial Gate
57 Governor Springs
58 Honor Valley
59 The Crop Terraces
60 Strider Way
61 Palisades of Idris
62 Southern Reach
63 The Breach

Freeplay allows you to freely explore all of Bastion with other friendly Lancers and is only available with the Privacy Setting set to Public. Gather resources, complete Challenges, clear out enemies, and participate in World Events. Freeplay becomes available early on in the story, during the "Lighting a Fire" critical objective.

There are four start locations, noted by the strider icons, selectable on the Launch Expedition map. To end a freeplay session, access the Map screen and hold the End Expedition button.

THE REGIONS

Bastion is split up into 10 regions. The following region maps show locations of all hidden places, tombs, landmarks, overlooks, and Library lore entries. Each region has a corresponding Challenge earned by discovering all the districts and landmarks within the region.

Freeplay Start

Hidden Place

Landmark

Library Lore

Overlook

Tomb

HIGH ROAD

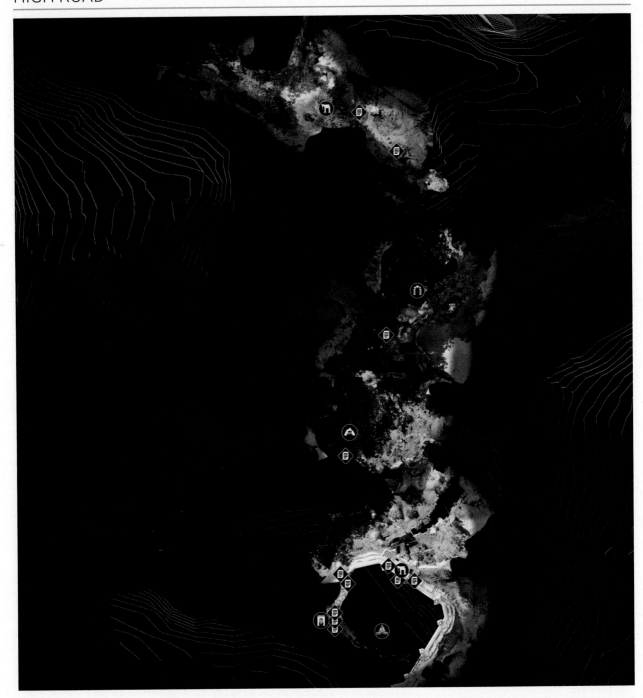

ACADEMY RUINS

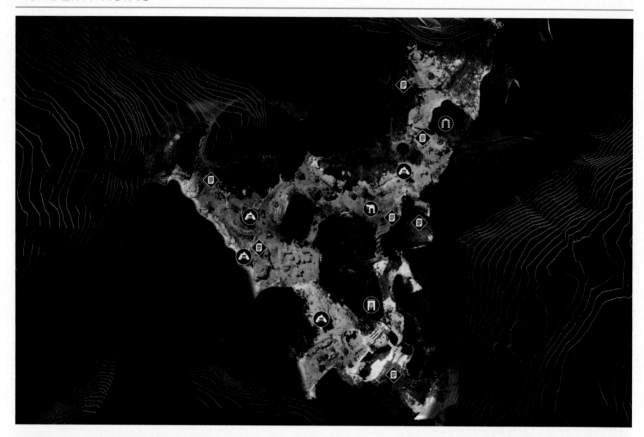

MONUMENT WATCH

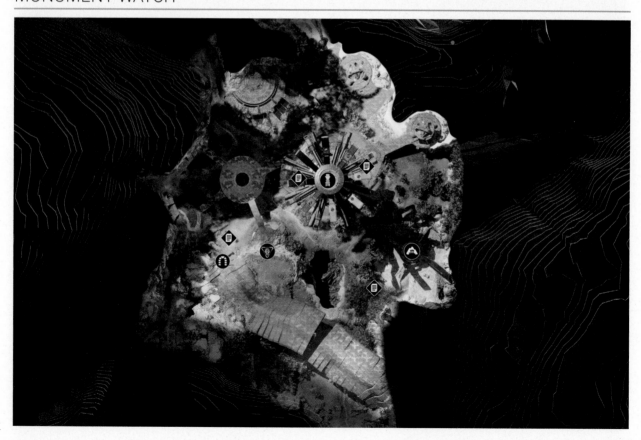

FORTRESS OF DAWN

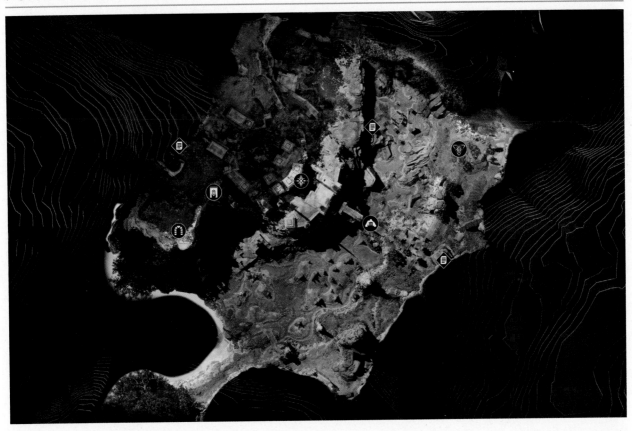

RUINS OF SHADOWMARK

VALLEY OF TARSIS

GREAT FALLS CANYON

EMERALD ABYSS

EAST GATE

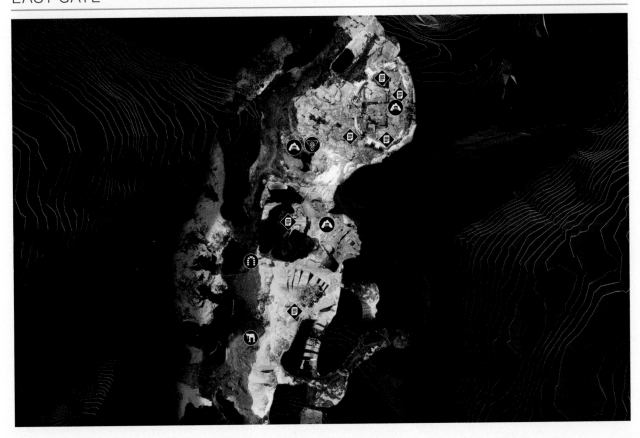

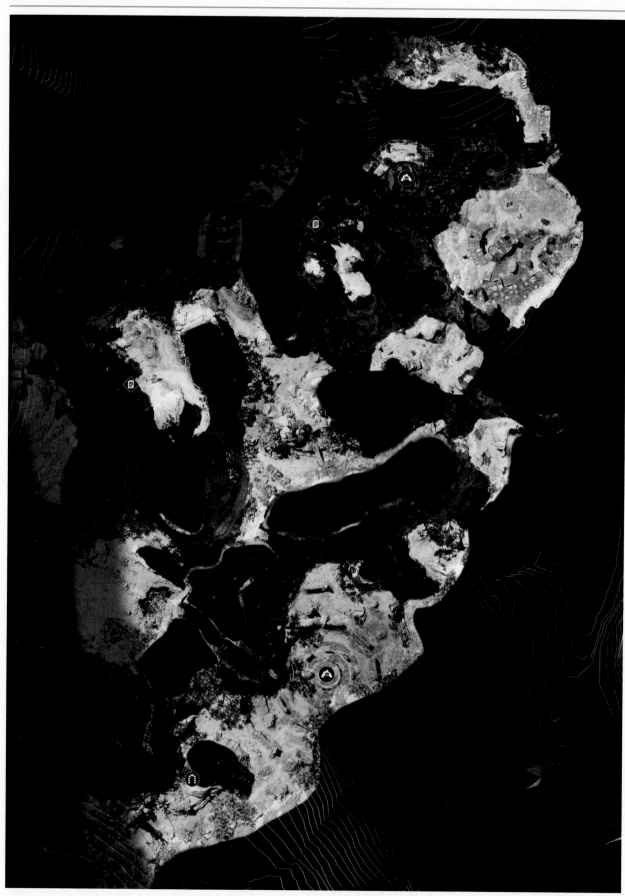

COLLECTIBLES

There are numerous items and places to find around Bastion. Lore, intel, resources, and treasure not only provide valuable insight and items, but also complete feats and Challenges. Discovering districts, landmarks, and overlooks also completes Challenges.

LIBRARY LORE

Lore items, such as scrolls and books, are found throughout Fort Tarsis and the 10 regions. These are added to the Library tab of your Cortex and provide extra information about the Anthem, Bastion, the inhabitants, and more. Three Challenges require collecting the lore: "Mederines' Disciple," "Mederines' Order," and "Mederines' Peer."

FACTION INTEL

The following intel items can be gathered for five factions of Bastion: Arcanist Archives, Sentinel Archives, Dominion Intel, Scar Intel, and Outlaw History. These are typically found lying around camps. They reappear after a short time, allowing you to collect multiples at the same location. Find certain amounts of these items to complete Challenges. The "Information Archivist" and "Master Archivist" Challenges require that you find all five types.

ARCANIST RUNES

After completing Matthias' Agent Quest "See in the Dark," bright runes appear around Bastion. Scan them to progress the "Hidden Messages" Challenges: "Hidden Messages," "Footsteps of Idris," and "Vassa's Triumph."

LANDMARKS AND DISTRICTS

Landmarks are noted by the gold graphic shown in this screenshot. Touch it to bring up more information about the location. The location is marked on your map with a landmark icon.

Each region is split into districts. Find all of these locations, along with the landmarks inside each region, to complete their respective Challenges, and ultimately the "Exploration Master" Challenge.

OVERLOOKS

Overlooks are found at high vantage points such as cliffs overlooking lower terrain. Interact with the small box that sits atop a stone pedestal to learn more about the view. Find all 10 overlooks to complete the "Trailblazer" Challenge.

TOMBS OF THE LEGIONNAIRES

For the critical objective called "Freeplay: Tombs of the Legionnaires," you must find and enter four tombs. Trials must be completed in order for you to enter each one; interact with the four Sarcophagi to complete a collectibles Challenge ("Grave Historian"). This objective is covered in detail later in this chapter.

LOOT

NATURAL RESOURCES

Chimeric Alloy is used when crafting weapons, Gear, and javelin components. It's harvested from deposits in the environment.

Chimeric Compound is also used when crafting weapons, Gear, and javelin components. It's harvested from plants in the environment. Both resources are most easily acquired during freeplay. Interact with the resource or shoot it to obtain the loot. Earn the "Botanist" and "Geologist" Challenges for collecting large amounts of the resources.

MAN-MADE RESOURCES

Weapon parts, used to craft weapons, are found in piles of scrap, treasure chests, and by salvaging other weapons. Javelin parts are found in the same locations and used to craft Gear and components unique to that javelin type. The type of javelin you're in dictates the type of parts found.

EMBER

Ember is a rare resource found within harvestable minerals, plants, and treasure chests, and by salvaging equipment. It comes in four rarities: Uncommon, Rare, Epic, and Masterwork. As your pilot level increases, the chance of acquiring higher rarities increases. Salvaged equipment produces a rarity of ember equal to that item.

Ember is used to inscribe equipment of the same level when crafting. It can also be used to craft consumables, which is a great use for your extra ember.

WORLD EVENTS

As you explore Bastion, a World Event may start up near your location. Listen for your Cypher to mention a nearby event and look for the icon. Any players in the area can partake in the event. Here we list possible events and how to complete them. After the World Event is completed, a chest appears in the area. Each player who participated in the event can grab the loot. Each World Event is associated with one of three rarities: Common, Rare, or Legendary. The higher the rarity, the less often they occur.

FIND REMAINING ENEMIES

Quite often, you're required to eliminate any remaining enemies to progress the event. Some enemies may become tough to find as they attack from range. Fortunately, all foes are noted on your compass as red dots. Spin the camera around to find these dots, then move in their direction.

GROUNDERS

Watch out for the Grounders that float in the air throughout Bastion. If you fly into the sphere around one of these nodes, your javelin gets zapped—overheating it and disabling flight. These nodes can be shot, shrinking them down to nothing, but they will return. These nodes are often found near volatile relics, making echo-collecting more of a challenge.

AN AGENT'S JOB

RARITY	Common
OBJECTIVE	Track down the missing Corvus agent and complete the agent's mission
ENEMY TYPES	Scars

An Agent's Job takes place inside a dungeon. Use the compass to find the Corvus agent and interact with the body. Defend the area against Scars while information is gathered from the agent's link.

Prevent the Scars from destroying the three Corvus Intel. The first two are around the cavern, while the third is held by a Legendary Scar Enforcer. Kill it and collect the intel. Next, complete the agent's mission. Locate captives deeper inside the location. Kill the Scars until a Legendary Scar Hunter drops a key. Use the key to rescue the captives.

AN AGENT'S MISSION

RARITY	Common, Rare
OBJECTIVE	Track down the missing Corvus agent and complete the agent's mission
ENEMY TYPES	Scars or Dominion

An Agent's Mission takes place inside a dungeon. Use the compass radar to find the Corvus agent and interact with the body. Defend the area against Scars while information is gathered from the agent's link.

Prevent the enemy from destroying the three Corvus Intel. The first two are around the cavern, while the third is held by an enemy. Kill it and collect the intel. Next, complete the agent's mission. Either destroy six Anchors and the Gate they arrived from, Assassinate a targeted enemy, or rescue the crew.

A CALL FROM CORVUS

RARITY	Common
OBJECTIVE	Locate Agent and defeat eneny
ENEMY TYPES	Scars or Dominion

Locate the Agent and then defeat the Scar or Dominion presence.

A FREELANCER'S DUTY

RARITY	Common, Rare
OBJECTIVE	Respond to the Arcanist distress call
ENEMY TYPES	Scars or Dominion

Find two Arcanists at the location. Rescue them from the enemy by unlocking both cages. This is a slow process, so make sure to eliminate any nearby foes. Watch for hives when facing the Scars. Once the Arcanists have been rescued, there are three possible objectives.

You may need to destroy the enemy's supply cache. Use the radar to find the explosives. Place an explosive next to a supply cache and defend the area until the explosive is armed. Clear out when the 10-second timer begins.

Destory the enemy's portal. Destroy six anchors, then the vulnerable gate.

Defeat targeted enemies. The Dominion may send two Furies. Facing the Scar requires defeating a Legendary Scar.

ARCANIST SECRETS

RARITY	Rare
OBJECTIVE	Secure the vault's contents for the Arcanists
ENEMY TYPES	Wolven, Anrisaur, Scars, Dominion

Search for a vault using the compass. A green glow indicates its location. Activate the vault to display eight attunement points around the immediate area. You must touch all eight before the one-minute timer runs out. Wolven and/or Anrisaur may inhabit the area. At Scar camps, you must also deal with them. Avoid enemies as much as possible in order to complete the attunement in time.

Some points may float high in the air, or behind obstacles. Take a quick look around first to plan out a good route. Your hover ability assists with finding the next point. The vault resets if you fail to hit all eight points in time.

Once all eight points are collected, activate the vault to begin the next step. Defend the objective zone until attunement progress is complete. Collect your reward from the vault.

A SENTINEL ASSIGNMENT

RARITY	Common, Rare
OBJECTIVE	Assist the Sentinels
ENEMY TYPES	Scars or Dominion

A Sentinel Assignment takes place inside a dungeon. You must assist Sentinels while completing one of the following objectives: defeat the enemy while protecting the Sentinels, assassinate a targeted foe, destroy Anchors and Gate, or use explosives to destroy their stockpiles.

DOMINION INCURSION (SUPPLY LINES)

RARITY	Common, Legendary
OBJECTIVE	Prevent the Dominion from establishing a presence Presence, or stop them from Interfering with Shaper Relic
ENEMY TYPES	Dominion

There are a few possible objectives with Dominion Incursion. The common variant has you take out the Dominion's supply lines by destroying five stockpiles around the area, or destroy two Dominion turrets. The stockpile objective may happen inside a dungeon. Defeat the remaining Dominion. You may need to defeat a targeted Dominion (Elite Valkyrie).

A rarer instance requires that you recover six fragments and deliver them to the volatile Shaper relic. Elementals spawn from the relic. Then, defeat the targeted Dominion (Elite Brute).

DOMINION FOOTHOLD

RARITY	Common
OBJECTIVE	Destory Dominion Camp
ENEMY TYPES	Dominion

Destroy the marked defenses at the Dominion camp. Make turrets your primary focus.

DOMINION PATROL

RARITY	Common
OBJECTIVE	Defeat Dominion Troops
ENEMY TYPES	Dominion

Defeat the Dominion troops in the area.

FRAGMENT RECOVERY

RARITY	Common
OBJECTIVE	Recover Shaper fragments for Arcanist study
ENEMY TYPES	Scars, Skorpions, Ursix

Use the compass to find and recover six fragments scattered around the area. Battle Scars, Skorpions, or Ursix as you complete the objective. This may occur inside a dungeon with Scars, and then Skorpions, attacking. Defeat remaining enemies, including a possible targeted Scar.

FREELANCER IN NEED

RARITY	Common
OBJECTIVE	Aid a fellow Freelancer
ENEMY TYPES	Scars or Dominion

Locate the Freelancer and either defend the body or assist with the objective.

LOCKED AWAY

RARITY	Common
OBJECTIVE	Explore the Shaper ruins
ENEMY TYPES	Elementals

This World Event starts just outside Shaper ruins. Deliver echoes to the volatile Shaper relic. Watch for Shaper nodes. Relic may spawn elementals.

Once the relic has been silenced, the entrance to the ruins opens. Explore the ruins and eliminate enemy threat in the main room (possible Titan).

OUTLAW GANGS

RARITY	Common
OBJECTIVE	Put a stop to Outlaw gang activity
ENEMY TYPES	Outlaws

Defeat the Outlaws in the area, including two Leaders.

OUTLAW INCURSION

RARITY	Common
OBJECTIVE	Stop the Outlaws from gaining a foothold
ENEMY TYPES	Outlaws

Destroy two Outlaw Turrets and eliminate Outlaws.

RELICS OF THE PAST

RARITY	Rare, Legendary
OBJECTIVE	Silence the Shaper relic by delivering eight echoes or six fragments
ENEMY TYPES	Scars, Dominion, Wolven, Elementals, Ursix, Titans

Deliver eight echoes or six fragments to the Shaper relic to silence it. Scars, Dominion, or a couple of Ursix may attack during the objective. Wolven or elementals may spawn from the relic when collecting fragments. Echoes float high in the air. Fragments are scattered around the ground. Watch out for possible Shaper nodes that will overheat javelin if you fly near their spheres. Once silenced, defeat remaining enemies.

Rarely, you may see a titan near a Shaper relic that requires echoes. Combine the titan with the Shaper nodes and you must be extremely aware as you fly through the echoes. Note you must defeat the enemies to complete the objective.

SCAR FOOTHOLD

RARITY	Common
OBJECTIVE	Prevent the Scars from gaining a foothold
ENEMY TYPES	Scars

Destroy the Scar camp by demolishing the turret and two munitions caches. Defeat the remaining Scars.

SCAR INCURSION

RARITY	Legendary
OBJECTIVE	Silence the Shaper relic and drive off the Scars
ENEMY TYPES	Scars, Elementals

This objective may require that you destroy Scar turrets. Or, a relic goes volatile and spawns elementals. Use the compass to recover the six fragments and deliver them to the relic. The Freelancers may be asked to destroy tar-geted Scars.

SCAR SCOUTS

RARITY	Common
OBJECTIVE	Eliminate Scars
ENEMY TYPES	Scars

Eliminate the Scars, including targeted scouts.

SCAR THREAT

RARITY	Common
OBJECTIVE	Destroy Scar stockpiles before they're put to use
ENEMY TYPES	Scars

Scar Threat may occur inside a dungeon. Five stockpiles are located around the Scar camp. Use the compass radar to find each one and destroy them. Scar combatants attack throughout the event.

SENTINEL SUPPORT

RARITY	Common, Rare
OBJECTIVE	Defend Sentinels from a Skorpion attack, or help them push back dangerous wildlife
ENEMY TYPES	Skorpions, Wyvern, Dominion, Anrisaur, Ursix

This objective may require that you rescue four Sentinels trapped in Skorpion's webbing. Attack the webbing to free them. You are always required to defeat the ambushers. Downed Sentinels can be repaired to get them back in the fight.

SKORPION INFESTATION

RARITY	Common
OBJECTIVE	Destroy the three Skorpion nests (clusters)
ENEMY TYPES	Skorpions

Clusters of Skorpion eggs, noted by objective markers, must be destroyed to complete the event. Destroy as many eggs as possible before Skorpions emerges from inside. Eliminate the Skorpions.

SKORPION SWARM

RARITY	Common
OBJECTIVE	Eliminate Skorpion Threat
ENEMY TYPES	Skorpions

Eliminate the Skorpions in the camp.

SLEEPING TITAN

RARITY	Legendary
OBJECTIVE	Prevent the Dominion from waking a Titan
ENEMY TYPES	Dominion, Titans

Destroy five machines before a two-minute timer runs out, all while fighting Dominion. If you're successful destroying the machines in time, defeat the remaining Dominion. If the machines aren't destroyed in time, defeat the Titan and Dominion.

STRIDER DISTRESS

RARITY	Common, Rare
OBJECTIVE	Defeat Ambushers and Repair Strider
ENEMY TYPES	Dominion

This event only takes place in large, open areas. Commonly, Outlaws harass a downed strider, but less likely it can be Scars, Dominion, or Skorpions. While fending off the large group of enemies, you must follow the objectives to repair the strider.

STRIDER TROUBLE

RARITY	Legendary
OBJECTIVE	Defeat Titan and Repair Strider
ENEMY TYPES	Titan

This event only takes place in large, open areas. This objective is similar to Strider Distress, but a titan is causing the trouble. While fending off titans, you must follow the objectives to repair the strider. Shaper nodes float in the air, making flight more difficult.

WANTED BY THE DOMINION

OBJECTIVE	Take out Dominion stalkers sent to assassinate Freelancers
ENEMY TYPES	Dominion

Defeat the four stalkers (Legendary Valkyries); lesser Dominion also attack. Defeat the remaining Dominion.

SCAR HATCH

RARITY	Very Rare
OBJECTIVE	Various
ENEMY TYPES	Scars

After destroying a Scar Hive during specific world events, there is a very small chance that a hatch spawns. This leads to three scenarios: Destroy a horde of Scars, destroy their Gate against Scars and Elementals, or fight Scar and Skorpions.

REGION ACHIEVEMENTS

For each of the 10 regions, you can earn an Achievement for discovering all districts, landmarks, and hidden places.

	Explorer: High Road	Discover all districts, landmarks, and hidden places in High Road.
	Explorer: Academy Ruins	Discover all districts, landmarks, and hidden places in Academy Ruins.
	Explorer: Monument Watch	Discover all districts, landmarks, and hidden places in Monument Watch.
	Explorer: Fortress of Dawn	Discover all districts, landmarks, and hidden places in Fortress of Dawn.
	Explorer: Ruins of Shadowmark	Discover all districts, landmarks, and hidden places in Ruins of Shadowmark.
	Explorer: Valley of Tarsis	Discover all districts, landmarks, and hidden places in Valley of Tarsis.
	Explorer: Great Falls Canyon	Discover all districts, landmarks, and hidden places in Great Falls Canyon.
	Explorer: Emerald Abyss	Discover all districts, landmarks, and hidden places in Emerald Abyss.
	Explorer: East Gate	Discover all districts, landmarks, and hidden places in East Gate.
	Explorer: Eastern Reach	Discover all districts, landmarks, and hidden places in Eastern Reach.

NO STONE UNTURNED

Complete all five Bastion collectibles Challenges. Collect or discover the required number of Arcanist runes, faction intel, Library lore, Tombs of the Legionnaires, and overlooks.

STRONGHOLDS

TYRANT MINE

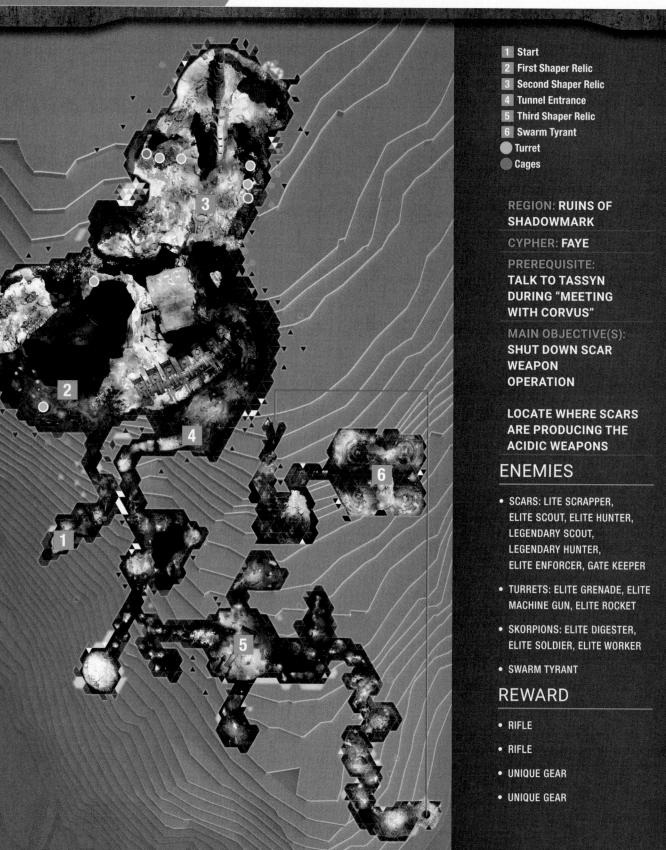

1 Start
2 First Shaper Relic
3 Second Shaper Relic
4 Tunnel Entrance
5 Third Shaper Relic
6 Swarm Tyrant
● Turret
● Cages

REGION: RUINS OF SHADOWMARK

CYPHER: FAYE

**PREREQUISITE:
TALK TO TASSYN
DURING "MEETING
WITH CORVUS"**

MAIN OBJECTIVE(S):
**SHUT DOWN SCAR
WEAPON
OPERATION**

**LOCATE WHERE SCARS
ARE PRODUCING THE
ACIDIC WEAPONS**

ENEMIES

- SCARS: LITE SCRAPPER,
 ELITE SCOUT, ELITE HUNTER,
 LEGENDARY SCOUT,
 LEGENDARY HUNTER,
 ELITE ENFORCER, GATE KEEPER

- TURRETS: ELITE GRENADE, ELITE
 MACHINE GUN, ELITE ROCKET

- SKORPIONS: ELITE DIGESTER,
 ELITE SOLDIER, ELITE WORKER

- SWARM TYRANT

REWARD

- RIFLE

- RIFLE

- UNIQUE GEAR

- UNIQUE GEAR

1 LAUNCH EXPEDITION

You can speak to Corvus Agent Sev in the Fort Tarsis bar before attempting the Stronghold, but it isn't necessary. When you launch the expedition, your team travels directly to the Stronghold. Move into the tunnel and follow it to a massive cavern, keeping an eye out for mines along the way.

MIND THE MINES

Many passageways within this Stronghold are protected by mines, so remain alert throughout the expedition. It's often a good idea to clear out the mines, since you never know when you may need to escape into one of these locations.

2 SILENCE THE FIRST RELIC

Two Shaper relics have been detected in the area, and as you investigate, your objective changes to silencing the first relic. The relic sits just to the left, up the ramp. Eight echoes must be collected and delivered to the relic in order to silence it. These echoes are scattered throughout the first area, which stretches around the large column. The compass radar points the way to the nearest light. There are only so many possible locations for the echoes, but there are enough that a second trip into the Stronghold may produce a completely different layout.

Several Elite Turrets protect the areas around the two Shaper relics. Some fire grenades or rockets, while others are equipped with machine guns. Ease around corners and destroy these powerful weapons first, from a safe location.

Elite and Legendary Scars spawn throughout these areas. You face Scrappers, Scouts, and Hunters first, while Enforcers are called in later. Be careful rushing too far in, or they can surround and overwhelm. Concentrate on clearing out the Scars as you move around the column. If possible, have your most agile javelin collect the echoes, while stronger allies eliminate the threat.

Our map displays locations of turrets and Scar gates, so plan accordingly. March up the ramp to the left of the relic, or fly around the right side of the column; just keep the group together for the greatest chance against the Scars. Once all eight echoes are delivered, it's time to fly north, across the large gap, toward the second relic.

3 SILENCE THE SECOND RELIC

The relic sits just inside the area, between a tunnel on the right and the waterfall. You can make a direct assault over the waterfall, but you'll take on more weapon fire on the approach. The tunnels on either side of the water are mined, but they offer the best protection as you assess the situation. Twelve echoes are scattered throughout the area, but four are initially inaccessible. These four are always located in cages.

As before, eliminate the turrets first and then take out the Scouts if possible. These guys are perched on the high cliffs and pick away at your health whenever they get a chance. Stick to the perimeter when possible and escape into the tunnels if your health gets too low.

With eight echoes delivered, a new squad of Scars spawns into the area, including a special Enforcer named Gate Keeper. Once this

powerful Scar is down, collect the key it drops. This unlocks a pair of cages on the northwest and southeast sides of the area. Interact with the panel on each cage and collect the echoes from inside. Deliver these to the relic to complete the objective. Scars vanish from the area once the relic is silenced, and a chest appears nearby; loot your reward.

4 EXPLORE THE TUNNELS

After you silence the second Shaper relic, the objective switches to "Locate the egg source." Fly south and follow the path until you reach a new opening. This leads down into a network of tunnels ruled by Skorpions. Many eggs can be destroyed along the way, reducing the number of foes you face.

Follow the tunnel until you reach a stream of water that pours into an opening on the left side of the room; follow it down into an underwater

passage. Swim right and continue along the path until you can exit the water to the east; objective markers lead the way.

5 SILENCE THE THREE SHAPER RELICS

Step through the doorway ahead and drop all the way down to a circular stage at the center of the tall cavern. Three Shaper relics rest

on the platform, while Skorpion eggs are ready to hatch around the perimeter. Spend time destroying the eggs and Skorpions as the relics go volatile.

Silencing each relic requires two fragments. Objective markers lead into three small caves along the perimeter of the cavern. Each

cave holds two fragments, along with a pack of Elite Skorpions. Remember that you can only carry one fragment at a time, and flying is unavailable when holding one. Start collecting the fragments and inserting them into the relics.

After you deliver two fragments, three Scar Hives appear in the cavern—spawning Elite Hunters, Scouts, Scrappers, and Enforcers.

Fight off the Scars and destroy the hives as you go after two more fragments.

After four fragments are returned to the relics, three more Scar Hives spawn into the area. These bring a tougher selection

of Scars. It isn't necessary to defeat them all, but fewer Scars means less resistance as you deliver the fragments.

Delivering the final fragment doesn't quite silence the relics. You must remain on the platform until the energy completely settles down. Exiting the platform causes progress to stop and possibly go backward. A few blue nodes appear over the platform, while a steady stream of Skorpions moves up the ramp toward your position. All of this interferes with the signal, which slows down the process.

Shoot the center of these nodes to shrink their presence, while continually shooting down the Skorpions that approach from the ramp. Once the progress bar fills completely, the objective is complete and you're rewarded with another chest. This opens the door at the end of the walkway.

CONTINUE EXPLORING THE TUNNELS

Follow the tunnel, destroying any eggs and Skorpions you come across. Head right up the steps, across the bridge, and out the other side. Eventually you reach a large hole in the ground. Drop to another underwater passage and follow it a short distance south until you emerge from the water. Fly through another opening on the left and continue into the final cavern.

6 DEFEAT SWARM TYRANT

An enormous boss emerges from a central pipe above. This is the Swarm Tyrant, the source of the eggs and a tough boss fight. Once it lands on the ground, begin your attack. Sacs on its backside are its weak point; aim for them whenever possible. The boss has a lot of health, so prepare for a lengthy fight.

The Swarm Tyrant has a couple of attacks that hit for devastating damage. When up close, it quickly attacks with its legs. Keep the fight at a safe distance, but if you have to get in close, be ready to evade these attacks or absorb the damage. From afar, it has the ability to leap high in the air and pounce on its target. This move is easy to spot, as long as you don't get too distracted fighting Skorpions. Evade away to avoid this attack. Be careful—it only needs to land nearby to cause damage.

The boss leans back before spitting acid at its target. If contact is made, you're inflicted with the Acid effect. Quickly evade sideways to avoid the attack. Its spit also has the ability to inflict the Webbed effect, which freezes you in place; rapidly press the indicated button to break loose. This overheats the javelin, so you must wait for your flight systems to return.

Elite Soldiers, Workers, and Digesters must also be dealt with throughout the boss fight. Be sure to collect the armor and ammo pickups from their corpses.

After you deplete a segment of the boss's health bar, the Swarm Tyrant moves toward the outer wall and climbs into a hole above. Keep your attacks up throughout this movement, getting in as much damage as possible before it disappears into the hole.

After a short while, an assembly of Skorpions crawls out of one of the webbed openings. Immediately take them down as they emerge. The boss rushes out just behind the smaller foes, so stand to the side to avoid extra damage.

Since it has the ability to ensnare its target, don't let your armor get too low. Escape around the central column for a breather, keeping an eye out for Repair Packs or Skorpions that can be killed.

Continue to target the weak sacs on the rear of the Swarm Tyrant, while evading its attacks. As its health gets low, it gets more desperate, with more Skorpions joining the fight. Eventually, it falls in defeat, which completes the mission.

THE TEMPLE OF SCAR

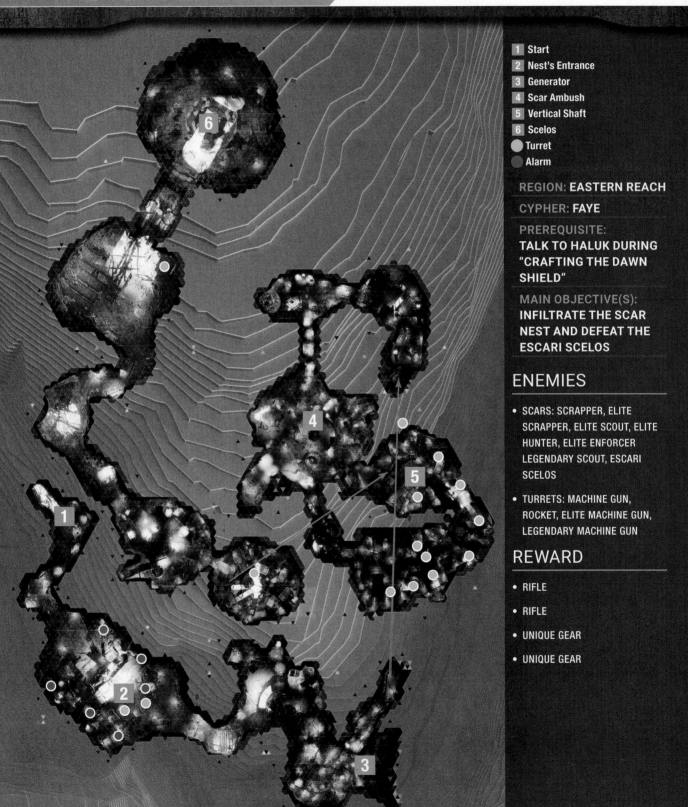

1 Start
2 Nest's Entrance
3 Generator
4 Scar Ambush
5 Vertical Shaft
6 Scelos
● Turret
● Alarm

REGION: EASTERN REACH

CYPHER: FAYE

PREREQUISITE:
TALK TO HALUK DURING "CRAFTING THE DAWN SHIELD"

MAIN OBJECTIVE(S):
INFILTRATE THE SCAR NEST AND DEFEAT THE ESCARI SCELOS

ENEMIES

- SCARS: SCRAPPER, ELITE SCRAPPER, ELITE SCOUT, ELITE HUNTER, ELITE ENFORCER LEGENDARY SCOUT, ESCARI SCELOS

- TURRETS: MACHINE GUN, ROCKET, ELITE MACHINE GUN, LEGENDARY MACHINE GUN

REWARD

- RIFLE

- RIFLE

- UNIQUE GEAR

- UNIQUE GEAR

1 LAUNCH THE EXPEDITION

You can speak to Corvus Agent Sev in the Fort Tarsis bar before heading out, but it isn't necessary. When you launch the expedition, your team travels directly to the Stronghold.

2 SECURE THE NEST'S ENTRANCE: DESTROY THREE TURRETS

The nest's entrance is well-defended. Three Legendary Machine Gun Turrets do a great job on their own, but a large pack of Scrappers and a few Legendary Scouts make this first room a challenge. Once the Scars detect your presence, step back into the corridor and let the Scrappers come to you. Scouts snipe from the sides, so avoid standing around out in the open.

Ramps lead up either side, but the right provides the most protection. This side also offers great locations from which to take out the turrets. Step out from cover, shoot the turret for a few seconds as it fires up its gun, then step back to avoid taking damage. A bridge runs between the two sides, providing a semi-protected route from one side to the other. Work your way around the room and eliminate the Scouts and turrets.

DESTROY SIX ALARMS AND DEFEAT THE SCAR

Your presence doesn't go over well, as the Scars set off the alarm. Six alarm boxes scattered around the cavern start to wail as another group of Scars shows up. This time Elite Hunters join Scouts and Scrappers. Carefully fight through the Scars and destroy the alarms.

DEFEAT THE GATE KEEPER

Once the alarms are destroyed and the accompanying Scars have been defeated, the Gate Keeper—a powerful Scar Enforcer—shows up. A few Scars join the boss, but the Enforcer should be your sole focus. Avoid absorbing too much of its flame, and hit it with your most powerful attacks. After it goes down, the rear gate opens. Step into the next area and loot your reward from the chest.

3 RESTORE POWER TO THE GENERATOR

Follow the wooden walkways until you spot another group of Scars in the distance. You can spend time in the previous area shooting the enemies, but it takes some firepower to get through the Hunter and Scout shields. If you tempt them, a Hunter and/or Scrapper will move away from the pack. Carefully fight your way into the room, watching out for the Hunter's machine gun and Scout's sniper rifle.

Power must be restored to a generator on the third floor of the room in order to proceed through the Scar nest. Ramps connect the perimeter walkways of the three levels, with three fuel cells scattered along the path. These must be carried, one at a time, to the generator to get it back online. Cautiously complete the objective, as Scars (including a Legendary Enforcer) attack along the way. Placing the third fuel cell opens a gate on the northwest wall.

EXPLORE THE SCAR NEST

 Follow the tunnel through Scar living quarters. Don't let your guard down, as a few Scars are spotted to the south; watch out for the familiar laser sight of a Legendary Scout. You encounter more Scars as you follow the path up and then east across a wood bridge. This is just a sampling of what awaits in the next room.

4 DEFEAT THE SCAR AND PLANT EXPLOSIVES AT THE EXIT

Scar mines have been placed on the north side of the lower level, so watch your step. Scars spawn into the room as you move farther inside, and the exit, located on the east side, is locked. Faye marks five explosives on your HUD; grab them, one at a time, and place them next to the exit. A ramp near the exit offers an easy route.

Legendary Scouts and Enforcers highlight the first group of Scars. Much of the room provides plenty of cover for avoiding the Scout's shots. Just don't remain still for too long. The cramped space makes it tough to avoid the Enforcer's flamethrower. Try to take them on in the open area on the south side.

SURVIVE THE AMBUSH

With the fifth explosive placed, more Scars spawn into the area. This time Elite Hunters join Elite Enforcers and Legendary Scouts. Stay on the move to avoid getting pinned into a corner, and look out for Repair Packs dropped by defeated Scars. Once the last Scar is defeated, the exit is blown open—leading into a sewer system.

FOLLOW THE SEWER PATH

Drop to the lower level and creep up to the pipe opening. Turrets and more Scars inhabit the next room, though it isn't necessary to defeat them. Pick off a few of the weaker Scars from the entrance. Then either quickly fly through the area, evading any incoming rockets, or go straight for the turrets and Legendary Scout. The turrets in this room are a mix of Rocket Turrets and Machine Gun Turrets. Note that your next visit may see a different arrangement. Continue along the path until you land on a wooden walkway that leads into the next room.

5 DESTROY THE FOUR TURRETS

This vertical shaft is defended by four turrets and a slew of Scouts, along with Hunters and Scrappers. Start out by destroying the turret straight ahead. Then spiral upward, taking out the remaining turrets along the way. Use cargo containers and makeshift walls to protect yourself against long-range fighters. Retreat back down, below cover, if health gets low. At the very top, find an opening on the southwest side.

CONTINUE TO EXPLORE THE SCAR NEST AND DEFEAT SCARS

Fight more Scars through the corridor and go right along the wooden walkway. Eventually, you reach a big open cavern. Two Elite Machine Gun Turrets sit on the far side, one on each side of the exit, along with Scar troops all around them. Cover along the rock path can be used to fight the Scars on the far side, but watch out for the Elite Hunters that enter to your left.

Another option, especially for melee fighters, is to fly over to the right turret and destroy it, along with the surrounding Scars. Then take care of the other side. Finish off the remaining Scars before exiting northwest to find Scelos.

6 DEFEAT SCELOS

Scelos is a powerful Luminary Escari who is assisted by a Shaper construct built into the chamber, and the occasional spawning of Scars. She remains in the center of the arena, but don't underestimate this boss. The construct protrudes from three walls with the ability to shield and power up the boss. Small, makeshift walls have been erected around the boss, providing temporary protection from the gunfire.

If you have fought an Escari, you know the basics for this boss fight. Aim for Scelos' leg armor. Once each of the four pieces is removed, that leg becomes a weak point. With enough force to the shielded head, it is possible to down the Luminary—exposing the pilot. She can also be exposed by destroying the armor on both legs. While downed, her rocket pods can be damaged. This reduces the number of rockets fired.

Scelos' main weapon is a machine gun with a high rate-of-fire, which she fires almost constantly in between other attacks. A cannon fires a high-power explosive round that causes lethal damage. It also has the ability to fire a salvo of seeking rockets at every player. The boss's laser sight signifies that rockets are imminent; take cover when you spot the red laser. When approached, the Luminary shoots flames out of its jets, damaging all targets around it.

When 5% of Scelos' health has been removed, blades emerge from the walls and protect the boss with an energy shield. Her attacks slow down at this point, but the shield is impenetrable. Therefore, you should focus your attention on the Scars that appear, and the pylons attached to the walls (located behind the fan blades).

Be careful near the blades as they do cause harm if you make contact. By causing enough damage to a pylon, the blades retract back into the wall. Force all three back into hiding to make Scelos vulnerable once again.

Whenever the construct shields the boss, a couple of groups of Scars spawn around the outside of the arena. The first spawning consists of Elite Scrappers and Destroyers. Later groups include Legendary Scouts and then Legendary Hunters, so target the powerful foes first. Be sure to collect Repair Packs and ammunition dropped by the Scars, when the opportunity arises. It is best to defeat the Scar reinforcements before retracting the last of the pylons. Otherwise the battle gets chaotic with increased attacks from the boss and Scars from the sides.

Once the shield drops again, Scelos resumes her full spread of attacks. Continue to shoot the boss—aiming for the legs for greatest effect. Keep an eye out for downed javelins and get them up as soon as you can, or risk losing the entire party.

For every additional 25% of damage done to Scelos, she resets the pylons—becoming shielded once again, and calling in another wave of reinforcements. Continue attacking the boss when vulnerable, along with the Scars and pylons when appropriate, until the boss finally collapses in defeat to complete the Stronghold.

THE HEART OF RAGE

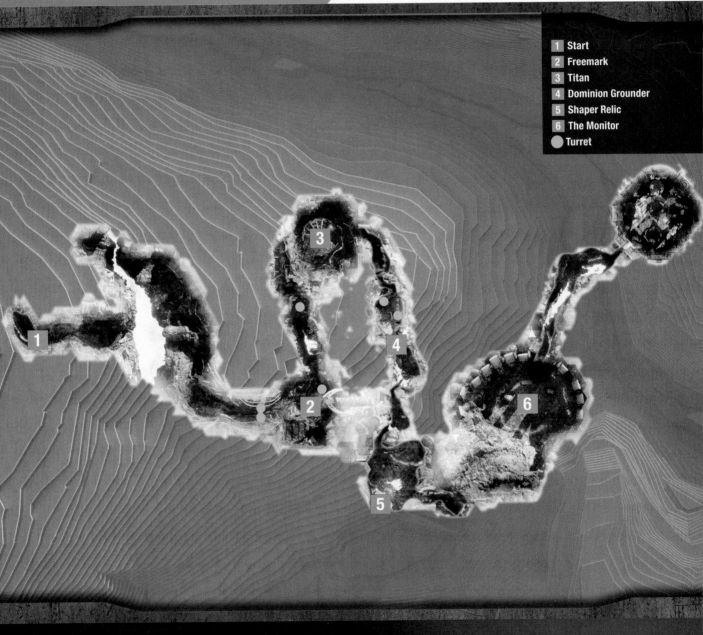

Map legend:
1. Start
2. Freemark
3. Titan
4. Dominion Grounder
5. Shaper Relic
6. The Monitor
● Turret

REGION: RUINS OF SHADOWMARK

CYPHER: FAYE

PREREQUISITE: COMPLETE THE CRITICAL OBJECTIVE "RETURN TO THE HEART OF RAGE"

MAIN OBJECTIVE(S): SILENCE THE CENOTAPH

ENEMIES

- WYVERNS

- TURRETS: ELITE GAUSS, ELITE FLAK

- DOMINION: ELITE SHOCKTROOPER, ELITE
 BRUTE, ELITE VALKYRIE, LEGENDARY BRUTE,
 LEGENDARY ELEMENTAL VALKYRIE, FURY
 (HOARDER, KEEPER)

- ELEMENTALS: ASH, MORDANT

- ANCIENT ASH TITAN

- THE MONITOR

REWARD

- RIFLE
- RIFLE
- UNIQUE GEAR
- UNIQUE GEAR

1 LAUNCH THE EXPEDITION

You can speak to Corvus Agent Sev in the Fort Tarsis bar before heading out, but it isn't necessary. When you launch the expedition, your team travels directly to the Stronghold. This mission is similar to the critical objective "Return to the Heart of Rage." Each encounter has been reinforced with tougher enemies, making this an extreme challenge for any javelin. Wyverns fly over the ravine, but they can be ignored.

2 ENTER FREEMARK

Follow the objective markers east, across the lava ravine, and move up the incline on the right. A pair of Elite Gauss Turrets greets you, with a large group of Dominion just beyond. Destroy the turrets from distance if you can, then move up the hill to take on the Dominion troops. An Elite Flak Turret fires from the far side of the area, so deal with it as soon as possible. Elite Brutes and Valkyries highlight the selection of Dominions in the area. Be ready to bust out of a frozen state if hit with their ice, and utilize the rocks and metal that jut out of the ground as cover.

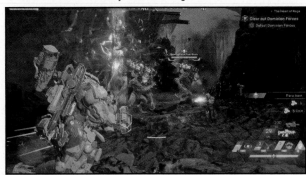

3 DEFEAT THE TITAN

Once the Dominion are defeated, head north and navigate across the ledges to reach the far side. A lone turret and small group of Dominion slow your progress, but shouldn't be too much trouble at this point. Stay on the path until you find a Legendary Ancient Ash Titan.

Remember to attack its weak spots as it powers up for attacks. There isn't a whole lot of space to flee from the Titan's attacks, but ruins allow you to take cover from its fireballs and beam. Its fire rings come in sets of four, but their heights vary randomly between ground level and just over your javelin's head.

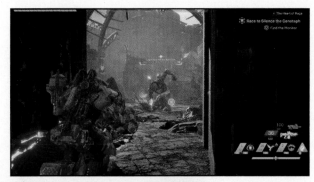

Be ready to quickly take flight or time your jumps. As you whittle down its health, it begins to combine its attacks. Watch for it to launch a fireball after a set of rings. With about two segments of health left, it launches a ring outward as it carves the ground with its chest beam. Stick to the outside of the arena and hop the rings. This chaotic attack ends as the Titan detonates in a massive explosion.

Exit east and follow the path until you reach more Dominion troops and a pair of Elite Gauss Turrets. Take out the one ahead first, then peek around the corner to get a shot at the second. Defeat Elite Shocktroopers and two Legendary Elemental Valkyries before exiting out the other side.

4 DISABLE THE DOMINION GROUNDER

You enter a flight-suppression area as you move up the next steps, as a Dominion grounder has been set up in the next clearing. Defend the objective zone until the grounder is disabled. A large group of Legendary Brutes and Elite Shocktroopers attacks from the south and east. Keep enemies out of the zone for quicker progress, and use the grounder as cover to avoid the Brute's elemental attacks. This fight gets chaotic, with a few Legendary Frost Brutes attacking at once. Flight is re-enabled once the suppressor is disabled; quickly fly up to the southern ledge and continue your exploration.

5 SILENCE THE RELIC

At the next clearing, a volatile Shaper relic keeps you from reaching the Cenotaph. Ten echoes float high above, and they must

be delivered to the relic in order to proceed. A large group of Dominion troops guards the area, with more spawning in as you work on the objective. This includes powerful Brutes and pesky Valkyries. Whenever possible, avoid their elemental attacks, and focus heavy attacks on them. Shocktroopers can be defeated in between in order to score Repair Packs and ammunition. Nodes also float in the area and zap javelins that fly too close. This overheats the javelin, disabling flight.

This is a challenging objective. You can choose to quickly collect the echoes while fending off the Dominion, or thin the opposition out from the entrance while grabbing echoes in between kills. Either way, you must silence the relic and defeat any remaining Dominion foes.

KILL THE DOMINION FURIES

Two Dominion Furies spawn into the area, named Hoarder and Keeper. Focus on one Fury at a time in order to get through its shield. Flee to the entry point if health gets dangerously low. These guys drop keys when defeated, and the exit finally opens. Follow the path until you reach a weakened stone wall; bust through to find the Cenotaph, and the Monitor.

6 DEFEAT THE MONITOR

The Monitor fight has three phases based on the elements fire, acid, and electric. In each stage, he's fully immune to the element he's controlling and resistant to physical and ice attacks. So using fire or acid in the electric phase, fire or electric in the acid phase, or electric and acid in the fire phase ensures maximum damage.

The Monitor has three weak points: one on the back of the neck and one on each side of the torso. When one of these weak points sustains enough damage, it bursts and no longer serves as a weak spot. Destroy all three weak spots to cause massive damage. At this point, the Monitor teleports to the arena center, and the weak points reappear.

PHASE 1: FIRE
The first phase takes place in a circular arena with a pair of pistons jutting out of the ground.

The Monitor wields a massive sword that hits extremely hard. Fortunately, his movements are slow and telegraphed; just don't lose track of him. His melee attacks include a devastating overhead slam, a horizontal sweep, and a powerful close-range slam. All of these, if left unchecked, can knock off a sizable chunk of armor. He also has a leap attack that deals massive damage to one player.

Watch for the boss to lift his left hand high into the air. This signals an incoming fire strike that causes damage on impact and adds the Burning effect.

Balls of fire occasionally drop into the arena, one in the center and the rest around the perimeter. They all detonate at the same time, after approximately 12 seconds. Quickly shoot as many as you can, focusing on the nearest first. The closer you are to one of these explosions, the more initial damage you receive. You also get hit with Burning, which continues damage over time.

Aim for the Monitor's glowing midsection or the top of his head for the most damage. The two pistons offer the best vantage points. Fly between the two locations as the boss closes in. Reduce his health to around 75%, and the boss teleports away; follow him north into the second arena.

PHASE 2: ACID

While the first phase is all about fire, Phase 2 introduces acidic attacks. The Monitor remains within the acidic areas, while you should stick to the five platforms as much as possible. Stay alert, as his attacks come quicker here, and he now has the ability to teleport around the arena.

When he thrusts his left hand toward his target, a flurry of green balls launches straight ahead—inflicting Acid when contact is made. With a direct hit, this has the ability to cause lethal damage. When you see this coming, move to another platform to avoid the attack.

If the Monitor lifts his left hand into the air, quickly flee the area. A ball of acid appears at your location. This causes damage and inflicts Acid, if you remain.

When the boss punches the ground, explosions randomly detonate all around the arena. This causes damage if you're caught nearby.

Stay on the move, while hitting the boss with your most powerful attacks. With around 25% health left, the Monitor spawns a group of Elementals and flees. Avoid their attacks, and take them down to produce valuable pickups. Then follow the boss west into the new arena.

PHASE 3: ELECTRIC

The Monitor's moves become more frenetic and aggressive in the electric phase. The Monitor has his usual melee attacks, but also possesses some new ones.

A projectile attack quickly fires three seeking missiles at every player. Be ready to evade these projectiles.

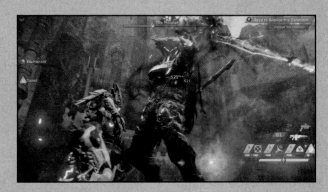

A new warp attack throws his weapon up in the air, which lands on a player for minor damage. Shortly after it lands, though, the Monitor warps to that location and explodes for massive damage. If you're hit with this initial attack, clear out of the area to avoid the big one.

Watch out for lightning-strike impacts that send out waves of electricity along the ground.

As the Monitor weakens, four areas open up, granting double damage for anyone inside. If there are four players and each is inside one of these areas, the damage increases to five times. Continue attacking the Monitor's weak spots until his health reaches 25% health.

PHASE 4: BURNDOWN

At this point, the Monitor enters the burndown. This phase is exclusive to the Stronghold. As the Monitor begins to die, his weak spots are reactivated. They cannot be destroyed, but he enters a stunned state. When he enters this stage, you must kill him within 30 seconds. Do so, and you are rewarded with additional loot.

CHALLENGES

Anthem's Challenges system is a behind-the-scenes, passive quest system that rewards you for completing certain tasks as you play the game. They don't have to be activated or started, and your Challenges progress is saved across all of your pilots. Rewards can vary, including profile banners, Coin, vanity equipment, and equipment blueprints.

View a complete list of Challenges from within the game's menus. Certain Challenges have time restraints that reset at a given time, determined by the game's server.

FACTION CHALLENGES

CHALLENGE NAME	IN-GAME DESCRIPTION	COMPLETE CONDITIONS	REWARD
Arcanist Loyalty 1	Complete activities that support Arcanists in their work. Build trust and you'll gain an introduction to a secret store run by resourceful Regulator friends. Your help also allows work to continue on a reliable source of clean water within Fort Tarsis. Loyalty Rewards (must be Level 10 to deploy): 1. Uncommon sigil blueprints 2. Rare sigil blueprints 3. Epic sigil blueprints	Earn 500 reputation with the Arcanists.	9 uncommon Expedition Consumable blueprints; Sayrna character becomes available in Fort Tarsis.
Arcanist Loyalty 2	Complete activities that support Arcanists in their work. Build trust and you'll gain an introduction to a secret store run by resourceful Regulator friends. Your help also allows work to continue on a reliable source of clean water within Fort Tarsis. Loyalty Rewards (must be Level 10 to deploy): 1. Uncommon sigil blueprints 2. Rare sigil blueprints 3. Epic sigil blueprints	Complete Arcanist Loyalty 1 and earn an additional 1500 reputation with the Arcanists.	9 rare Expedition Consumable blueprints; courtyard fountain is restored.
Arcanist Loyalty 3	Complete activities that support Arcanists in their work. Build trust and you'll gain an introduction to a secret store run by resourceful Regulator friends. Your help also allows work to continue on a reliable source of clean water within Fort Tarsis. Loyalty Rewards (must be Level 10 to deploy): 1. Uncommon sigil blueprints 2. Rare sigil blueprints 3. Epic sigil blueprints	Complete Arcanist Loyalty 2 and earn an additional 3000 reputation with the Arcanists.	Achievement: Arcanist Executor and 9 epic Expedition Consumable blueprints; Aquaduct in Freelancer Enclave is restored.
Freelancer Loyalty 1	Complete activities that further the Freelancer cause. The work you do will help the Enclave grow and expand: more amplifiers in use, more Freelancers, and a return to the glory days. Loyalty Rewards: 1. Uncommon universal component blueprints 2. Rare universal component blueprints 3. Epic universal component blueprints	Earn 500 reputation with the Freelancers.	13 uncommon universal component blueprints; Cypher statue is now in the Enclave.
Freelancer Loyalty 2	Complete activities that further the Freelancer cause. The work you do will help the Enclave grow and expand: more amplifiers in use, more Freelancers, and a return to the glory days. Loyalty Rewards: 1. Uncommon universal component blueprints 2. Rare universal component blueprints 3. Epic universal component blueprints	Complete Freelancer Loyalty 1 and earn an additional 1500 reputation with the Freelancers.	13 rare universal component blueprints; Freelancer javelin now appears in the Enclave.
Freelancer Loyalty 3	Complete activities that further the Freelancer cause. The work you do will help the Enclave grow and expand: more amplifiers in use, more Freelancers, and a return to the glory days. Loyalty Rewards: 1. Uncommon universal component blueprints 2. Rare universal component blueprints 3. Epic universal component blueprints	Complete Freelancer Loyalty 2 and earn an additional 1500 reputation with the Freelancers.	Achievement: Freelancer Veteran and 13 epic universal component blueprints; Trophy Plinths appear in the Enclave.
Sentinel Loyalty 1	Complete activities that aid Sentinels in their duties. Space is at a premium, but Sentinels control the fort, and helping them means you'll be granted a larger storage vault near the Forge. As the fort prospers, you'll see Sentinel-sponsored artworks appear and a med-bay for non-lancers. Loyalty Rewards: 1. Uncommon iconic component blueprints 2. Rare iconic component blueprints 3. Epic iconic component blueprints	Earn 500 reputation with the Sentinels.	40 (10 per javelin) uncommon iconic component blueprints; Fort Tarsis vault is restored.
Sentinel Loyalty 2	Complete activities that aid Sentinels in their duties. Space is at a premium, but Sentinels control the fort, and helping them means you'll be granted a larger storage vault near the Forge. As the fort prospers, you'll see Sentinel-sponsored artworks appear and a med-bay for non-lancers. Loyalty Rewards: 1. Uncommon iconic component blueprints 2. Rare iconic component blueprints 3. Epic iconic component blueprints	Complete Sentinel Loyalty 1 and earn an additional 1500 reputation with the Sentinels.	40 (10 per javelin) rare iconic component blueprints; Murals now appear in corridor between Courtyard and Market.
Sentinel Loyalty 3	Complete activities that aid Sentinels in their duties. Space is at a premium, but Sentinels control the fort, and helping them means you'll be granted a larger storage vault near the Forge. As the fort prospers, you'll see Sentinel-sponsored artworks appear and a med-bay for non-lancers. Loyalty Rewards: 1. Uncommon iconic component blueprints 2. Rare iconic component blueprints 3. Epic iconic component blueprints	Complete Sentinel Loyalty 2 and earn an additional 3000 reputation with the Sentinels.	Achievement: Sentinel Ally and 40 (10 per javelin) epic iconic component blueprints; Sentinel Medbay is now in the space above the Forge.
Champion of Tarsis	Earn high levels of support from the Arcanists, Freelancers, and Sentinels to create a new monument to honor General Tarsis, the first among the Legion of Dawn.	Complete Arcanist Loyalty 3, Freelancer Loyalty 3, and Sentinel Loyalty 3. Additionally earn 50000 reputation with each of the 3 factions.	8 (2 per javelin) masterwork component blueprints; Sarcophagus of Tarsis now appears in the Courtyard.

AGENT MISSIONS CHALLENGES

CHALLENGE NAME	IN-GAME DESCRIPTION	COMPLETE CONDITIONS	REWARD
Freelancer's Handbook	After silencing the Heart of Rage, complete contracts for Yarrow, Brin, and Matthias.	Complete Return to the Heart of Rage, Freelancer Work, Fort Patrol, and Field Work.	Coin
Complete Agent Challenges	Complete Agent Missions and Contracts	Complete the challenges: Brin: Need to Know I, Brin: Need to Know II, Matthias: Riddles of Raban Maur, Matthias: Search for Knowledge, Yarrow: Shallow Grave, and Yarrow: Keeping Promises.	Coin
Brin: Need to Know I	Complete Need to Know I storyline	Complete Incursion, Preventative Precautions, Cautious Cooperation, A Simple Job, and Scar Control.	Achievement: Comrades in Arms, and Coin
Brin: Need to Know II	Complete Need to Know II storyline	Complete Enemy Mine, Research and Rescue, Sentinel Collaboration, In the Wrong Hands, Sentinel Collaboration, and In the Wrong Hands.	Achievement: Military Pursuit, and Coin
Contract: Threat Assessment	Complete Brin's Contract: Threat Assessment	Complete Return to the Heart of Rage and Threat Assessment.	Coin
Dax: Emerald Abyss	Complete Emerald Abyss storyline	Complete Mysterious Beginnings, Dear Diary, and Vanishing Act.	Achievement: A Royal Favor, and Coin
Matthias: Search for Knowledge	Complete Search for Knowledge storyline	Complete Arcanist Hunt, Arcanist Runes, Decryption Research, Field Work, Disaster Protocol, and Decription Research.	Achievement: Arcanist Mysteries, and Coin

CHALLENGE NAME	IN-GAME DESCRIPTION	COMPLETE CONDITIONS	REWARD
Matthias: Riddles of Raban Maur	Complete Riddles of Raban Maur storyline	Complete Lost Arcanist, See in the Dark, Hidden Depths, and Arcanist Runes.	Achievement: Scholarly Pursuits, and Coin
Matthias: Triple Threat	Complete Triple Threat storyline	Complete Manifold, Inverse Functions, and Convergence.	Achievement: Triple Threat, and Coin
Yarrow: Shallow Grave	Complete Shallow Grave storyline	Complete Incursion, What Freelancers Do, A Favor To Ask, Cry For Help, Protection Duty, and Helping Hand.	Achievement: Honorable Pursuits, and Coin
Yarrow: Keeping Promises	Complete Keeping Promises storyline	Complete Overdue, Tempting Target, Bad Deal, Imposter, and First Response.	Achievement: Restoring Glory, and Coin
Contract: Hazard Pay	Complete Yarrow's Contract: Hazard Pay	Complete Return to the Heart of Rage and Hazard Pay.	Coin

CRITICAL MISSIONS CHALLENGES

CHALLENGE NAME	IN-GAME DESCRIPTION	COMPLETE CONDITIONS	REWARD
Complete Mission Challenges	Complete Mission Challenges	Complete the challenges: Agent Challenges, Return to the Heart of Rage, Emerald Abyss, and Triple Threat.	Coin
Incursion	Complete the Mission: Incursion	Complete Incursion	Achievement: Incursion, and Coin
Finding Old Friends	Complete the Mission: Finding Old Friends.	Complete Finding Old Friends	Achievement: Finding Old Friends, and Coin
Tomb of General Tarsis	Complete the Mission: Tomb of General Tarsis	Complete Tomb of General Tarsis	Achievement: The Tomb of General Tarsis, and Coin
Fortress of Dawn	Complete the Mission: Fortress of Dawn	Complete Fortress of Dawn	Achievement: The Fortress of Dawn, and Coin
Freelancer Down	Complete the Mission: Freelancer Down	Complete Freelancer Down	Achievement: Freelancer Down, and Coin
Return to the Heart of Rage	Complete the Mission: Return to the Heart of Rage	Complete Return to the Heart of Rage	Achievement: Return to the Heart of Rage, and Coin
Lighting a Fire	Enter Freeplay and collect uncommon ember. The ember can be acquired from certain plants, mineral deposits, and treasure chests, or by salvaging uncommon equipment. Completion unlocks new challenges to obtain equipment blueprints.	Collect 3 uncommon ember	Unlocks crafting in the forge and unlocks the uncommon blueprint challenges.
Early Warnings	Complete the Mission: Early Warnings.	Complete Early Warnings	Achievement Early Warnings and 2 personalization banners.
Trial of Yvenia	Honor the memory of Yvenia, Forgewright of the Legion. Completing this challenge unlocks the Tomb of Yvenia.	Complete Finding Old Friends, open 15 treasure chests, harvest 25 plants or minerals, repair 3 allied javelins, and collect 10 collectibles.	Allow entry into the Tomb of Yvenia.
Trial of Gawnes	Honor the memory of Gawnes, Blademaster of the Legion. Completing this challenge unlocks the Tomb of Gawnes.	Complete Finding Old Friends, 1 stronghold, defeat 30 enemies with melee, defeat 30 enemies with an ultimate, and defeat 5 legendary enemies.	Allow entry into the Tomb of Gawnes.
Trial of Artinia	Honor the memory of Artinia, Sharpshooter of the Legion. Completing this challenge unlocks the Tomb of Artinia.	Complete Finding Old Friends, 4 world events, defeat 30 enemies with weapons, defeat 15 enemies via weak points, and defeat 9 elite enemies.	Allow entry into the Tomb of Artinia.
Trial of Cariff	Honor the memory of Cariff, Tactician of the Legion. Completing this challenge unlocks the Tomb of Cariff.	Complete Finding Old Friends, 3 missions, defeat 30 enemies with Gear, trigger 15 combos, and trigger 3 multi-kills.	Allow entry into the Tomb of Cariff
Challenge of Might	Prove your might by defeating enemies from the Dominion, Scar, and Outlaw factions; defeat Elite and Legendary enemies.	Defeat 2500 Dominion enemies, defeat 2500 Scar enemies, 2500 Outlaw enemies, 1000 elite enemies, and 200 legendary enemies.	Coin
Challenge of Resolve	Prove your resolve by completing daily and weekly trials.	Complete 30 Daily Challenges and Complete 5 Weekly Challenges.	Coin
Challenge of Valor	Prove your valor by completing events in Freeplay, Strongholds, and Contracts, and by reinforcing other Freelancers.	Complete Return to the Heart of Rage, 100 world events, 25 strongholds, 25 contracts, and 25 reinforcements.	Coin

STRONGHOLD MISSIONS CHALLENGES

CHALLENGE NAME	IN-GAME DESCRIPTION	COMPLETE CONDITIONS	REWARD
Stronghold Master I	Successfully complete Stronghold expeditions.	Complete Finding Old Friends and 1 stronghold.	4 uncommon elemental match consumable blueprints
Stronghold Master II	Successfully complete Stronghold expeditions.	Reach level 10 and complete Stronghold Master I and 10 strongholds.	4 rare elemental match consumable blueprints
Stronghold Master III	Successfully complete Stronghold expeditions.	Reach level 20 and complete Stronghold Master 2 and 25 strongholds.	4 rare elemental match consumable blueprints

STRONGHOLD MISSIONS CHALLENGES

CHALLENGE NAME	IN-GAME DESCRIPTION	COMPLETE CONDITIONS	REWARD
Stronghold Master I	Successfully complete Stronghold expeditions.	Complete Finding Old Friends and 1 stronghold.	4 uncommon elemental Expedition Consumable blueprints
Stronghold Master II	Successfully complete Stronghold expeditions.	Reach level 10 and complete Stronghold Master I and 10 strongholds.	4 rare elemental Expedition Consumable blueprints
Stronghold Master III	Successfully complete Stronghold expeditions.	Reach level 20 and complete Stronghold Master 2 and 25 strongholds.	4 rare elemental Expedition Consumable blueprints

BASTION COLLECTIBLES CHALLENGES

CHALLENGE NAME	IN-GAME DESCRIPTION	COMPLETE CONDITIONS	REWARD
The Clam Before the Storm	Take a moment to appreciate the Clam Before the Storm.	Find the clam before the storm.	Coin
Distinguished Explorer	Complete all Bastion Collectibles challenges.	Complete Vassa's Triumph, Master Archivist, Mederines' Disciple, Grave Historian, and Trailblazer.	No Stone Unturned, and Coin
Hidden Messages	Discover Arcanist Runes	Complete Incursion and find 10 Arcanist Runes.	Coin
Footsteps of Idris	Discover Arcanist Runes	Complete Hidden Messages and find 20 Arcanist Runes.	Coin
Vassa's Triumph	Discover Arcanist Runes	Complete Footsteps of Idris and find 50 Arcanist Runes.	Coin
Master Archivist	Gather archives from each of the factions.	Complete Arcanist Archives, Sentinel Archives, Dominion Intel, Scar Intel, and Outlaw History.	Coin
Arcanist Archives	Gather Arcanist Archives	Find 25 Arcanist Archives.	Coin
Dominion Intel	Gather Dominion Intel	Find 25 Dominion Intel.	Coin
Outlaw History	Gather Outlaw History	Find 25 Outlaw history.	Coin
Scar Intel	Gather Scar Intel	Find 25 Scar Intel.	Coin
Sentinel Archives	Gather Sentinel Archives	Find 25 Sentinel Archives.	Coin
Geologist	Harvest Chimeric Alloys	Harvest 200 mineral nodes.	Coin
Botanist	Harvest Chimeric Compounds	Harvest 200 plant nodes.	Coin
Mederines' Disciple	Gather records, files, manuscripts, and other misplaced writings.	Find 10 writings.	Coin
Mederines' Order	Gather records, files, manuscripts, and other misplaced writings.	Complete Mederines' Disciple and find 30 writings.	Coin
Mederines' Peer	Gather records, files, manuscripts, and other misplaced writings.	Complete Mederines' Order and find 40 writings	Coin
Trailblazer	Discover the Overlooks in Bastion.	Discover High Road Overlook, Academy Ruins Overlook, Monument Watch Overlook, Fortress of Dawn Overlook, The Ruins of Shadowmark Overlook, Valley of Tarsis Overlook, Great Fall Canyon Overlook, The Emerald Abyss Overlook, Skystone Overlook, and Eastern Reach Overlook.	Coin
Grave Historian	Find the Legionnaire tombs.	Complete Finding Old Friends and discover the sarcophagi of Legionnaires Artinia, Cariff, Gawnes, and Yvenia.	Coin

BASTION REGION CHALLENGES

CHALLENGE NAME	IN-GAME DESCRIPTION	COMPLETE CONDITIONS	REWARD
Exploration Master	Fully explore all the regions in Bastion.	Complete High Road Exploration, Academy Ruins Exploration, Monument Watch Exploration, Ruins of Shadowmark Exploration, Valley of Tarsis Exploration, Great Falls Canyon Exploration, Emerald Abyss Exploration, East Gate Exploration, and Easter Reach Exploration	Coin
High Road Exploration	Discover all locations in the High Road region.	Find the districts: Tarsis Bypass, Tarsis Falls, Watchtower of Arath, Tower Road, Hureen Slide, Serpent's View, and Giants Crossroads and the landmark: Last Sentinel.	Achievement: Explore High Road, and Coin
Academy Ruins Exploration	Discover all locations in the Academy Ruins region.	Find the districts: Tarsis Forest, First Refuge, Moonpod Lagoon, Solarium Court, Sanadeen's Pass, Observatory of Velathra, Praedean Falls, Exile's Arch, Garrison of Velathra, and Bullet Mires, and the landmarks: Radio Tower, Astronomy Tower, Ring Gate, Garrison, and the space: Hollow.	Achievement: Explorer: Academy Ruins, and Coin
Monument Watch Exploration	Discover all locations in the Monument Watch region.	Find the district: Iron Serpent, and the landmarks: Monument, and Drill, and the space: Bane Engine.	Achievement: Explorer: Monument Watch, and Coin
Fortress of Dawn Exploration	Discover all locations in the Fortress of Dawn region.	Find the districts: Morning's Edge, Darkwood Barrens, Fortress of Dawn, Legionnaire Ravine, Legions Plateau, and the Crosslands, and the landmarks: Fortress of Dawn, Vassa's Way, and the Dungeon.	Achievement: Explorer: Fortress of Dawn, and Coin
Ruins of Shadowmark Exploration	Discover all locations in the Ruins of Shadowmark region.	Find the districts: Tracks of Midderon, Helena's Walk, Strider Alley, Shadowmark, Crescent Lake, North Rock, and Dawn Gates, and the landmarks: Sunken Gardens, Shadow Lock, and Wrecked Gazebo, and the spaces: Vault, and Sovereign Mine.	Achievement: Explorer: Ruins of Shadowmark, and Coin
Valley of Tarsis Exploration	Discover all locations in the Valley of Tarsis region.	Find the districts: Southern Reach, Strider Way, Memorial Gate, Crop Terraces, Governor Springs, Honor Valley, and Spires of the Ancients, and the landmarks: Antium Lock, Honor Valley Dam, Howel's Tower, Workshop, Stone Bridge, and The Hound, and the space: Haven.	Achievement: Explorer: Valley of Tarsis, and Coin.
Great Falls Canyon Exploration	Discover all locations in the Great Falls Canyon region.	Find the districts: Bowl, Krox Shallows, Tears of Liatrelle, Gathering Falls, Double-Cross, Blackshore, and Eddian Grove, and the landmarks: Scar Tower, Great Eddian, and The Wedged Key, and the space: The Mandible. .	Achievement: Explorer: Great Falls Canyon, and Coin
Emerald Abyss Exploration	Discover all locations in the Emerald Abyss region.	Find the districts: Arden's Road, Guardians of Dunar, Dark Canopy, Mentor's Trail, Sanctuary of Dunar, and Abyssal Loch, and the landmarks: West Valve, East Valve, and Sanctuary Ruins, and the space: The Foundry.	Achievement: Explorer: Emeral Abyss, and Coin
East Gate Exploration	Discover all locations in the East Gate region.	Find the districts: Skystone Pass, Lover's Spring, Silent Path, and Skystone Mine, and the landmarks: Skystone Lock, Scar Mast, and The Mining Platform, and the space: The Necropolis.	Achievement: Explorer: East Gate, and Coin
Eastern Reach Exploration	Discover all locations in the Eastern Reach region.	Find the districts: Breach, Junkhead Basin, Lost Road, Phantom Crag, Stinging Gulch, The Pistons, Scar's Duskheap, and Headless Hollow, and the landmarks: Scar Burrow, Mining Platform, and the Hate Engine, and the space: The Shrine.	Achievement: Explorer: Eastern Reach, and Coin

COLOSSUS CHALLENGES

CHALLENGE NAME	IN-GAME DESCRIPTION	COMPLETE CONDITIONS	REWARD
Colosssus Gear I Master	Complete all Colossus Gear I Challenges.	Complete Battle Cry I, Burst Mortar I, Firewall Mortar I, Flak Cannon I, Flamethrower I, High-Explosive Mortar I, Lightning Coil I, Railgun I, Shield Pulse I, Shock Coil I, Siege Cannon I, and Venon Spitter I.	2 Banners and Coin
Battle Cry I	Complete Missions or World Events on any difficulty with Battle Cry.	Complete 4 missions or world events.	Unlock the uncommon Battle Cry blueprint·
Burst Mortar I	Complete Missions or World Events on any difficulty with Burst Mortar.	Complete 4 missions or world events.	Unlock the uncommon Burst Mortar blueprint
Firewall Mortar I	Complete Missions or World Events on any difficulty with Firewall Mortar.	Complete 4 missions or world events.	Unlock the uncommon Firewall Mortar blueprint
Flak Cannon I	Complete Missions or World Events on any difficulty with Flak Cannon.	Complete 4 missions or world events.	Unlock the uncommon Flak Cannon blueprint
Flamethrower I	Complete Missions or World Events on any difficulty with Flamethrower.	Complete 4 missions or world events.	Unlock the uncommon Flamethrower blueprint
High-Explosive Mortar I	Complete Missions or World Events on any difficulty with High-Explosive Mortar.	Complete 4 missions or world events.	Unlock the uncommon High-Explosive Mortar blueprint
Lightning Coil I	Complete Missions or World Events on any difficulty with Lightning Coil.	Complete 4 missions or world events.	Unlock the uncommon Lightning Coil blueprint
Railgun I	Complete Missions or World Events on any difficulty with Railgun.	Complete 4 missions or world events.	Unlock the uncommon Railgun blueprint
Shield Pulse I	Complete Missions or World Events on any difficulty with Shield Pulse.	Complete 4 missions or world events.	Unlock the uncommon Shield Pulse blueprint
Shock Coil I	Complete Missions or World Events on any difficulty with Shock Coil.	Complete 4 missions or world events.	Unlock the uncommon Shock Coil blueprint
Siege Cannon I	Complete Missions or World Events on any difficulty with Siege Cannon.	Complete 4 missions or world events.	Unlock the uncommon Siege Cannon blueprint
Venom Spitter I	Complete Missions or World Events on any difficulty with Venom Spitter.	Complete 4 missions or world events.	Unlock the uncommon Venom Spitter blueprint
Battle Cry II	Complete Missions or World Events on any difficulty with Battle Cry.	Complete 8 missions or world events.	Unlock the rare Battle Cry blueprint
Burst Mortar II	Complete Missions or World Events on any difficulty with Burst Mortar.	Complete 8 missions or world events.	Unlock the rare Burst Mortar blueprint
Firewall Mortar II	Complete Missions or World Events on any difficulty with Firewall Mortar.	Complete 8 missions or world events.	Unlock the rare Firewall Mortar blueprint
Flak Cannon II	Complete Missions or World Events on any difficulty with Flak Cannon.	Complete 8 missions or world events.	Unlock the rare Flak Cannon blueprint
Flamethrower II	Complete Missions or World Events on any difficulty with Flamethrower.	Complete 8 missions or world events.	Unlock the rare Flamethrower blueprint
High-Explosive Mortar II	Complete Missions or World Events on any difficulty with High-Explosive Mortar.	Complete 8 missions or world events.	Unlock the rare High-Explosive Mortar blueprint
Lightning Coil II	Complete Missions or World Events on any difficulty with Lightning Coil.	Complete 8 missions or world events.	Unlock the rare Lightning Coil blueprint
Railgun II	Complete Missions or World Events on any difficulty with Railgun.	Complete 8 missions or world events.	Unlock the rare Railgun blueprint
Shield Pulse II	Complete Missions or World Events on any difficulty with Shield Pulse.	Complete 8 missions or world events.	Unlock the rare Shield Pulse blueprint
Shock Coil II	Complete Missions or World Events on any difficulty with Shock Coil.	Complete 8 missions or world events.	Unlock the rare Shock Coil blueprint
Siege Cannon II	Complete Missions or World Events on any difficulty with Siege Cannon.	Complete 8 missions or world events.	Unlock the rare Siege Cannon blueprint
Venom Spitter II	Complete Missions or World Events on any difficulty with Venom Spitter.	Complete 8 missions or world events.	Unlock the rare Venom Spitter blueprint
Battle Cry III	Complete Missions or World Events on any difficulty with Battle Cry.	Complete 12 missions or world events.	Unlock the epic Battle Cry blueprint
Burst Mortar III	Complete Missions or World Events on any difficulty with Burst Mortar.	Complete 12 missions or world events.	Unlock the epic Burst Mortar blueprint
Firewall Mortar III	Complete Missions or World Events on any difficulty with Firewall Mortar.	Complete 12 missions or world events.	Unlock the epic Firewall Mortar blueprint
Flak Cannon III	Complete Missions or World Events on any difficulty with Flak Cannon.	Complete 12 missions or world events.	Unlock the epic Flak Cannon blueprint
Flamethrower III	Complete Missions or World Events on any difficulty with Flamethrower.	Complete 12 missions or world events.	Unlock the epic Flamethrower blueprint
High-Explosive Mortar III	Complete Missions or World Events on any difficulty with High-Explosive Mortar.	Complete 12 missions or world events.	Unlock the epic High-Explosive Mortar blueprint
Lightning Coil III	Complete Missions or World Events on any difficulty with Lightning Coil.	Complete 12 missions or world events.	Unlock the epic Lightning Coil blueprint
Railgun III	Complete Missions or World Events on any difficulty with Railgun.	Complete 12 missions or world events.	Unlock the epic Railgun blueprint
Shield Pulse III	Complete Missions or World Events on any difficulty with Shield Pulse.	Complete 12 missions or world events.	Unlock the epic Shield Pulse blueprint
Shock Coil III	Complete Missions or World Events on any difficulty with Shock Coil.	Complete 12 missions or world events.	Unlock the epic Shock Coil blueprint
Siege Cannon III	Complete Missions or World Events on any difficulty with Siege Cannon.	Complete 12 missions or world events.	Unlock the epic Siege Cannon blueprint
Venom Spitter III	Complete Missions or World Events on any difficulty with Venom Spitter.	Complete 12 missions or world events.	Unlock the epic Venom Spitter blueprint
Best Defense	Complete Missions or World Events on Grandmaster 1+ with Best Defense.	Complete 35 missions or world events.	Unlock the masterwork Best Defense blueprint
Black Powder	Complete Missions or World Events on Grandmaster 1+ with Black Powder.	Complete 35 missions or world events.	Unlock the masterwork Black Powder blueprint
Final Judgment	Complete Missions or World Events on Grandmaster 1+ with Final Judgment.	Complete 35 missions or world events.	Unlock the masterwork Final Judgment blueprint
Fist of the Crucible	Complete Missions or World Events on Grandmaster 1+ with Fist of the Crucible.	Complete 35 missions or world events.	Unlock the masterwork Fist of the Crucible blueprint
Garred's Hammer	Complete Missions or World Events on Grandmaster 1+ with Garred's Hammer.	Complete 35 missions or world events.	Unlock the masterwork Garred's Hammer blueprint
Rubidium Furnace	Complete Missions or World Events on Grandmaster 1+ with Rubidium Furnace.	Complete 35 missions or world events.	Unlock the masterwork Rubidium Furnace blueprint
Solvent Green	Complete Missions or World Events on Grandmaster 1+ with Solvent Green.	Complete 35 missions or world events.	Unlock the masterwork Solvent Green blueprint
Titan's Hail	Complete Missions or World Events on Grandmaster 1+ with Titan's Hail.	Complete 35 missions or world events.	Unlock the masterwork Titan's Hail blueprint
Vassa's Arc	Complete Missions or World Events on Grandmaster 1+ with Vassa's Arc.	Complete 35 missions or world events.	Unlock the masterwork Vassa's Arc blueprint
Voltaic Dome	Complete Missions or World Events on Grandmaster 1+ with Voltaic Dome.	Complete 35 missions or world events.	Unlock the masterwork Voltaic Dome blueprint

INTERCEPTOR CHALLENGES

CHALLENGE NAME	IN-GAME DESCRIPTION	COMPLETE CONDITIONS	REWARD
Interceptor Gear I Master	Complete all Interceptor Gear I Challenges.	Complete Cluster Mine I, Gryo Glaive I, Detonating Strike I, Plasma Star I, Rally Cry I, Searching Glaive I, Spark Dash I, Target Beacon I, Tempest Strike I, Venom Bomb I, Venom Spray I, and Wraith Strike I.	2 Banners and Coin
Cluster Mine I	Complete Missions or World Events on any difficulty with Cluster Mine.	Complete 4 missions or world events.	Unlock the uncommon Cluster Mine blueprint
Cryo Glaive I	Complete Missions or World Events on any difficulty with Cryo Glaive.	Complete 4 missions or world events.	Unlock the uncommon Cryo Glaive blueprint
Detonating Strike I	Complete Missions or World Events on any difficulty with Detonating Strike.	Complete 4 missions or world events.	Unlock the uncommon Detonating Strike blueprint
Plasma Star I	Complete Missions or World Events on any difficulty with Plasma Star.	Complete 4 missions or world events.	Unlock the uncommon Plasma Star blueprint
Rally Cry I	Complete Missions or World Events on any difficulty with Rally Cry.	Complete 4 missions or world events.	Unlock the uncommon Rally Cry blueprint
Searching Glaive I	Complete Missions or World Events on any difficulty with Searching Glaive.	Complete 4 missions or world events.	Unlock the uncommon Searching Glaive blueprint
Spark Dash I	Complete Missions or World Events on any difficulty with Spark Dash.	Complete 4 missions or world events.	Unlock the uncommon Spark Dash blueprint
Target Beacon I	Complete Missions or World Events on any difficulty with Target Beacon.	Complete 4 missions or world events.	Unlock the uncommon Target Beacon blueprint
Tempest Strike I	Complete Missions or World Events on any difficulty with Tempest Strike.	Complete 4 missions or world events.	Unlock the uncommon Tempest Strike blueprint
Venom Bomb I	Complete Missions or World Events on any difficulty with Venom Bomb.	Complete 4 missions or world events.	Unlock the uncommon Venom Bomb blueprint
Venom Spray I	Complete Missions or World Events on any difficulty with Venom Spray.	Complete 4 missions or world events.	Unlock the uncommon Venom Spray blueprint
Wraith Strike I	Complete Missions or World Events on any difficulty with Wraith Strike.	Complete 4 missions or world events.	Unlock the uncommon Wraith Strike blueprint
Cluster Mine II	Complete Missions or World Events on any difficulty with Cluster Mine.	Complete 8 missions or world events.	Unlock the rare Cluster Mine blueprint
Cryo Glaive II	Complete Missions or World Events on any difficulty with Cryo Glaive.	Complete 8 missions or world events.	Unlock the rare Cryo Glaive blueprint
Detonating Strike II	Complete Missions or World Events on any difficulty with Detonating Strike.	Complete 8 missions or world events.	Unlock the rare Detonating Strike blueprint
Plasma Star II	Complete Missions or World Events on any difficulty with Plasma Star.	Complete 8 missions or world events.	Unlock the rare Plasma Star blueprint
Rally Cry II	Complete Missions or World Events on any difficulty with Rally Cry.	Complete 8 missions or world events.	Unlock the rare Rally Cry blueprint
Searching Glaive II	Complete Missions or World Events on any difficulty with Searching Glaive.	Complete 8 missions or world events.	Unlock the rare Searching Glaive blueprint
Spark Dash II	Complete Missions or World Events on any difficulty with Spark Dash.	Complete 8 missions or world events.	Unlock the rare Spark Dash blueprint
Target Beacon II	Complete Missions or World Events on any difficulty with Target Beacon.	Complete 8 missions or world events.	Unlock the rare Target Beacon blueprint
Tempest Strike II	Complete Missions or World Events on any difficulty with Tempest Strike.	Complete 8 missions or world events.	Unlock the rare Tempest Strike blueprint
Venom Bomb II	Complete Missions or World Events on any difficulty with Venom Bomb.	Complete 8 missions or world events.	Unlock the rare Venom Bomb blueprint
Venom Spray II	Complete Missions or World Events on any difficulty with Venom Spray.	Complete 8 missions or world events.	Unlock the rare Venom Spray blueprint
Wraith Strike II	Complete Missions or World Events on any difficulty with Wraith Strike.	Complete 8 missions or world events.	Unlock the rare Wraith Strike blueprint
Cluster Mine III	Complete Missions or World Events on any difficulty with Cluster Mine.	Complete 12 missions or world events.	Unlock the epic Cluster Mine blueprint
Cryo Glaive III	Complete Missions or World Events on any difficulty with Cryo Glaive.	Complete 12 missions or world events.	Unlock the epic Cryo Glaive blueprint
Detonating Strike III	Complete Missions or World Events on any difficulty with Detonating Strike.	Complete 12 missions or world events.	Unlock the epic Detonating Strike blueprint
Plasma Star III	Complete Missions or World Events on any difficulty with Plasma Star.	Complete 12 missions or world events.	Unlock the epic Plasma Star blueprint
Rally Cry III	Complete Missions or World Events on any difficulty with Rally Cry.	Complete 12 missions or world events.	Unlock the epic Rally Cry blueprint
Searching Glaive III	Complete Missions or World Events on any difficulty with Searching Glaive.	Complete 12 missions or world events.	Unlock the epic Searching Glaive blueprint
Spark Dash III	Complete Missions or World Events on any difficulty with Spark Dash.	Complete 12 missions or world events.	Unlock the epic Spark Dash blueprint
Target Beacon III	Complete Missions or World Events on any difficulty with Target Beacon.	Complete 12 missions or world events.	Unlock the epic Target Beacon blueprint
Tempest Strike III	Complete Missions or World Events on any difficulty with Tempest Strike.	Complete 12 missions or world events.	Unlock the epic Tempest Strike blueprint
Venom Bomb III	Complete Missions or World Events on any difficulty with Venom Bomb.	Complete 12 missions or world events.	Unlock the epic Venom Bomb blueprint
Venom Spray III	Complete Missions or World Events on any difficulty with Venom Spray.	Complete 12 missions or world events.	Unlock the epic Venom Spray blueprint
Wraith Strike III	Complete Missions or World Events on any difficulty with Wraith Strike.	Complete 12 missions or world events.	Unlock the epic Wraith Strike blueprint
Absolute Zero	Complete Missions or World Events on Grandmaster 1+ with Absolute Zero.	Complete 35 missions or world events.	Unlock the masterwork Absolute Zero blueprint
Bitter Harvest	Complete Missions or World Events on Grandmaster 1+ with Bitter Harvest.	Complete 35 missions or world events.	Unlock the masterwork Bitter Harvest blueprint
Cariff's Talon	Complete Missions or World Events on Grandmaster 1+ with Cariff's Talon.	Complete 35 missions or world events.	Unlock the masterwork Cariff's Talon blueprint
Raneri's Charge	Complete Missions or World Events on Grandmaster 1+ with Raneri's Charge.	Complete 35 missions or world events.	Unlock the masterwork Raneri's Charge blueprint
Ruthless Stalker	Complete Missions or World Events on Grandmaster 1+ with Ruthless Stalker.	Complete 35 missions or world events.	Unlock the masterwork Ruthless Stalker blueprint
Sanadeen's Respite	Complete Missions or World Events on Grandmaster 1+ with Sanadeen's Respite.	Complete 35 missions or world events.	Unlock the masterwork Sanadeen's Respite blueprint
Serpent's Veil	Complete Missions or World Events on Grandmaster 1+ with Serpent's Veil.	Complete 35 missions or world events.	Unlock the masterwork Serpent's Veil blueprint
Shadow Claw	Complete Missions or World Events on Grandmaster 1+ with Shadow Claw.	Complete 35 missions or world events.	Unlock the masterwork Shadow Claw blueprint
Sudden Death	Complete Missions or World Events on Grandmaster 1+ with Sudden Death.	Complete 35 missions or world events.	Unlock the masterwork Sudden Death blueprint
Viper's Bite	Complete Missions or World Events on Grandmaster 1+ with Viper's Bite.	Complete 35 missions or world events.	Unlock the masterwork Viper's Bite blueprint

RANGER CHALLENGES

CHALLENGE NAME	IN-GAME DESCRIPTION	COMPLETE CONDITIONS	REWARD
Ranger Gear I Master	Complete all Ranger Gear I Challenges.	Complete Blast Missile I, Bulwark Point I, Frag Grenade I, Frost Grenade I, Inferno Grenade I, Muster Point I, Pulse Blast I, Seeker Grenades I, Seeking Missile I, Spark Beam I, Sticky Grenade I, and Venom Darts I.	2 Banners and Coin
Blast Missile I	Complete Missions or World Events on any difficulty with Blast Missile.	Complete 4 missions or world events.	Unlock the uncommon Blast Missile blueprint
Bulwark Point I	Complete Missions or World Events on any difficulty with Bulwark Point.	Complete 4 missions or world events.	Unlock the uncommon Bulwark Point blueprint
Frag Grenade I	Complete Missions or World Events on any difficulty with Frag Grenade.	Complete 4 missions or world events.	Unlock the uncommon Frag Grenade blueprint
Frost Grenade I	Complete Missions or World Events on any difficulty with Frost Grenade.	Complete 4 missions or world events.	Unlock the uncommon Frost Grenade blueprint
Inferno Grenade I	Complete Missions or World Events on any difficulty with Inferno Grenade.	Complete 4 missions or world events.	Unlock the uncommon Inferno Grenade blueprint
Muster Point I	Complete Missions or World Events on any difficulty with Muster Point.	Complete 4 missions or world events.	Unlock the uncommon Muster Point blueprint
Pulse Blast I	Complete Missions or World Events on any difficulty with Pulse Blast.	Complete 4 missions or world events.	Unlock the uncommon Pulse Blast blueprint
Seeker Grenades I	Complete Missions or World Events on any difficulty with Seeker Grenades.	Complete 4 missions or world events.	Unlock the uncommon Seeker Grenades blueprint
Seeking Missile I	Complete Missions or World Events on any difficulty with Seeking Missile.	Complete 4 missions or world events.	Unlock the uncommon Seeking Missile blueprint
Spark Beam I	Complete Missions or World Events on any difficulty with Spark Beam.	Complete 4 missions or world events.	Unlock the uncommon Spark Beam blueprint
Sticky Grenade I	Complete Missions or World Events on any difficulty with Sticky Grenade.	Complete 4 missions or world events.	Unlock the uncommon Sticky Grenade blueprint
Venom Darts I	Complete Missions or World Events on any difficulty with Venom Darts.	Complete 4 missions or world events.	Unlock the uncommon Venom Darts blueprint
Blast Missile II	Complete Missions or World Events on any difficulty with Blast Missile.	Complete 8 missions or world events.	Unlock the rare Blast Missile blueprint
Bulwark Point II	Complete Missions or World Events on any difficulty with Bulwark Point.	Complete 8 missions or world events.	Unlock the rare Bulwark Point blueprint
Frag Grenade II	Complete Missions or World Events on any difficulty with Frag Grenade.	Complete 8 missions or world events.	Unlock the rare Frag Grenade blueprint
Frost Grenade II	Complete Missions or World Events on any difficulty with Frost Grenade.	Complete 8 missions or world events.	Unlock the rare Frost Grenade blueprint
Inferno Grenade II	Complete Missions or World Events on any difficulty with Inferno Grenade.	Complete 8 missions or world events.	Unlock the rare Inferno Grenade blueprint
Muster Point II	Complete Missions or World Events on any difficulty with Muster Point.	Complete 8 missions or world events.	Unlock the rare Muster Point blueprint
Pulse Blast II	Complete Missions or World Events on any difficulty with Pulse Blast.	Complete 8 missions or world events.	Unlock the rare Pulse Blast blueprint
Seeker Grenades II	Complete Missions or World Events on any difficulty with Seeker Grenades.	Complete 8 missions or world events.	Unlock the rare Seeker Grenades blueprint
Seeking Missile II	Complete Missions or World Events on any difficulty with Seeking Missile.	Complete 8 missions or world events.	Unlock the rare Seeking Missile blueprint
Spark Beam II	Complete Missions or World Events on any difficulty with Spark Beam.	Complete 8 missions or world events.	Unlock the rare Spark Beam blueprint
Sticky Grenade II	Complete Missions or World Events on any difficulty with Sticky Grenade.	Complete 8 missions or world events.	Unlock the rare Sticky Grenade blueprint
Venom Darts II	Complete Missions or World Events on any difficulty with Venom Darts.	Complete 8 missions or world events.	Unlock the rare Venom Darts blueprint
Blast Missile III	Complete Missions or World Events on any difficulty with Blast Missile.	Complete 12 missions or world events.	Unlock the epic Blast Missile blueprint
Bulwark Point III	Complete Missions or World Events on any difficulty with Bulwark Point.	Complete 12 missions or world events.	Unlock the epic Bulwark Point blueprint
Frag Grenade III	Complete Missions or World Events on any difficulty with Frag Grenade.	Complete 12 missions or world events.	Unlock the epic Frag Grenade blueprint
Frost Grenade III	Complete Missions or World Events on any difficulty with Frost Grenade.	Complete 12 missions or world events.	Unlock the epic Frost Grenade blueprint
Inferno Grenade III	Complete Missions or World Events on any difficulty with Inferno Grenade.	Complete 12 missions or world events.	Unlock the epic Inferno Grenade blueprint
Muster Point III	Complete Missions or World Events on any difficulty with Muster Point.	Complete 12 missions or world events.	Unlock the epic Muster Point blueprint
Pulse Blast III	Complete Missions or World Events on any difficulty with Pulse Blast.	Complete 12 missions or world events.	Unlock the epic Pulse Blast blueprint
Seeker Grenades III	Complete Missions or World Events on any difficulty with Seeker Grenades.	Complete 12 missions or world events.	Unlock the epic Seeker Grenades blueprint
Seeking Missile III	Complete Missions or World Events on any difficulty with Seeking Missile.	Complete 12 missions or world events.	Unlock the epic Seeking Missile blueprint
Spark Beam III	Complete Missions or World Events on any difficulty with Spark Beam.	Complete 12 missions or world events.	Unlock the epic Spark Beam blueprint
Sticky Grenade III	Complete Missions or World Events on any difficulty with Sticky Grenade.	Complete 12 missions or world events.	Unlock the epic Sticky Grenade blueprint
Venom Darts III	Complete Missions or World Events on any difficulty with Venom Darts.	Complete 12 missions or world events.	Unlock the epic Venom Darts blueprint
Argo's Mace	Complete Missions or World Events on Grandmaster 1+ with Argo's Mace.	Complete 35 missions or world events.	Unlock the masterwork Argo's Mace blueprint
Avenger's Boon	Complete Missions or World Events on Grandmaster 1+ with Avenger's Boon.	Complete 35 missions or world events.	Unlock the masterwork Avenger's Boon blueprint
Cold Blooded	Complete Missions or World Events on Grandmaster 1+ with Cold Blooded.	Complete 35 missions or world events.	Unlock the masterwork Cold Blooded blueprint
Ember's Lance	Complete Missions or World Events on Grandmaster 1+ with Ember's Lance.	Complete 35 missions or world events.	Unlock the masterwork Ember's Lance blueprint
Explosive Blaze	Complete Missions or World Events on Grandmaster 1+ with Explosive Blaze.	Complete 35 missions or world events.	Unlock the masterwork Explosive Blaze blueprint
Grand Opening	Complete Missions or World Events on Grandmaster 1+ with Grand Opening.	Complete 35 missions or world events.	Unlock the masterwork Grand Opening blueprint
Last Argument	Complete Missions or World Events on Grandmaster 1+ with Last Argument.	Complete 35 missions or world events.	Unlock the masterwork Last Argument blueprint
Recurring Vengeance	Complete Missions or World Events on Grandmaster 1+ with Recurring Vengeance.	Complete 35 missions or world events.	Unlock the masterwork Recurring Vengeance blueprint
Tactical Onslaught	Complete Missions or World Events on Grandmaster 1+ with Tactical Onslaught.	Complete 35 missions or world events.	Unlock the masterwork Tactical Onslaught blueprint
The Gambit	Complete Missions or World Events on Grandmaster 1+ with The Gambit.	Complete 35 missions or world events.	Unlock the masterwork The Gambit blueprint

STORM CHALLENGES

CHALLENGE NAME	IN-GAME DESCRIPTION	COMPLETE CONDITIONS	REWARD
Storm Gear I Master	Complete all Storm Gear I Challenges.	Complete Arc Burst I, Burning Orb I, Flame Burst I, Frost Shards I, Glacial Spear I, Ice Blast I, Ice Storm I, Lightning Strike I, Living Flame I, Quickening Field I, and Shock Burst I.	2 Banners and Coin
Arc Burst I	Complete Missions or World Events on any difficulty with Arc Burst.	Complete 4 missions or world events.	Unlock the uncommon Arc Burst blueprint
Burning Orb I	Complete Missions or World Events on any difficulty with Burning Orb.	Complete 4 missions or world events.	Unlock the uncommon Burning Orb blueprint
Flame Burst I	Complete Missions or World Events on any difficulty with Flame Burst.	Complete 4 missions or world events.	Unlock the uncommon Flame Burst blueprint
Frost Shards I	Complete Missions or World Events on any difficulty with Frost Shards.	Complete 4 missions or world events.	Unlock the uncommon Frost Shards blueprint
Glacial Spear I	Complete Missions or World Events on any difficulty with Glacial Spear.	Complete 4 missions or world events.	Unlock the uncommon Glacial Spear blueprint
Ice Blast I	Complete Missions or World Events on any difficulty with Ice Blast.	Complete 4 missions or world events.	Unlock the uncommon Ice Blast blueprint
Ice Storm I	Complete Missions or World Events on any difficulty with Ice Storm.	Complete 4 missions or world events.	Unlock the uncommon Ice Storm blueprint
Lightning Strike I	Complete Missions or World Events on any difficulty with Lightning Strike.	Complete 4 missions or world events.	Unlock the uncommon Lightning Strike blueprint
Living Flame I	Complete Missions or World Events on any difficulty with Living Flame.	Complete 4 missions or world events.	Unlock the uncommon Living Flame blueprint
Quickening Field I	Complete Missions or World Events on any difficulty with Quickening Field.	Complete 4 missions or world events.	Unlock the uncommon Quickening Field blueprint
Shock Burst I	Complete Missions or World Events on any difficulty with Shock Burst.	Complete 4 missions or world events.	Unlock the uncommon Shock Burst blueprint
Wind Wall I	Complete Missions or World Events on any difficulty with Wind Wall.	Complete 4 missions or world events.	Unlock the uncommon Wind Wall blueprint
Arc Burst II	Complete Missions or World Events on any difficulty with Arc Burst.	Complete 8 missions or world events.	Unlock the rare Arc Burst blueprint
Burning Orb II	Complete Missions or World Events on any difficulty with Burning Orb.	Complete 8 missions or world events.	Unlock the rare Burning Orb blueprint
Flame Burst II	Complete Missions or World Events on any difficulty with Flame Burst.	Complete 8 missions or world events.	Unlock the rare Flame Burst blueprint
Frost Shards II	Complete Missions or World Events on any difficulty with Frost Shards.	Complete 8 missions or world events.	Unlock the rare Frost Shards blueprint
Glacial Spear II	Complete Missions or World Events on any difficulty with Glacial Spear.	Complete 8 missions or world events.	Unlock the rare Glacial Spear blueprint
Ice Blast II	Complete Missions or World Events on any difficulty with Ice Blast.	Complete 8 missions or world events.	Unlock the rare Ice Blast blueprint
Ice Storm II	Complete Missions or World Events on any difficulty with Ice Storm.	Complete 8 missions or world events.	Unlock the rare Ice Storm blueprint
Lightning Strike II	Complete Missions or World Events on any difficulty with Lightning Strike.	Complete 8 missions or world events.	Unlock the rare Lightning Strike blueprint
Living Flame II	Complete Missions or World Events on any difficulty with Living Flame.	Complete 8 missions or world events.	Unlock the rare Living Flame blueprint
Quickening Field II	Complete Missions or World Events on any difficulty with Quickening Field.	Complete 8 missions or world events.	Unlock the rare Quickening Field blueprint
Shock Burst II	Complete Missions or World Events on any difficulty with Shock Burst.	Complete 8 missions or world events.	Unlock the rare Shock Burst blueprint
Wind Wall II	Complete Missions or World Events on any difficulty with Wind Wall.	Complete 8 missions or world events.	Unlock the rare Wind Wall blueprint
Arc Burst III	Complete Missions or World Events on any difficulty with Arc Burst.	Complete 12 missions or world events.	Unlock the epic Arc Burst blueprint
Burning Orb III	Complete Missions or World Events on any difficulty with Burning Orb.	Complete 12 missions or world events.	Unlock the epic Burning Orb blueprint
Flame Burst III	Complete Missions or World Events on any difficulty with Flame Burst.	Complete 12 missions or world events.	Unlock the epic Flame Burst blueprint
Frost Shards III	Complete Missions or World Events on any difficulty with Frost Shards.	Complete 12 missions or world events.	Unlock the epic Frost Shards blueprint
Glacial Spear III	Complete Missions or World Events on any difficulty with Glacial Spear.	Complete 12 missions or world events.	Unlock the epic Glacial Spear blueprint
Ice Blast III	Complete Missions or World Events on any difficulty with Ice Blast.	Complete 12 missions or world events.	Unlock the epic Ice Blast blueprint
Ice Storm III	Complete Missions or World Events on any difficulty with Ice Storm.	Complete 12 missions or world events.	Unlock the epic Ice Storm blueprint
Lightning Strike III	Complete Missions or World Events on any difficulty with Lightning Strike.	Complete 12 missions or world events.	Unlock the epic Lightning Strike blueprint
Living Flame III	Complete Missions or World Events on any difficulty with Living Flame.	Complete 12 missions or world events.	Unlock the epic Living Flame blueprint
Quickening Field III	Complete Missions or World Events on any difficulty with Quickening Field.	Complete 12 missions or world events.	Unlock the epic Quickening Field blueprint
Shock Burst III	Complete Missions or World Events on any difficulty with Shock Burst.	Complete 12 missions or world events.	Unlock the epic Shock Burst blueprint
Wind Wall III	Complete Missions or World Events on any difficulty with Wind Wall.	Complete 12 missions or world events.	Unlock the epic Wind Wall blueprint

CHALLENGE NAME	IN-GAME DESCRIPTION	COMPLETE CONDITIONS	REWARD
Binary Star	Complete Missions or World Events on Grandmaster 1+ with Binary Star.	Complete 35 missions or world events.	Unlock the masterwork Binary Star blueprint
Black Ice	Complete Missions or World Events on Grandmaster 1+ with Black Ice.	Complete 35 missions or world events.	Unlock the masterwork Black Ice blueprint
Chaotic Rime	Complete Missions or World Events on Grandmaster 1+ with Chaotic Rime.	Complete 35 missions or world events.	Unlock the masterwork Chaotic Rime blueprint
Hailstorm's Renewal	Complete Missions or World Events on Grandmaster 1+ with Hailstorm's Renewal.	Complete 35 missions or world events.	Unlock the masterwork Hailstorm's Renewal blueprint
Lightning Strike	Complete Missions or World Events on Grandmaster 1+ with Lightning Strike.	Complete 35 missions or world events.	Unlock the masterwork Lightning Strike blueprint
Seal of the Open Mind	Complete Missions or World Events on Grandmaster 1+ with Seal of the Open Mind.	Complete 35 missions or world events.	Unlock the masterwork Seal of the Open Mind blueprint
Stasis Chain	Complete Missions or World Events on Grandmaster 1+ with Stasis Chain.	Complete 35 missions or world events.	Unlock the masterwork Stasis Chain blueprint
Ten Thousand Suns	Complete Missions or World Events on Grandmaster 1+ with Ten Thousand Suns.	Complete 35 missions or world events.	Unlock the masterwork Ten Thousand Suns blueprint
Venomous Blaze	Complete Missions or World Events on Grandmaster 1+ with Venomous Blaze.	Complete 35 missions or world events.	Unlock the masterwork Venomous Blaze blueprint
Winter's Wrath	Complete Missions or World Events on Grandmaster 1+ with Winter's Wrath.	Complete 35 missions or world events.	Unlock the masterwork Winter's Wrath blueprint

ASSAULT RIFLE CHALLENGES

CHALLENGE NAME	IN-GAME DESCRIPTION	COMPLETE CONDITIONS	REWARD
Assault Rifle Master I	Complete Assault Rifle I Challenges.	Complete Warden I, Defender I, and Hammerhead I.	Coin
Warden I	Defeat enemies using Warden.	Defeat 50 enemies.	Unlock the uncommon Warden blueprint
Defender I	Defeat enemies using Defender.	Defeat 50 enemies.	Unlock the uncommon Defender blueprint
Hammerhead I	Defeat enemies using Hammerhead.	Defeat 50 enemies.	Unlock the uncommon Hammerhead blueprint
Warden II	Defeat Elite enemies using Warden.	Defeat 25 enemies.	Unlock the rare Warden blueprint
Defender II	Defeat Elite enemies using Defender.	Defeat 25 enemies.	Unlock the rare Defender blueprint
Hammerhead II	Defeat Elite enemies using Hammerhead.	Defeat 25 enemies.	Unlock the rare Hammerhead blueprint
Warden III	Defeat Legendary enemies using Warden.	Defeat 10 enemies.	Unlock the epic Warden blueprint
Defender III	Defeat Legendary enemies using Defender.	Defeat 10 enemies.	Unlock the epic Defender blueprint
Hammerhead III	Defeat Legendary enemies using Hammerhead.	Defeat 10 enemies.	Unlock the epic Hammerhead blueprint
Divine Vengeance	Defeat Legendary enemies using Divine Vengeance.	Defeat 10 enemies.	Unlock the masterwork Divine Vengeance blueprint
Elemental Rage	Defeat Legendary enemies using Elemental Rage.	Defeat 10 enemies.	Unlock the masterwork Elemental Rage blueprint
Ralner's Blaze	Defeat Legendary enemies using Ralner's Blaze.	Defeat 10 enemies.	Unlock the masterwork Ralner's Blaze blueprint

AUTOCANNON CHALLENGES

CHALLENGE NAME	IN-GAME DESCRIPTION	COMPLETE CONDITIONS	REWARD
Autocannon Master I	Complete Autocannon I Challenges.	Complete Torrent I, Mauler I, and Cloudburst I.	Coin
Torrent I	Defeat enemies using Torrent.	Defeat 50 enemies.	Unlock the uncommon Torrent blueprint
Mauler I	Defeat enemies using Mauler.	Defeat 50 enemies.	Unlock the uncommon Mauler blueprint
Cloudburst I	Defeat enemies using Cloudburst.	Defeat 50 enemies.	Unlock the uncommon Cloudburst blueprint
Torrent II	Defeat Elite enemies using Torrent.	Defeat 25 enemies.	Unlock the rare Torrent blueprint
Mauler II	Defeat Elite enemies using Mauler.	Defeat 25 enemies.	Unlock the rare Mauler blueprint
Cloudburst II	Defeat Elite enemies using Cloudburst.	Defeat 25 enemies.	Unlock the rare Cloudburst blueprint
Torrent III	Defeat Legendary enemies using Torrent.	Defeat 10 enemies.	Unlock the epic Torrent blueprint
Mauler III	Defeat Legendary enemies using Mauler.	Defeat 10 enemies.	Unlock the epic Mauler blueprint
Cloudburst III	Defeat Legendary enemies using Cloudburst.	Defeat 10 enemies.	Unlock the epic Cloudburst blueprint
Endless Siege	Defeat Legendary enemies using Endless Siege.	Defeat 10 enemies.	Unlock the masterwork Endless Siege blueprint
The Last Stand	Defeat Legendary enemies using The Last Stand.	Defeat 10 enemies.	Unlock the masterwork The Last Stand blueprint
Fist of Stral	Defeat Legendary enemies using Fist of Stral.	Defeat 10 enemies.	Unlock the masterwork Fist of Stral blueprint

GRENADE LAUNCHER CHALLENGES

CHALLENGE NAME	IN-GAME DESCRIPTION	COMPLETE CONDITIONS	REWARD
Grenade Launcher Master I	Complete Grenade Launcher I Challenges.	Complete Bombardier I, Lurker I, and Aftershock I.	Coin
Bombardier I	Defeat enemies using Bombardier.	Defeat 50 enemies.	Unlock the uncommon Bombardier blueprint
Lurker I	Defeat enemies using Lurker.	Defeat 50 enemies.	Unlock the uncommon Lurker blueprint
Aftershock I	Defeat enemies using Aftershock.	Defeat 50 enemies.	Unlock the uncommon Aftershock blueprint
Bombardier II	Defeat Elite enemies using Bombardier.	Defeat 25 enemies.	Unlock the rare Bombardier blueprint
Lurker II	Defeat Elite enemies using Lurker.	Defeat 25 enemies.	Unlock the rare Lurker blueprint
Aftershock II	Defeat Elite enemies using Aftershock.	Defeat 25 enemies.	Unlock the rare Aftershock blueprint
Bombardier III	Defeat Legendary enemies using Bombardier.	Defeat 10 enemies.	Unlock the epic Bombardier blueprint
Lurker III	Defeat Legendary enemies using Lurker.	Defeat 10 enemies.	Unlock the epic Lurker blueprint
Aftershock III	Defeat Legendary enemies using Aftershock.	Defeat 10 enemies.	Unlock the epic Aftershock blueprint
Insult And Injury	Defeat Legendary enemies using Insult And Injury.	Defeat 10 enemies.	Unlock the masterwork Insult And Injury blueprint
Balm of Gavinicus	Defeat Legendary enemies using Balm of Gavinicus.	Defeat 10 enemies.	Unlock the masterwork Balm of Gavinicus blueprint
Sentinel's Vengeance	Defeat Legendary enemies using Sentinel's Vengeance.	Defeat 10 enemies.	Unlock the masterwork Sentinel's Vengeance blueprint

HEAVY PISTOL CHALLENGES

CHALLENGE NAME	IN-GAME DESCRIPTION	COMPLETE CONDITIONS	REWARD
Heavy Pistol Master I	Complete Heavy Pistol I Challenges.	Complete Resolution I, Blastback I, and Barrage I.	Coin
Resolution I	Defeat enemies using Resolution.	Defeat 50 enemies.	Unlock the uncommon Resolution blueprint
Blastback I	Defeat enemies using Blastback.	Defeat 50 enemies.	Unlock the uncommon Blastback blueprint
Barrage I	Defeat enemies using Barrage.	Defeat 50 enemies.	Unlock the uncommon Barrage blueprint
Resolution II	Defeat Elite enemies using Resolution.	Defeat 25 enemies.	Unlock the rare Resolution blueprint
Blastback II	Defeat Elite enemies using Blastback.	Defeat 25 enemies.	Unlock the rare Blastback blueprint
Barrage II	Defeat Elite enemies using Barrage.	Defeat 25 enemies.	Unlock the rare Barrage blueprint
Resolution III	Defeat Legendary enemies using Resolution.	Defeat 10 enemies.	Unlock the epic Resolution blueprint
Blastback III	Defeat Legendary enemies using Blastback.	Defeat 10 enemies.	Unlock the epic Blastback blueprint
Barrage III	Defeat Legendary enemies using Barrage.	Defeat 10 enemies.	Unlock the epic Barrage blueprint
Glorious Result	Defeat Legendary enemies using Glorious Result.	Defeat 10 enemies.	Unlock the masterwork Glorious Result blueprint
Avenging Herald	Defeat Legendary enemies using Avenging Herald.	Defeat 10 enemies.	Unlock the masterwork Avenging Herald blueprint
Close Encounter	Defeat Legendary enemies using Close Encounter.	Defeat 10 enemies.	Unlock the masterwork Close Encounter blueprint

LIGHT MACHINE GUN CHALLENGES

CHALLENGE NAME	IN-GAME DESCRIPTION	COMPLETE CONDITIONS	REWARD
Light Machine Gun Master I	Complete Light Machine Gun I Challenges.	Complete Relentless I, Savage I, and Sledgehammer I.	Coin
Relentless I	Defeat enemies using Relentless.	Defeat 50 enemies.	Unlock the uncommon Relentless blueprint
Savage I	Defeat enemies using Savage.	Defeat 50 enemies.	Unlock the uncommon Savage blueprint
Sledgehammer I	Defeat enemies using Sledgehammer.	Defeat 50 enemies.	Unlock the uncommon Sledgehammer blueprint
Relentless II	Defeat Elite enemies using Relentless.	Defeat 25 enemies.	Unlock the rare Relentless blueprint
Savage II	Defeat Elite enemies using Savage.	Defeat 25 enemies.	Unlock the rare Savage blueprint
Sledgehammer II	Defeat Elite enemies using Sledgehammer.	Defeat 25 enemies.	Unlock the rare Sledgehammer blueprint
Relentless III	Defeat Legendary enemies using Relentless.	Defeat 10 enemies.	Unlock the epic Relentless blueprint
Savage III	Defeat Legendary enemies using Savage.	Defeat 10 enemies.	Unlock the epic Savage blueprint
Sledgehammer III	Defeat Legendary enemies using Sledgehammer.	Defeat 10 enemies.	Unlock the epic Sledgehammer blueprint
Artinia's Gambit	Defeat Legendary enemies using Artinia's Gambit.	Defeat 10 enemies.	Unlock the masterwork Artinia's Gambit blueprint
Renewed Courage	Defeat Legendary enemies using Renewed Courage.	Defeat 10 enemies.	Unlock the masterwork Renewed Courage blueprint
Cycle of Pain	Defeat Legendary enemies using Cycle of Pain.	Defeat 10 enemies.	Unlock the masterwork Cycle of Pain blueprint

MACHINE PISTOL CHALLENGES

CHALLENGE NAME	IN-GAME DESCRIPTION	COMPLETE CONDITIONS	REWARD
Machine Pistol Master I	Complete Machine Pistol I Challenges.	Complete Trajector I, Hailstorm I, and Fulcrum I.	Coin
Trajector I	Defeat enemies using Trajector.	Defeat 50 enemies.	Unlock the uncommon Trajector blueprint
Hailstorm I	Defeat enemies using Hailstorm.	Defeat 50 enemies.	Unlock the uncommon Hailstorm blueprint
Fulcrum I	Defeat enemies using Fulcrum.	Defeat 50 enemies.	Unlock the uncommon Fulcrum blueprint
Trajector II	Defeat Elite enemies using Trajector.	Defeat 25 enemies.	Unlock the rare Trajector blueprint
Hailstorm II	Defeat Elite enemies using Hailstorm.	Defeat 25 enemies.	Unlock the rare Hailstorm blueprint
Fulcrum II	Defeat Elite enemies using Fulcrum.	Defeat 25 enemies.	Unlock the rare Fulcrum blueprint
Trajector III	Defeat Legendary enemies using Trajector.	Defeat 10 enemies.	Unlock the epic Trajector blueprint
Hailstorm III	Defeat Legendary enemies using Hailstorm.	Defeat 10 enemies.	Unlock the epic Hailstorm blueprint
Fulcrum III	Defeat Legendary enemies using Fulcrum.	Defeat 10 enemies.	Unlock the epic Fulcrum blueprint
Retaliation of Garretus	Defeat Legendary enemies using Retaliation of Garretus.	Defeat 10 enemies.	Unlock the masterwork Retaliation of Garretus blueprint
Vassa's Surprise	Defeat Legendary enemies using Vassa's Surprise.	Defeat 10 enemies.	Unlock the masterwork Vassa's Surprise blueprint
Unending Battle	Defeat Legendary enemies using Unending Battle.	Defeat 10 enemies.	Unlock the masterwork Unending Battle blueprint

MARKSMAN RIFLE CHALLENGES

CHALLENGE NAME	IN-GAME DESCRIPTION	COMPLETE CONDITIONS	REWARD
Marksman Rifle Master I	Complete Marksman Rifle I Challenges.	Complete Anvil I, Scout I, and Guardian I.	Coin
Anvil I	Defeat enemies using Anvil.	Defeat 50 enemies.	Unlock the uncommon Anvil blueprint
Scout I	Defeat enemies using Scout.	Defeat 50 enemies.	Unlock the uncommon Scout blueprint
Guardian I	Defeat enemies using Guardian.	Defeat 50 enemies.	Unlock the uncommon Guardian blueprint
Anvil II	Defeat Elite enemies using Anvil.	Defeat 25 enemies.	Unlock the rare Anvil blueprint
Scout II	Defeat Elite enemies using Scout.	Defeat 25 enemies.	Unlock the rare Scout blueprint
Guardian II	Defeat Elite enemies using Guardian.	Defeat 25 enemies.	Unlock the rare Guardian blueprint
Anvil III	Defeat Legendary enemies using Anvil.	Defeat 10 enemies.	Unlock the epic Anvil blueprint
Scout III	Defeat Legendary enemies using Scout.	Defeat 10 enemies.	Unlock the epic Scout blueprint
Guardian III	Defeat Legendary enemies using Guardian.	Defeat 10 enemies.	Unlock the epic Guardian blueprint
Soothing Touch	Defeat Legendary enemies using Soothing Touch.	Defeat 10 enemies.	Unlock the masterwork Soothing Touch blueprint
Thunderbolt of Yvenia	Defeat Legendary enemies using Thunderbolt of Yvenia.	Defeat 10 enemies.	Unlock the masterwork Thunderbolt of Yvenia blueprint
Death From Above	Defeat Legendary enemies using Death From Above.	Defeat 10 enemies.	Unlock the masterwork Death From Above blueprint

SHOTGUN CHALLENGES

CHALLENGE NAME	IN-GAME DESCRIPTION	COMPLETE CONDITIONS	REWARD
Shotgun Master I	Complete Shotgun I Challenges.	Complete Scattershot I, Contrictor I, and Vengeance I.	Coin
Scattershot I	Defeat enemies using Scattershot.	Defeat 50 enemies.	Unlock the uncommon Scattershot blueprint
Constrictor I	Defeat enemies using Constrictor.	Defeat 50 enemies.	Unlock the uncommon Constrictor blueprint
Vengeance I	Defeat enemies using Vengeance.	Defeat 50 enemies.	Unlock the uncommon Vengeance blueprint
Scattershot II	Defeat Elite enemies using Scattershot.	Defeat 25 enemies.	Unlock the rare Scattershot blueprint
Constrictor II	Defeat Elite enemies using Constrictor.	Defeat 25 enemies.	Unlock the rare Constrictor blueprint
Vengeance II	Defeat Elite enemies using Vengeance.	Defeat 25 enemies.	Unlock the rare Vengeance blueprint
Scattershot III	Defeat Legendary enemies using Scattershot.	Defeat 10 enemies.	Unlock the epic Scattershot blueprint
Constrictor III	Defeat Legendary enemies using Constrictor.	Defeat 10 enemies.	Unlock the epic Constrictor blueprint
Vengeance III	Defeat Legendary enemies using Vengeance.	Defeat 10 enemies.	Unlock the epic Vengeance blueprint
Papa Pump	Defeat Legendary enemies using Papa Pump.	Defeat 10 enemies.	Unlock the masterwork Papa Pump blueprint
Radiant Fortress	Defeat Legendary enemies using Radiant Fortress.	Defeat 10 enemies.	Unlock the masterwork Radiant Fortress blueprint
Rolling Carnage	Defeat Legendary enemies using Rolling Carnage.	Defeat 10 enemies.	Unlock the masterwork Rolling Carnage blueprint

SNIPER RIFLE CHALLENGES

CHALLENGE NAME	IN-GAME DESCRIPTION	COMPLETE CONDITIONS	REWARD
Sniper Rifle Master I	Complete Sniper Rifle I Challenges.	Complete Devastator I, Whirlwind I, and Deadeye I.	Coin
Devastator I	Defeat enemies using Devastator.	Defeat 50 enemies.	Unlock the uncommon Devastator blueprint
Whirlwind I	Defeat enemies using Whirlwind.	Defeat 50 enemies.	Unlock the uncommon Whirlwind blueprint
Deadeye I	Defeat enemies using Deadeye.	Defeat 50 enemies.	Unlock the uncommon Deadeye blueprint
Devastator II	Defeat Elite enemies using Devastator.	Defeat 25 enemies.	Unlock the rare Devastator blueprint
Whirlwind II	Defeat Elite enemies using Whirlwind.	Defeat 25 enemies.	Unlock the rare Whirlwind blueprint
Deadeye II	Defeat Elite enemies using Deadeye.	Defeat 25 enemies.	Unlock the rare Deadeye blueprint
Devastator III	Defeat Legendary enemies using Devastator.	Defeat 10 enemies.	Unlock the epic Devastator blueprint
Whirlwind III	Defeat Legendary enemies using Whirlwind.	Defeat 10 enemies.	Unlock the epic Whirlwind blueprint
Deadeye III	Defeat Legendary enemies using Deadeye.	Defeat 10 enemies.	Unlock the epic Deadeye blueprint
Truth of Tarsis	Defeat Legendary enemies using Truth of Tarsis.	Defeat 10 enemies.	Unlock the masterwork Truth of Tarsis blueprint
Siege Breaker	Defeat Legendary enemies using Siege Breaker.	Defeat 10 enemies.	Unlock the masterwork Siege Breaker blueprint
Wyvern Blitz	Defeat Legendary enemies using Wyvern Blitz.	Defeat 10 enemies.	Unlock the masterwork Wyvern Blitz blueprint

FEATS

CHALLENGE NAME	IN-GAME DESCRIPTION	COMPLETE CONDITIONS	REWARD
Allies Repaired	Earn the "Allies Repaired" feat by repairing downed ally javelins.	Earn 20 Allies Repaired feats.	Coin
Collection	Earn the "Collections" feat by finding collectible objects in the world.	Earn 20 Conditions feats.	Coin
Combos	Earn the "Combos" feat by triggering combos on enemies suffering from status effects.	Earn 20 Combos feats.	Coin
Elite Slayer	Earn the "Elite Slayer" feat by defeating Elite enemies.	Earn 20 Elite Slayer feats.	Coin
Gear Master	Earn the "Gear Master" feat by defeating enemies with Gear.	Earn 20 Gear Master feats.	Coin
Legendary Slayer	Earn the "Legendary Slayer" feat by defeating Legendary enemies.	Earn 20 Legendary Slayer feats.	Coin
Melee Master	Earn the "Melee Master" feat by defeating enemies with melee attacks.	Earn 20 Conditions feats.	Coin
Ultimate Master	Earn the "Ultimate Master" feat by defeating enemies with an ultimate ability.	Earn 20 Ultimate Master feats.	Coin
Weak Point Striker	Earn the "Weak Point Striker" feat by hitting enemies' weak points to defeat them.	Earn 20 Weakpoint Striker feats.	Coin
Weapon Master	Earn the "Weapon Master" feat by using weapons to defeat enemies.	Earn 20 Conditions feats.	Coin
Materials Harvested	Earn the "Materials Harvested" feat by harvesting crafting materials.	Earn 20 Materials Harvested feats.	Coin
Mission Complete	Earn the "Mission Complete" feat by successfully completing missions.	Earn 20 Mission Complete feats.	Coin
Multi-Kills	Earn "Multi-Kills" feat by defeating numerous enemies simultaneously.	Earn 20 Multi-Kills feats.	Coin
Reinforcement	Earn the "Reinforcement" feat by reinforcing other Freelancers during missions.	Earn 20 Reinforcement feats.	Coin
World Events	Earn the "World Events" feat by successfully completing World Events in Freeplay.	Earn 20 World Events feats.	Coin

COMBAT CHALLENGES

CHALLENGE NAME	IN-GAME DESCRIPTION	COMPLETE CONDITIONS	REWARD
Combo Master I	Trigger combo reactions during combat.	Trigger 50 combos.	Unlock the uncommon Combo Sigil Expedition Consumable blueprint.
Combo Master II	Trigger combo reactions during combat.	Trigger 100 combos.	Unlock the rare Combo Sigil Expedition Consumable blueprint.
Combo Master III	Trigger combo reactions during combat.	Trigger 250 combos.	Unlock epic Combo Sigil Expedition Consumable blueprint.
Melee Master I	Defeat enemies by using melee combat.	Defeat 100 enemies with melee.	Unlock the uncommon Melee Sigil Expedition Consumable blueprint.
Melee Master II	Defeat enemies by using melee combat.	Defeat 250 enemies with melee.	Unlock the rare Melee Sigil Expedition Consumable blueprint.
Melee Master III	Defeat enemies by using melee combat.	Defeat 500 enemies with melee.	Unlock the epic Melee Sigil Expedition Consumable blueprint.
Ultimate Master I	Defeat enemies using a javelin's Ultimate ability.	Defeat 100 enemies with an ultimate ability.	Unlock the uncommon Ultimate Sigil Expedition Consumable blueprint.

CHALLENGE NAME	IN-GAME DESCRIPTION	COMPLETE CONDITIONS	REWARD
Ultimate Master II	Defeat enemies using a javelin's Ultimate ability.	Defeat 250 enemies with an ultimate ability.	Unlock the rare Ultimate Sigil Expedition Consumable blueprint.
Ultimate Master III	Defeat enemies using a javelin's Ultimate ability.	Defeat 500 enemies with an ultimate ability.	Unlock the epic Ultimate Sigil Expedition Consumable blueprint.
Dominion Eradicator	Defeat Dominion	Defeat 200 Dominion enemies.	Coin
Dominion Equipment Destroyer	Destroy Dominion Turrets	Defeat 50 Dominion turrets.	Coin
Outlaw Eradicator	Defeat Outlaws	Defeat 200 Outlaw enemies.	Coin
Outlaw Equipment Destroyer	Destroy Outlaw Turrets	Defeat 50 Outlaw turrets.	Coin
Scar Eradicator	Defeat Scars	Defeat 200 Scars.	Coin
Scar Equipment Destroyer	Destroy Scar Turrets and Hives	Defeat 50 Scar turrets.	Coin
Skorpion Eradicator	Defeat Skorpions	Defeat 200 Skorpions.	Coin
Titan Eradicator	Defeat Titans	Defeat 50 Titans.	Coin
Ursix Eradicator	Defeat Ursix	Defeat 100 Ursix.	Coin
Wildlife Eradicator	Defeat Wolven, Wyverns or Anrisaurs	Defeat 200 Wolven, Wyvenrs or Anrisaurs.	Coin

JAVELIN CHALLENGES

CHALLENGE NAME	IN-GAME DESCRIPTION	COMPLETE CONDITIONS	REWARD
Uncommon Javelin	Complete a mission in an Uncommon javelin.	Complete a mission with a javelin of at least uncommon rarity.	Achievement: Uncommon Talent, and Coin
Rare Javelin	Complete a mission in a Rare javelin.	Complete a mission with a javelin of at least rare rarity.	Achievement: Rare Talent, and Coin
Epic Javelin	Complete a mission in an Epic javelin.	Complete a mission with a javelin of at least epic rarity.	Achievement: Epic Talent, and Coin
Masterwork Javelin	Complete a mission in a Masterwork javelin.	Complete a mission with a javelin of at least masterwork rarity	Achievement: Master Talent, and Coin

FREELANCER CHALLENGES

CHALLENGE NAME	IN-GAME DESCRIPTION	COMPLETE CONDITIONS	REWARD
Legendary Freelancer	Complete All Listed Challenges	Complete the Challenges: Distinguished Explorer, Uncommon Javelin, Rare Javelin, Epic Javelin, Masterwork Javelin, Assault Rifle Master I, Marksman Rifle Master I, Light Machine Gun Master I, Machine Pistol Master I, Heavy Pistol Master I, Shotgun Master I, Sniper Rifle Master I, Autocannon Master I, Grenade Launcher Master I, Ranger Gear I Master, Colossus Gear I Master, Storm Gear I Master, Interceptor Gear I Master, Exploration Master, and Complete Mission Challenges.	A decal and Coin
Artifact Silencer	Silence Artifacts	Silence 10 Artifacts.	Coin
Treasure Hunter	Open Chests	Open 50 treasure chests.	Coin

FEATS

Feats are the sole source of XP in *Anthem*. You earn Feats by participating in major activities, such as completing missions, strongholds, world events, and for reinforcing other players. You can also earn Feats through repeatable activities within missions, such as defeating enemies, harvesting materials, and reviving other players. At the end of an expedition you are granted a lore Feat which gives you a classification of your playstyle based on your Feats. When playing multiplayer, a portion of your XP is added to each other player in your squad (without reducing your own pool).

BONUS FEATS

FEAT	REQUIREMENTS	EASY	NORMAL	HARD	GRANDMASTER +
Mission Complete	Successfully complete a Mission	1200 XP	2000 XP	2800 XP	3600 XP
Stronghold Complete	Successfully complete a Stronghold	300 XP	500 XP	700 XP	900 XP
FEAT	REQUIREMENTS	1 EVENT	2 EVENTS	3 EVENTS	
World Events	Successfully complete World Events in Freeplay	200 XP	600 XP	1400 XP	—
Reinforcement	Reinforce other Freelancers on Missions	200 XP	—	—	—

All of the following Feats award 50 XP for Bronze, 100 XP for Silver, and 200 for Gold

ARTINIA-"SOLDIER"

FEAT	REQUIREMENTS	ENEMIES DEFEATED		
		BRONZE	SILVER	GOLD
Weapon Master	Defeat enemies with weapons	10	20	30
Weak Point Striker	Defeat enemies by hitting their weak points	5	10	15
Elite Slayer	Defeat Elite enemies	3	6	9

CARIFF – "ARTILLERY"

FEAT	REQUIREMENTS	ENEMIES DEFEATED		
		BRONZE	SILVER	GOLD
Combos	Trigger combos on enemies that have effect on them	5	10	15
Multi-Kills	Defeat numerous enemies simultaneously	1	2	3
Gear Master	Defeating enemies with Gear	10	20	30

GAWNES – "EXECUTIONER"

FEAT	REQUIREMENTS	ENEMIES DEFEATED		
		BRONZE	SILVER	GOLD
Melee Master	Defeat enemies with melee attacks	10	20	30
Legendary Slayer	Defeat Legendary enemies	1	2	3
Ultimate Master	Defeat enemies with an Ultimate ability	10	20	30

YVENIA – "SAGE"

FEAT	REQUIREMENTS	ENEMIES DEFEATED		
		BRONZE	SILVER	GOLD
Materials Harvested	Harvest crafting animals	3	6	9
Ally Javelins Repaired	Repair downed ally javelins	1	2	3
Collection	Find collectible objects in the world	2	5	10

ANTHEM

STANDARD EDITION GUIDE

Written by Michael Owen, Kenny Sims, and Long Tran

Maps by Loren Gilliland

DK/Prima Games, a division of Penguin Random House LLC
6081 East 82nd Street, Suite #400
Indianapolis, IN 46250

ISBN: 978-0-7440-1897-4

Printing Code: The rightmost double-digit number is the year of the book's printing; the rightmost single-digit number is the number of the book's printing. For example, 19-1 shows that the first printing of the book occurred in 2019.

22 21 20 19 4 3 2 1

001-310104-Feb/2019

Printed in the USA.

CREDITS

Senior Product Manager	Book Designers	Production	Copy Editor
Jennifer Sims	Tim Amrhein	Beth Guzman	Serena Stokes
	Wil Cruz		
	Brent Gann		

THANK YOU TO ALL OUR LOYAL FANS!

The Prima Games team:

Beth Guzman	Jennifer Coghlan	Mike Roque	Stacey Ginther
Beth Kline	Julie Asbury	Paul Giacomotto	Tim Cox
Brent Gann	Mark Hughes	Rob Howell	Tim Amrhein
Jeff Barton	Mike Degler	Shaida Boroumand	Wil Cruz
Jennifer Sims			

ACKNOWLEDGMENTS

Prima Games would like to thank Kyle Tetarenko for his invaluable help in making this guide, tirelessly tracking down info and assets, and especially for making our team feel very welcome at BioWare's studio. We would also like to thank Rob deMontarnal, Amanda Klesko, Camden Fagar, and the rest of the amazing team at BioWare for their support.